DARK LIGHT OF THE SOUL

Encounters with Gabrielle Roth

'

Compiled & Edited by Eliezer Sobel

Foreword by Andrew Harvey

RAVEN RECORDING, INC.
www.ravenrecording.com

Published by Raven Recording, Inc.
42 W. 13th St #4G 10011
www.ravenrecording.com

Cover Design:Ana Cvjetićanin
Cover Photo: Julie Skarratt
Photo Editor: Robert Ansell
Graphic Design: Eliezer Sobel
Proofreader: Scott Ansell

2nd Edition
ISBN: 978-X-XX-XXXXXX-X
Library of Congress Control Number: 2021921196

Editor's Note:
The contributors to this celebration of Gabrielle's spirit come from all over the world, and some of them use different spellings than American English. For example, the British spell "humour" the original way, instead of the American "humor," and "realised" instead of "realized," "towards" rather than "toward."

some people write in all lowercase letters,
and some prefer not to indent paragraphs or use periods

I left all of these differences alone, so if you find yourself thinking that the editing style for this book seems inconsistent throughout, you're right, it is.

(Also, most of the book is in alphabetical order by first names, except where it isn't.)

It has always been my yearning
to dance toward the One,
to dance cheek to cheek with God.

—Gabrielle Roth

DEDICATION

*To Gabrielle...who else?**

* Oh, and to Robert Ansell, that's who else, whose enthusiasm and support for this project—and me—was unwavering. Also, he's a really great guy; and a very generous, kind and loving friend to me for 40 years.

And to

Jonathan Horan,

Gabrielle's beloved son,

for keeping

her work and lineage

alive and pulsating

around the world.

At Gabrielle's Memorial Service in New York City, January 2013, Lori Saltzman created a "writing prompt" that was printed on hundreds of blank cards, requesting that people read the prompt and spontaneously respond on the cards.

Many of these are sprinkled throughout the book.

Lori's prompt was,

"I will never forget…"

For example:

> # I will never forget…
>
> the movement of her
> Arms, her
> Hands, her
> Sunken chest, her
> Massive heart, her
> Surprise, her
> sharp precise words, her
> <u>Her</u> Love
> Rodney Yee

Rodney Yee was Gabrielle's friend and yoga teacher.

FOREWORD

By Andrew Harvey

I adored and revered Gabrielle Roth, both as an intimate spiritual friend whose honesty and radiance inspired me, but also as one of the true pioneers of sacred modern dance. Her book, *Sweat Your Prayers,* should be read by every human being who's still mobile.

Gabrielle felt that the 5Rhythms® community had achieved a great deal and she was profoundly thrilled and deeply moved by everything that had happened, and by the spread of the movement all over the world. But she also thought there was another level to which the whole dance community could go, a more instinctual and focused mystical level, which would enable the movement to be even more impregnated by the Divine and even more powerful in providing a container for Divine energies to go deep into the body and give us all the strength and the power and the passion and the stamina to rise up to the challenges of a time that she knew was apocalyptic.

At the end of her life, Gabrielle and I were working on what could have been a truly pioneering book, in which we were going to marry, intimately and gorgeously, the 5Rhythms to the different stages of Rumi's mystical path to Divine Love. We met many times to work on the book, and I was astonished by the energy and focus that she brought to the project, even though she was clearly extremely ill. It was something that galvanized her, and whenever I asked her if it was too much, she would say,

"No no no, this is what I am living for!"

Perhaps the most wonderful moment in our many conversations came one afternoon, while lying back in her chair, when she started to describe the genesis of the 5Rhythms. She went into a long, rich, elaborate, and extraordinarily dramatic account of the birth of Jonathan, which had been extremely rigorous, but also of course, in the end, profoundly ecstatic.

I shall never forget the way in which Gabrielle lived out, on that chair, all the different stages of the birthing process that had so seized and possessed and transformed her; the way in which she described each stage of that process and how it engendered the 5Rhythms was electrifying. I realized that one of the reasons why the 5Rhythms had become so internationally successful is that they truly *do* represent and incarnate the rhythms of the birthing process itself, the process that engenders the Divine Human from the human.

What stayed with me most acutely was her description of her experience as the contractions of birth started to possess her. I remember her saying,

"I became entirely flooded by this majestic, unstoppable, Primordial Mother-force that threw my body around like a rag."

Before I heard her talk in this way, I had never understood, not being a woman or a mother, how birthing a child is a direct initiation into the birthing power of the universe. Gabrielle acting that out and speaking of it made an indelible impression on me, and I realized even more deeply than I'd ever done before that what we call Divine, or Divine energies, are not in any way separate from ordinary life. They are *inherent* in ordinary life, and expressed in so many amazing ways each day if only we have the inner intelligence to see and know them.

Gabrielle Roth was an irreplaceable person with her depths and mystical range and her own exquisite, amazing power as a dancer. It always struck me so deeply that Gabrielle's vision of dance was far from being concentrated on the physical dimension. She felt herself more like a wind with a body, rather than a body, and her emphasis in all of our conversations was on melting into the transcendent and drowning in it, so that the transcendent itself could move the body like a feather on the wind.

This was very moving for me to hear because I've had a lot of friendships with dancers and the greatest of them all said things not unlike Gabrielle. This comes to the heart of what is at stake in authentic, sacred physical disciplines such as yoga, the Dance of Oneness, and other systems: they try to birth a sacred marriage between transcendence and immanence, so that there is a complete vanishing into the spirit while also being completely present in the body. This marriage of utter abandonment to transcendence and utter focus in the depths of the cells is, in the larger sense, the key to the evolutionary process that we're now undergoing, the process of giving birth to an embodied Divine humanity.

So just as Gabrielle had opened up for me this vision of birthing at the center of ordinary/extraordinary life, so too she very simply gave me the clue to the embodiment process itself in her own very eloquent statement of how she danced the way she did, because she strove with all her might and passion to unify herself in the depths of her soul with the Eternal Beloved.

I am honored to introduce this rich, poignant, hilarious smorgasbord of stories about Gabrielle. She was indeed an unforgettable person, and she revealed her strange and mysterious mastery not only in her extraordinary teaching, and not only in her passionate, poetic prose, but in the slightest gestures she made, and in the way she *listened*, and in the way she opened her heart to you—cryptically sometimes, but always with deep insight. Gabrielle will always remain for me not only one of the most powerful teachers that I've met in any realm, but a living and flaming example of an absolutely authentic person, authentic in every action and every thought of her being. It's that passionate authenticity that always wakes up in my soul when I think of her. I am so happy that so many others will now know Gabrielle—or at least a part of Gabrielle—in the way that the extraordinary range of people assembled here reveal.

I wish this book tremendous success, and hope that the vision presented herein of Gabrielle as a ruggedly real *person* will inspire mystics and seekers all over the planet.

Andrew Harvey
Oak Park, Il.
April 29, 2019

INTRODUCTION

By Eliezer Sobel

In the grand, phantasmagorical theater production that is this world, Gabrielle Roth's cameo role was to play an inscrutable incarnation of a Vast, Inner Silence and Stillness, and double-cast as a Dancing Devotee of a Dark, Eternal Emptiness, forever moving "Toward the One" in the spirit of total, joyful surrender.

She also appeared as an edgy, street-smart, New York bohemian alchemist, transmuting slumbering souls into awakened artists of ecstatic expression, lucid lovers of Divine delights, and transformational truth-tellers trapped in the treacherous trenches of daily life:

"We're not searching for some big Truth with a Capital T that belongs to everybody," she'd say, "but the get-down-and-dirty personal kind, the what's-happening-in-me-right-now kind of truth."

If you showed up around her parading your ego and needing validation, she would be bored to tears and likely turn away, with no warning or excuse, simply uninterested in engaging with someone who was clearly not really *there*.

A skinny lady-in-black, shapeshifting through space like a sinewy catwoman in midnight shadows, she would suddenly appear on the dance floor in your peripheral vision, beckoning you to come closer, seducing you to the cliff of an unknown inner cavern that was at once terrifying and irresistible. Like a Siren call, it was the pull of dissolution beckoning you home, and Gabrielle dared you to leap over yourself into the *Zero Zone* and enter the *Unified Field* for a much-needed restorative respite from the insanity of this crazy, mad world that is suffering the deep and ancient wounds of disconnection and fragmentation: from each other, from nature, from our own bodies, souls and spirits.

When we trusted ourselves enough to take that fearful, faltering step beyond the familiar and predictable version of ourselves, instead of free-falling down an endless, spiraling abyss, Gabrielle would be right there to catch us, take our hands and our hearts—and our *feet*—and guide our spirits to let go, to soar, to

dance.

Yet we, meanwhile, her creative *collaborators* (a more accurate word than "followers") continued to make our best efforts merely to *exist*; to get through another day, to desperately strive to appear semi-normal and simply survive, let alone express the pulsing power, beauty and exquisite artistry burning at the core of each one of us.

To fan *that* flame, we turned to Gabrielle. And the first thing that had to go was this fixed idea of being normal, because none of us are. Normalcy is merely the concoction of agreed-upon, "proper" behaviors, thrown together by a misguided culture, a collection of out-of-touch, clueless earthlings anxious to fit in at all costs. And Gabrielle was the last person in the world to provide guidance about how to fit in, unless it was into your own skin, or possibly an expensive, designer black boot.

People would often try to define her. A dancer? Well sure, of course, but that didn't nearly cover it. A shaman? Definitely, even though she would grow to find that word problematic for her. But she *did* feel as though she had been given a unique shamanic offering to pass along as a healing gift to her disembodied Western urban world, almost as if she had been sent here on assignment. (*Special Ops.*)

Her mission was to breathe life into what appeared to be a sleepwalking population of mostly battle-scarred veterans of "The Child Wars," wounded, suffering, and slowly dying without ever having truly lived, people asleep to the fullness of feeling totally alive and finally free. The method that she used to shake up our somnambulist charade—apart from simply showing up and being herself—was a multi-layered, worldwide movement practice, "The 5Rhythms®," composed of maps of the psyche detailing the labyrinthine path of the being, the unraveling of the body, heart, mind, soul and spirit, through using the body itself, in motion, as the primary teaching device.

"Put your mind in your feet and your body in the beat," she'd call out, and, "The rhythms are the real teacher"—Flowing, Staccato, Chaos, Lyrical and Stillness, inspired and lit up by rock 'n roll, world music, and the nonstop beating of live conga drums, tom-toms, djembes, percussion of every stripe, and yet more drums.

Or to keep it easy and simple: Gabrielle's trade was obviously that of a healer and teacher. As well as a writer (three books); musician (25 CDs); and Muse (to thousands across the globe).

Or how about Psychic-Intuitive-Empath? Check.

Good witch/bad witch/Magician of the Tarot deck? Check.

Feminine Warrior,

 Lover,

 Mother,

 Mistress,

 Madonna?

Checkmate.

She was all of those things, and yet she often confessed that she was truly a theater director at heart. So along with multiple live productions over the years, she would devote a portion of her workshops to "Ritual Theater," in which smaller groups would have 20-30 minutes to create a powerful, spontaneous and brilliant piece of unscripted theater that, like a Tibetan sand mandala, would be witnessed only once, then disappear forever.

Ultimately, though, she put even *that* label aside, and there was only one word remaining that felt most accurate to her:

Artist.

More than anything, Gabrielle Roth was a fervent disciple of the creative process, devoted to diving fully into the heart of the artist's and seeker's insatiable longing for the Unknown, the Nameless, Numinous Dark Mystery that is the very core of life itself. And then expressing that wondrous place in *any* form— dancing, painting, cooking—or even *no* form, only the silent stillpoint in the moving center of the soul.

And thus she had very strong feelings about Art, and was not shy about expressing them. I once escorted her to a musical performance of a dear friend of ours, and shortly into it, we exchanged a look that basically communicated a mutual thumbs down. This guy did not have that elusive spark of originality that separates every teenager with a guitar from Bob Dylan.

When it was over we headed backstage to greet the performer, and I asked G,

"What are you going to say to him?"

"Art is the one thing I will not lie about to spare someone's feelings. If he asks me, I will tell him what I think. He deserves to hear my truth. It might save him a lot of time in the long run. Hopefully he won't ask."

Apart from "Artist," when pushed to come up with a term to describe her particular role in the tribal circle in which everyone had an equal voice but a unique *function*, the word she chose was "catalyst." Not therapist, not spiritual guide, guru or dance teacher, but *catalyst*, which the dictionary defines as,

"That which causes or inspires movement and change."

And catalyze us she did.

Gabrielle worshipped at the feet and beat of the Divine Feeling Feminine—the nurturing Mother, the mischievous Mistress, and the mystical Madonna—bowing to the Sacred and outrageous, while firmly rooted in the Soul, the Imagination, and the bottoms of her two feet on the ground. The sorrowful heart of humanity was excruciatingly evident to her on the wild streets of New York City, where she observed the profound wounds of our culture on the subway—(okay, she almost exclusively took cabs)—and in the throbbing beat of incessant boom boxes, the very pulse of the city moving up from the pavement through her veins and feet, schooling her in the customs of the local inhabitants. Like a scout sent ahead to survey the terrain, she brought her findings back to guide us in how to navigate our shared, chaotic surroundings, how to surf the wild waves of our times, how to dance a tango with our collective, cataclysmic cosmos.

*And...*as many here will report, Gabrielle Roth was also quite an ordinary—albeit hilarious—woman who loved shopping and shoes and meeting over a cup of tea in the Village to talk about clothes, movies and men, her three favorites being her son Jonny, husband Rob—Robert to everyone else—and George Clooney. I used to assume that I *must* have been next on that list, but then slowly realized that at least 1,437 other men believed the same thing.

It was truly uncanny: nearly everyone who interacted with Gabrielle, whether for a moment or for years, always felt very special, as if they and they alone had a precious and unique connection with this unusual woman, this *mystic*. And the fact is, they *did*. Person after person, literally thousands all over the world, felt their own version of the same phenomenon. It remains incomprehensible that one woman could deeply connect on such a deep soul level with virtually everyone with whom she came into contact, but that was Gabrielle's astounding and rare gift: the ability to offer *all of her attention and presence* to the person

13

standing before her, to bypass their persona and intimately see and speak directly to their inner brilliance, their dormant creative genius and vulnerable heart. It was love at first sight—or rather, *soul* at first sight—over and over and over again. People felt truly *seen* and touched in their very core. Inside her gaze there was nowhere to hide, and nothing *to* hide. She was a human x-ray machine who could see through bones into the marrow of one's life force itself.

This is not the place for biography (or, for that matter, hagiography; she would hate that.) Gabrielle's personal "story" was mostly irrelevant to her and she rarely spoke of it. After being friends for 34 years, I only learned that she had a brother and sister while putting this book together. But more to the point than *her* story, *our* stories were equally irrelevant to her. If anything, her mission was to radically disrupt our usual narratives that we'd been reciting to ourselves for years and repeating to anyone who would listen. She challenged us to abandon the safe choice of our predictability, and instead, dared us to step forth as an edgy, risk-taking, *alive* and authentic, fully expressed *human*, a Warrior of the Spirit.

(As distinct from, as she put it, a "Nice, normal, neutral, neurotic nobody.")

Gabrielle was a catalyst of surprise and the unexpected, a rare, intuitive being who dared to dance her prayers so far out of the box there was no turning back and the box itself dissolved. And she beckoned anyone who had the courage and readiness to join her, to come along for the ride, a journey of pure Imagination through a tunnel of love that would one day quietly arrive at the "Silver Desert Café," Gabrielle's favorite mythical destination suitable for sitting with a friend or two and enjoying a simple and relaxing cup of tea. "One day we will meet there," she'd promise, "at the Silver Desert Cafe."

Cut off from the artist within,

our soul withers and fades,

for art is what keeps us vibrant.

It is the language of the soul.

—Gabrielle

photo by Robert Ansell

BIOGRAPHICAL PRELUDE

By Martha Peabody

Gabrielle Roth was born and raised in the West, lived in the East and worked the everywhere in between and over. Educated as a teacher she spent her life coming into her true calling—A Mysterious Contradiction.

A white woman with the soul of a black preacher man
A mother with a teenager's heart
A dancer with a starving poet's body
An anthropologist with a silver shovel gaze
A loner who attracted crowds
A healer who wrote prescriptions with her feet
A survivor of an ancient wisdom cult held in
modern rock & roll
A director possessed by visions
A wanderer obsessed by maps
A witch shaman warrior priestess guru mistress drinking red
wine at the table next to you
She was the softest black leather trench coat with ballet
shoes as a belt.
She smelled like all your best memories and
could point to the core of your most vivid nightmares.
She was shy and nothing and everything scared her.
Fierce and fragile she could stand-up comedian trick you into
the deepest wholes of yourself then see this unraveling as art.
She believed in the physical power of motion,
the wisdom of gravity,
the emptiness of true love, the fact that there is no way out
but thru the body,
no way up unless we all go together,
no way down unless we follow the beat,
and no way in unless we embrace the dark.
She was the deepest shadow of the brightest light.

Martha Peabody 2007
Amended 2013

photo by Robert Ansell

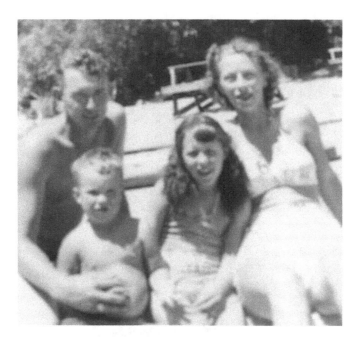

FAMILY

Note from Gary Carroll, Gabrielle's brother:

G's Mama, our mother Jeanne, passed on March 8, 2019, at 99 years, 8 months and 16 days. She died as a result of blood clots in arteries on both sides of the brain. She was very special to Sis. Our mother called G's followers "Gabrielle's Warriors." Many times we played CDs of the Mirrors and would move about the room together. I'd move her around in her wheelchair and her hands would move gracefully about. The prayers of movement keep us all close.

We had a private burial on her 100th Birthday, when she joined our father. After the service, we celebrated her life at my home. It was truly a special day.

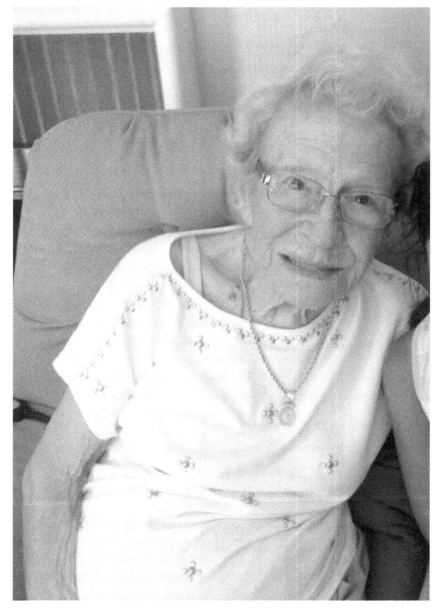

photo by Bella Dreizler

Jeanne P. Carroll

July 19, 1919 to March 8, 2019

R.I.P.

Over the years, Gabrielle's student, friend and 5Rhythms teacher, Bella Dreizler, developed a relationship with Gabrielle's mother, Jeanne. When Jeanne was approaching 100, she attended a few of Bella's classes in Sacramento where they both lived. Bella was kind enough to interview Jeanne on behalf of this collection, but first, a little background from Bella about how their connection began:

Bella:

It's October 2008 and I'm driving home to Sacramento from Westerbeke Ranch after the third and final module of the Teacher Training, the imprint of Gabrielle's hands pushing me into the world still palpable, like angel-wing tattoos.

I know her mom lives in Sacramento and that Gabrielle is also on her way there, because she asked if I could treat her shoulder since we were landing in the same place. We set a time for the next day.

Our garage had been torn down and a studio for my bodywork practice was being erected. When Gabrielle entered that next day, she was the first patient through the door, the first spirit on the treatment table in my new space, and it was the first time I laid my hands on her. (Patient confidentiality has me halting right here.)

But afterward, she insisted I meet her mom and offer her a treatment as well. I drove to south Sacramento the following week, and so began a decade-long relationship with Jeanne Carroll.

From the beginning, I incorporated dance into Jeanne's movement treatment. She'd stand at her walker and totally shake a leg! Over the course of the next four years, from time to time I'd pick her up and bring her to my class on Thursday nights. She just sparkled, and on the way home wanted all the dirt I could dish out on each participant. The community totally embraced her.

On the Thursday night in 2012 when Gabrielle's final passage was near, Jeanne showed up at the class with her son Gary and his wife. I exclusively played two hours of Gabrielle's music from her "Mirrors" CDs. The room was deep, dark, so incredibly still. It is seared in my memory and people still talk about that night. That was the last time Jeanne came; it was just getting too hard for her to get in and out of the car and make her way into the space.

Although Jeanne has since passed on, at the time of this writing, I was still seeing her periodically.

She was 99 years old and really slowing down. But that sparkle? That insatiable curiosity about people? Still totally alive. Now Jeanne's words:

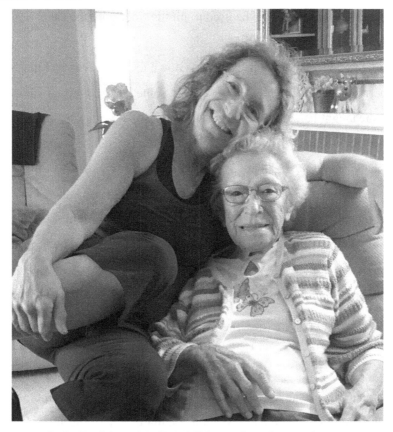

Bella Dreizler with Gabrielle's mother, Jeanne Carroll

<div align="right">

Jeanne P. Carroll
Heaven

</div>

At one time Gabrielle wanted to be a nun, and nothing could change her mind, being that she was at the Catholic school…oh, I know something you can tell: In Newark, California, where we lived for 13 years, the lady who ran the library, Josephine Dorley, said to me, "Oh Jeannie, your daughter has possibly read every book in this library!" When she was a little girl we read stories to her all the time. She loved that, and became a very avid reader. She loved going to school, she was very adaptable and did a lot of reading and she

got good grades. Very studious.

I put both her and her sister Christine into a dancing school run by Sylvia Something; she had been a dancer, this old lady, and she had a cane, and she used to hit the floor with the cane. She had all the neighborhood kids at her dancing school.

In high school Gabrielle went with a pack of girls down to Santa Cruz and they took up baton twirling with a young man, Robert Olmstead, and later they stayed at some sort of summer camp he owned by Lake Tahoe somewhere, and she taught baton twirling for him there. She was also with the San Francisco 49ers! She sometimes did the baton twirling with fire, and her brother Gary said, "Oh God…"

When she was in Washington High, she formed a class of little kids who came from the block and surrounding areas. They heard about her and they wanted to be in the class, and so she had a nice group of kids who worked out on the lawn at the school. Every mother and every child loved her, because she did things for them: she taught them baton twirling, and she babysat, and she could be trusted. She would go to somebody's house to babysit and she'd end up ironing and doing housework too, and she played with the kids. She was really gifted that way. She had a lot of different jobs—she even worked at the theater in Fremont, selling tickets. She was very enterprising.

She was very close to her dad, Gene. He doted on Gabrielle because she was smart. He favored her, I think.

One day she came here, and she always had a twinkle in her eye when something was happening. And she sat there and I looked at her and I said, "What is the matter?" and she said,

"I'm going to have baby!"

And that's how she told me she was pregnant and having a baby. And Jonathan was such a beautiful baby.

When she and Robert got married she called me up and said,

"We got married," and I said,

"I hope you didn't do it on my account!"

And he's been a wonderful son-in-law. I am just crazy about him. He really deeply loved her. Early on he once called up when Gabrielle was at the house for dinner. The phone rang and she talked to Robert forever and then she came and told us,

"I'm leaving. I'm going back East. Right now I'm getting on a plane and I'm going to Robert's

place," and she went to live with him. She said,

"Sell the car."

And she had people in San Francisco pile her clothes into bags and ship them, and that's when she moved in with him. And she grew to love the East Coast.

A TV crew came here once and the woman kept asking me, "How come Gabrielle was so private?" I said, "She's always been private. She never broadcast anything that was going on. She was a very private person." And she was very independent. She could do anything, and she *did* do everything that she wanted to, and it was always the right thing. And as far as I know she was a "good girl"—[laughter].

She had quite an exciting life, I think. When she was in college we didn't see much of her, she was all wrapped up in things. She earned some cash by ironing the guys' shirts and stuff like that. We went down to see her one time—she was in San Jose—and she said,

"Oh Mom and Dad, you're welcome here, but I wish you'd called first."

We brought her some cookies and then we left.

And now it seems like everyone's dying except me.

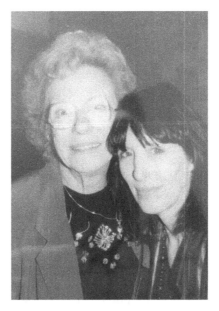

Mother & Daughter

Gary Carroll
Elk Grove, CA

More from Gabrielle's brother:

Growing up mostly in San Francisco, we would go on holidays with our parents to the Russian River, just north of the city. When I was three I wanted to join the older kids as they went by on a raft, floating on the river. G saved my life that day. As we were all playing, as kids will, I decided to jump off the raft. G, with quick reflexes, grabbed me by my swim trunks and held me until our father and others swam to the raft to get me. G was seven years old at that time and it took all her strength to hold me. She gave me a big kiss and hug and never got mad. Amazing sister!

When I was 12 years old I was invited to my first birthday party that was a "boy-girl" party with dancing. I didn't want to go. G asked me "Why???" I said, "Because I don't know how to dance." G then grabbed my hand, took me in her room and put a Little Richard song— "Lucille"—on her record player and taught me how to dance. We never stopped dancing from that moment on.

Our Nana once asked G, "Where did you learn to dance so gracefully?" My sister loved to dance. Ballet was her first love, as she saw this woman dancing once through the window of a dance school. G could not stop thinking about her and how beautiful her movements were. I remember her moving furniture so she had more room to dance on our hardwood floor. She took ballet, tap, heck, she just fell in love with movement.

G also had a real hunger for reading. It was not uncommon for her to have four to five books going at a time. One was usually for simple enjoyment. Possibly fiction or poetry, which she loved, but the others might be about Stalin or Buddha or Einstein. She would always tell me,

"It is from books I can learn, but it is up to *me* to interpret the meaning of what the books are trying to say. I want to come to my own conclusions and not be swayed by someone else's influence. By reading you can understand life."

The Head Librarian at City Library once told our mother that Gabrielle must have read every available book in stock, from simple reading to books that spoke of knowledge in many subjects. She told Mom, "Someday your daughter will make an impact on people." Guess she was right.

Dad & G

Gabrielle loved her mother and was very close to our father, who passed away in 1981. Our father was a big influence on her writing. Dad was gifted with words and would challenge her writing, and make her think about what she wanted to say. How with the use of the right words, she could create the message: "Make it real" is what G said Dad taught her. He would say, "What's a joke without a punch line? Right! What's a story without a plot? Right!" Then later she would become the teacher, and would say to me,

"If you want to tell something, make sure you understand first what you want to convey, then find the words that best describe the thought."

G was also an amazing talent with the baton. She was the main half-time attraction at high school football games. This talent earned her money, as she taught baton twirling both in high school and college. One of her students would later use baton twirling as her talent when she won the 1964 Miss California pageant!

Side note: the high school football coach was Bill Walsh who went on to a great coaching career with the San Francisco 49ers. The irony was that one day G would become part of the 49ers Majorettes and was part of the parades and half-time performances on game days. G always loved to perform.

~ ~ ~

My sister was very private about her personal life. Our home was her getaway location, her place to wind down and breathe. She was special to us all. She and I just shared our energy through positive vibes. I could think of her at any point in time, just concentrate on her being, and I could feel her warmth and love. There were times when, for no reason, I could sense her around me; maybe she was having thoughts of her

brother. No explanation; it just happened.

When she passed, I remained silent for some time. Too much going on to take a moment to reflect on missing moments in memory. I was always close to my sister, who later in life blessed so many with her being. G was an amazing young girl who grew into this very special creative woman whose gift to heal has helped so many.

Her words are remembered, but it's what her vision was that still ROCKS the many who follow her path. A Teacher she was. From the early days of her life, mostly through her leadership qualities, G would get people to understand how they could achieve anything no matter the magnitude or difficulty, if they first understood and then believed in themselves.

"Nothing can not be accomplished providing you first prepare," she would say. "The power of who you are is the power of what you become. Let your feet take you through the Rhythms and your soul to your new life. Let loose of what holds you back and become free. Dance!"

G said that to me about 23 years ago when I lost a job.

"Life will continue, it was a temporary setback, now on to better things. Dance! Dance! Dance!"

Her life was always moving forward. She pretty much left her past out of her thinking. She would say,

"Hey, I can't change what is past so why waste thoughts? I want to make a difference, not just exist."
And,

"Know who you are, BLB (Big Little Brother), as life will take many turns, so educate your mind and be prepared. If you want to get somewhere you must first make the effort, for nothing has meaning until it is earned." Gabrielle was an amazing girl. Perfect. No. She was normal at times as well. She just had a specialness that through her life developed her into someone who has made a difference in life for so many she came in contact with. Believe this: She once wanted to become a nun! We went to Catholic school in San Francisco. I think her desire really wasn't to be a nun but a teacher. And she is still teaching.

Our father was a smoker, and just like G, his left lung was infected first. Gabrielle smoked as a young woman and then dropped it, and I believe that her cancer was really from the falling debris of 9/11. That first plane flew right over her and Robert's loft, trembling the window on East 13th Street. Then the explosion came. My sister was home and Robert was at work. G felt a duty to donate blood for the mass of injured

people, so she went down there and ingested that air filled with toxic chemicals while waiting her turn. This is what I believe.

A fighter she proved to be as she fought this killer for three years. "Fuck Cancer," is what her t-shirt said. G left a message for all who follow on her path of Rhythm, and that is:

"Don't look back, and believe in yourself, your being. Find your center, live and love life, let your feet find the way and your soul embrace what is yours: LIFE."

Let my Sis dance barefoot across the hardwood of our skies,
flowing gracefully with her wings in full extension.

I will never forget...
My Loving Sis
for All our shared
moments
The joy we had as
Children
Your Saving my Life
That day At Russian River
And you The Spiritual one
who has given To so Many
Love forever Marv

Lucia Horan
Big Sur, CA

Lucia began her shamanic apprenticeship with Gabrielle shortly before she was born, and has been dancing by her side ever since.

RAVEN

I was 29.

In my darkest hour

You called me

On the phone

And asked

"Lucia, what do you need right now?"

I responded with an answer that no one could fulfill.

So you instructed me

To give That, whatever I wanted most, to someone else.

And I did

And what I found

Was that I had received my own medicine.

The one I felt no one could ever gift me.

It was your Shamanic Prescription. That day, it saved my life.

Forever in gratitude for our connection.
This is love. What else are we here for?

Always yours,
Lucia

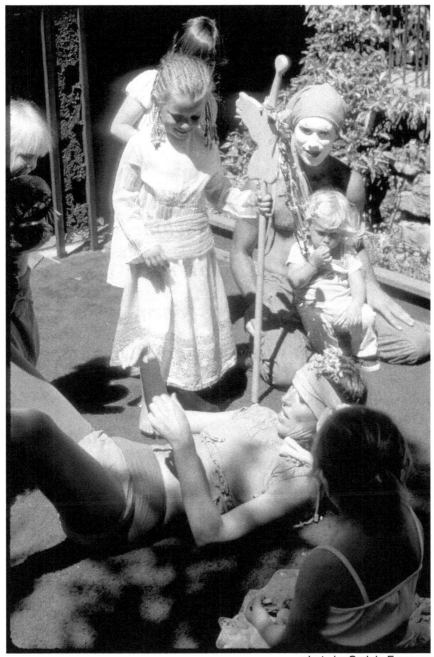

photo by Sydele Foreman

Gabrielle lying down, Lucia standing over her,
and sister Jasmine sitting on Glen Cheda's lap.

When I'm teaching,

I just show up,

rip my chest open,

let my heart spill out all over the place,

and offer the same space to everybody else.

—Gabrielle

Jasmine Star
Big Sur, CA

Jasmine is an author, educator, art activist, Lucia's sister and Gabrielle's goddaughter.

She would have loved my lover now, she would have loved my daughter now. She was sexy, obsessive, neurotic and anxious and completely spellbindingly direct. I remember her describing what herpes sores looked like at the dinner table. She liked to shock people. She liked to swear. She liked to shake people to life turning everything upside-down and inside-out with a drumbeat and a dance floor and hold words above them like dream-catchers to hang meaning on. She was a writer, words were her bridge, but movement was her medicine. She loved art, music, movies, shopping, dreams, healers, singers, dancers, dreamers. She loved talent and people, and at times she wanted to be left alone, to be swallowed by her white couches and surrounded by the stillness of being inside a loft in Manhattan surrounded by rainbow Quichole yarn paintings. She was shadow and light. Gabrielle was human, flawed, imperfect, incredible, powerful, loved so hard, danced so hard, left a hole in this world that is too hard to fill with anything but outrageously deep breaths and hot dances that leave you open and dripping and crying on the dance floor.

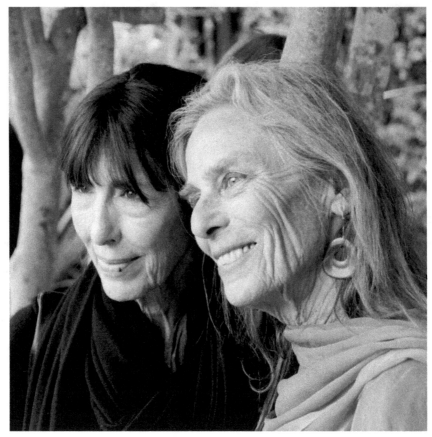

Gabrielle with Peggy Peggy Horan

Big Sur, CA

Peggy, a longtime Esalen massage therapist and teacher, is Lucia and Jasmine's mother.

A few one-liners from G:

"Of course Jasmine will marry an African!" (And she did.)

~ ~ ~

"Just move, no one is watching!"

~ ~ ~

"We are a family of dancers.

~ ~ ~

"I'm off to do an Arica training: you can have my house, its contents, Dick, and the real bonus, Jonathan comes with it!"

~ ~ ~

Such fond memories…G was the best shopper in the world! Christmas calls every year: What size? Color?? Her need to get it just right to make everyone in the family happy, and she always did!
I went to see Gabrielle during her last days. She was dressed in white, reclining; she looked translucent, beautiful, clear and at peace. We both burst into tears, feeling the depth and impact of the moment.

I will never forget…

Seeing a sign in the window of the Esalen office - December 14, 1969 "Gabrille HAD A BOY" AND SO DID I! We shared THE GreATeST GIFT of all - our children ~

My gratitude, my love will Be Forever IN my Heart with my memories ~ of my ♡ PEGGY Dear Sister -

Sofia Ansell
Nashville, TN

Sofia is a singer/songwriter and Gabrielle's granddaughter.

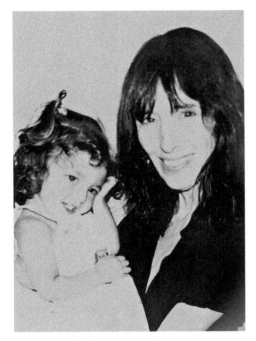

Sofia with her Nana

Sofia releases her new song about G!
[Download at RavenRecording.com]

I don't know where to start with my Nana.

I was so fortunate to have her as my grandmother and learn the stories, wisdom and lessons she taught me. Her advice was unmatchable, from boys to my parents to life in general. She always knew exactly what to say. It's funny, in the times I need her the most I will still send her a text or two to her old phone number, venting about my problems and asking her spirit to guide me. She was not like normal little old grandmas who bake cookies and listen to classical music.

Gabrielle had a style that was cooler than anybody I know. People come up to me asking where I got my leather jackets and they're always stunned when I say they were my grandma's. When I was four years

old, I remember Gabrielle introducing me to No Doubt and Gwen Stefani. I knew every word on that album and still do. I'm so beyond honored to have known her for the time that I did and for my 18th birthday I'm getting a tattoo of a raven in honor of her, so no matter where I am or what I'm doing, she will always be by my side.

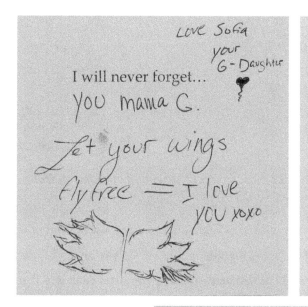

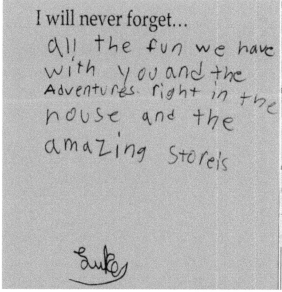

Luke Ansell
Nashville, TN

Luke is Gabrielle's grandson.

Well, I remember her always telling us stories, and we talked about heaven and spirit animals and how they represent our soul and our freedom.

Kevin Ansell
Nashville, TN

Kevin is a musician, Robert's son, Gabrielle's stepson, father to Sofia and Luke, and husband to Jen.

In 1979, my dad Robert's girlfriend/lifemate Gabrielle (they hadn't married yet) sat in front of me while I played a song I had written. I was 12 and had been playing guitar a few years already and looked up to the band of hippies and dancers that created music in their Middletown living room at G and R's Tarot Farm. (I secretly wanted to be part of it).

She listened with complete focus on me and with total attention and when I was done, she said to me, "You are a musical genius!" Of course, some hyperbole there, but I will never forget the positive affirmation Gabrielle laid upon me that day and I ended up pursuing a musical career with some small successes along the way.

Thank you again G—
love you,
Kevin

Scott Ansell
Asbury Park, NJ

Scott is a Recording Engineer and Producer. He has recorded, mixed and co-produced most of the 25 CDs released by "Gabrielle Roth & The Mirrors." Scott is Robert's son and Gabrielle's stepson.

Here's one of my earliest memories of being in the recording studio with Gabrielle. I was a young engineer and was getting close to finishing a mix. I asked Gabrielle how it sounded, which is a pretty standard studio question. Her reply, which was pretty non-standard, stays with me to this day. She said,

"I don't know about how it sounds, but I'll tell you how it dances…"

~ ~ ~

We all know Gabrielle was a prolific shopper, both for herself and for others. I was a lucky beneficiary of 35 years of gifts from her; birthdays, Christmas, etc. Of all the designer, amazing, fancy, expensive gifts she gave me over the years, it's one of the more "mundane" ones that stands out. It was probably Christmas, maybe 25-30 years ago. She gave me a sweater that at the time I thought was bulky, uncomfortable, ugly and left me scratching my head. That sweater stayed buried in my closet for years, but as it turns out, it has become my warmest and favorite winter sweater to this day. She really knew her business.

Brian Ansell
Ocean, N.J.

Brian is Robert's middle son and is an attorney and partner in ANSELL, GRIMM & AARON, PC, Robert's old firm. He is the father of Robert's granddaughter Ava.

After my parents' divorce, my father would bring one of us alone with him on his frequent trips to Los Angeles. As a 13-year-old, I was very jealous and protective of the time I had to spend alone with my father. As the divorce was still raw, I never took to any of the women my father had dated. At the age of 13, I

became a fan of the Grateful Dead and my friends and I started smoking marijuana. We actually got caught at school in the woods and the police found a bong we had left behind after we fled the scene.

My father picked me up from school after being disciplined and pointedly asked me if I was smoking pot. I could not bring myself to be honest with him and vehemently denied it. At the time, my hair was shoulder-length and my shirts were tie-dyed. I am sure the casual observer would have concluded that I was experimenting.

Later that year my father took me alone on one of his trips to Los Angeles. He told me he had met a new woman and that he felt very connected to her and that I would be meeting her. Of course, I was jealous and resentful of her even before we met, especially when my father told me to sit in the back seat of the car on our way to dinner. Shortly after, Gabrielle got in the car, and to my utter shock, she took a joint out of her purse, lit it up and, after taking a hit, she turned around and handed it to me.

With that simple gesture, Gabrielle not only melted my heart and my defense mechanisms, but more importantly, opened the door to a pure and honest relationship with my father.

<div align="right">

Amber Ryan
Lyons, CO

</div>

Amber Ryan was Gabrielle's daughter-in-law, friend, assistant, and a 5Rhythms teacher.

I see Gabrielle in snippets, yet experience her influence in my life like an undercurrent: ever-present.

Gabrielle and I wore many hats together. She was my teacher; I became one of her producers and worked with her on a daily basis for years; she was a friend; and she was also my mother-in-law. Wearing all of these hats, we saw a lot of each other; the light and the shadow. We shared day-to-day challenges and a common cause for the work of the 5Rhythms, as well as the heart-space of immense family love. I had the privilege to see many aspects of her wild, dedicated, vulnerable strength and artistry. She was a human being

who accessed maps that brought us into the union of body and spirit, and her gift to us was to dedicate her life to bringing those maps to the world.

Here are a few moments I remember with love in my heart and eternal gratitude in my soul:

The First Moment:

She saw me. She saw most of us. She was a "seer." During our first conversation, she invited me:

"Come to New York to do theater with me there."

I said yes.

As a Mentor:

"Plan your future schedule when you have just come off the road, so you can feel in your body the best path forward."

As a Mother:

"There is only one person you can change: yourself.

[See the rest of Amber's reminiscences in "The Final Journey" section, page 300.]

The 5Rhythms were born in dialogue with
the great emptiness I found in my dance
when I moved to the edge of myself
and leapt without knowing
where I was going or why.

—Gabrielle

Robert Ansell
New York, NY

Robert is Gabrielle's lover, soulmate, best friend, photographer, drummer, producer, and husband *(yes, they eventually got married 11 years in. They did it on a weekday, during a short work break.)*

As a litigator, a criminal defense lawyer, surprise was my deadly enemy. The idea, always, was to know what was going to happen in the courtroom or make happen what you decided in advance should happen. I believed that a lawyer who was surprised in the courtroom was guilty of malpractice.

Gabrielle loved surprise, in her life and, most incredibly, in her work. She never planned the details or outcome of a workshop or class. Of course, she was somewhat limited by the title of the event, something she had to provide months in advance for PR and registration purposes. But, titles were malleable to her; it was the moment that always ruled. Naturally, if the workshop was entitled, "Heartbeat," she was committed to it dealing with emotions. But that was it. She would enter the room with no idea what exactly she would say to the people, what exercises she would use, what music would be played. She used to tell me that she didn't know in advance what would actually happen in a workshop because she didn't know who would be there, what they were feeling, etc. She went into a workshop to see what would happen, not to make something specific happen.

She said it best one night in Vermont. She was scheduled to address a large group of corporate financiers, lawyers, accountants, comptrollers, etc., the next morning and, not only that, but get them to dance! As we got into bed, I asked what she was going to say to these folks in the morning.

"No idea," she said. I told her she was crazy, that I couldn't imagine going into that situation without a script.

Well, Rob," she said as she turned out the light, "after you jump and before you land, is god." I turned the light back on and wrote it down. The next morning, they danced.

~ ~ ~

We were in the elevator of our apartment building and a neighbor was complaining about her teenaged son:

"Three years ago, he was taking bass lessons. Then last year he started to study violin. Now he wants to play guitar. What am I supposed to do?"

Gabrielle answered:

"You might want to honor his artistic impulses. He could grow up to be a composer or conductor."

~ ~ ~

Someone asked me on Facebook about Gabrielle's connection with Osho. I posted the following:

"They never actually met in person, but were totally interested in each other. She loved his intellect—his thinking and profound expression. He wanted her to come to India and actually sent someone to New York City with plane tickets. She said:

"I don't look good in orange."

~ ~ ~

I was telling some people about my switch from being a hotshot lawyer to a drummer/photographer and explaining what a shock it was, after getting together with Gabrielle, to go from "Who's the lady with Robert?" to "Who's the guy with Gabrielle?"

"Nah," she said, "you went from one side of your brain to the other."

~ ~ ~

Gabrielle could let go. During our time together, she let go of tobacco, coffee, recreational drugs, sugar, alcohol, meat, vegetarianism. Some of this was health-related, some about lifestyle, some as an experiment to check her energy response. But not tea! No way. Tea was a constant. It was amazing how much comfort she could find in a cup of tea.

I, on the other hand, am addicted to sugar, caffeine and carbs, and pray to the Goddess Nicotina. Being a bit of a control freak, I spend much focus on dealing with these afflictions. Gabrielle's assessment was,

"You are addicted to controlling your addictions."

A Few Memorable Robert Quotes:

I married a bad-ass-baton-twirling-laundress-shaman. How many of those are there in the world?

—Rob, after reading Mama Jeanne's contribution to this
book, which revealed some of the secrets of Gabrielle's youth.

~ ~ ~

I generally follow this rule in my music, photography and writing:
THE SPACE YOU LEAVE IS AS IMPORTANT AS THE SPACE YOU TAKE.

—Robert, coaching Eliezer about this very book!

~ ~ ~

There is no reason to be afraid of lightning. If you see it, it didn't hit you. If it hits you, you won't see it.

—Roberto

~ ~ ~

You can control the way things come out of the dishwasher by the way you put them in.

—R.

Look for the wild child

everyone told to sit down and shut up;

the part of you that cannot be hemmed in,

that knows lies are dangerous, nice is death,

and pretending is just bad acting.

—Gabrielle

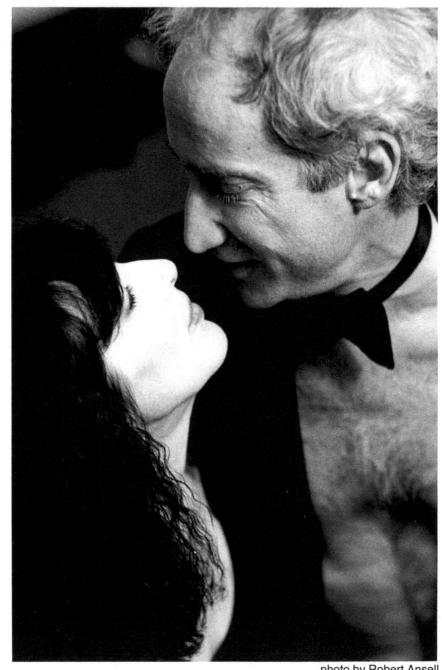

photo by Robert Ansell

G&R

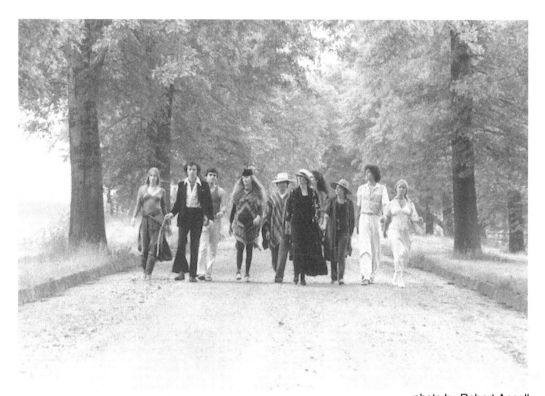

L to R: Melissa Rosenberg, Raphael Sharpe, Jay Kaplan,
Amber Kaplan, Jeffrey Hoffman, Gabrielle, Louise Rifkin,
Sally 'Lolita' Block, Otto Richter, Wendy Green

THE MIRRORS THEATER TROUPE

Over the course of three decades, Gabrielle Roth & The Mirrors was the name of Gabrielle's band, which released some 25 CDs of percussion-driven music rooted in the 5Rhythms, to support her worldwide, ever-growing group of movement practitioners. However, back in the early '80s, "The Mirrors" was also the name of her original "Ritual Theater" troupe, which performed regularly in New York City and elsewhere.

The people in this section were part of the original Mirrors Theater Ensemble. Missing are original core members **Martha "Connie Cling" Peabody** *and* **Robert "Sidney Sniper" Ansell,** *whose contributions to*

*this book appear elsewhere. Also missing are **Bonita "Tara Toughguy" Mugnani, Bobby "Victor Vain" Miller,** and **Wendy Green,** who also sang vocals with the band.*

This was our intense Bohemian artsy look:

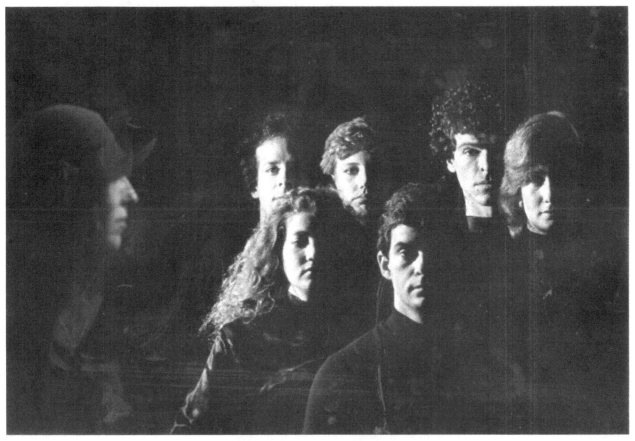

photo by Robert Ansell

**Left to Right: Gabrielle, Eliezer Sobel, Martha Peabody,
Melissa Rosenberg, Jay Kaplan, Otto Richter, Amber Kaplan**

And a bit more playful:

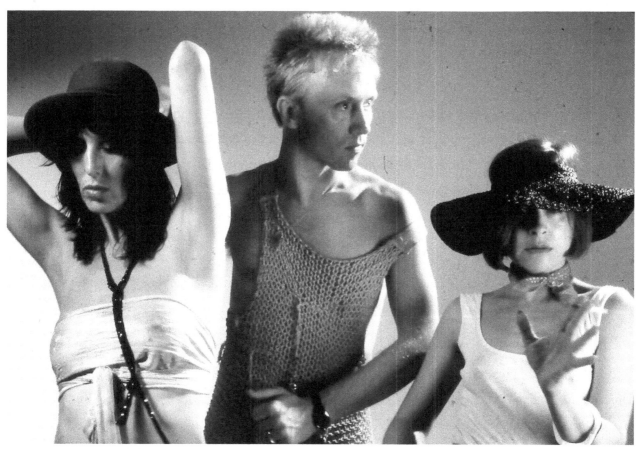

photo by Robert Ansell

Gabrielle, Bobby Miller, Carole Moran

Jay Kaplan
"Captain Control"
New Orleans, LA

Jay is a leader in his field of Emergency Medicine, and claims that his time with Gabrielle rivals his eight years at Harvard, where nobody taught him to dance.

In late '77, in the final day of one of my first workshops, after I had done my individual dance, Gabrielle said to me,

"Jay, compassion is not your father's bad back."

At that time I was very close with my father. He was a physician as was I (a resident at that time); he had a bad back and so did I (my identification with him). Her words shook me to my core. Through dancing my heart-mind-soul in Moving Center work (what we called it at that time), my bad back was discarded. It is now 40 years later with my 70th birthday having passed not too long ago. I would like to believe that I remain a compassionate physician; and I have no need for nor do I have a bad back.

~ ~ ~

I was talking to Gabrielle about the difficulties I was having with my girlfriend and she said to me,

"If you are spending more time working on your relationship than on enjoying your relationship, it's time to move on and let go of that relationship."

~ ~ ~

At that time I was very serious and controlled, linear and organized. Gabrielle felt I would be a much happier human being if I learned to relax and let down more. She told me I needed to intentionally schedule time and space for me to consciously let go of my busy, ultra-controlled life and let myself release and be more playful and free.

To assist me in that project, I remember her empowering the women in the original Mirrors theater group to,

"Corrupt Jay Kaplan."

She also once gave me the prescription to get stoned and stay that way for five days, and that may have been the last time I would use any mind-altering substances for the next 30+ years.

Also, when I first started doing the work, my handwriting in my journal was tiny. Gabrielle encouraged me to write big and not between the lines.

~ ~ ~

Below is an email I received from Gabrielle after Amber and I sent her a loaf of "Dr. Jay's Whole Wheat Spice Bread." In the last year of her life we would send her a loaf of bread every few weeks to help in her healing.

Kaplan, Jay

From:	Gabrielle Roth [gabraven@panix.com]
Sent:	Wednesday, November 09, 2011 8:50 PM
To:	Kaplan, Jay
Cc:	Jay & Amber Kaplan
Subject:	wow

```
my beloveds,
mister postman left the most amazing box at my door.
the bread! yummmmmmmmmmmmmmmmeeeeeeeeee.
the honey - those marin bees.
the donation- that is so dear of you. and we need it. go to 5RhythmsReachOut.org and check it
out.
and the picnic at my mama's house- she was so excited.
i have much more to say. and i will.
but for this moment my heart is bursting with love for my dearest friends.
i love you and appreciate you and hold you so dear in my heart.
forever yours,
g
```

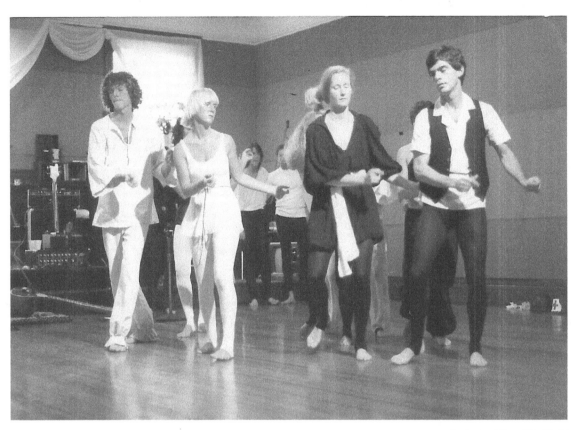

photo by Ellen Sheffield

L to R: Otto Richter, Wendy Green, Amber Kaplan, Jay Kaplan

Amber Rose Kaplan
"Priscilla Perfect"
New Orleans, LA

Amber is forever grateful for her three years living at Tarot Farm as part of Gabrielle, Robert and Jonathan's family, where she learned not only to love herself but embraced the possibility that a true love story could happen in her own life.

Mere words cannot tell of my love for Gabrielle; she dances inspiration inside me.

50

Jay and I met Gabrielle the same day in two different locations in November of 1977. Pacific Palisades in Los Angeles was my location, at an event celebrating dance and memorializing a dancer who had died. I went because my older sister Penny had died the year prior and I mourned the remembrance of my sister teaching me her best moves to Van Morrison's "Moondance" while downing shots of tequila. I went home early from the "Cell to Soul" event stating with complete conviction to my mom,

"I am going to work with this woman Gabrielle one day."

Gabrielle had opened the event and I remember her talking about human nature, the dance of feminine and masculine, Mother Nature and Father Spirit, and then a funny quip she had made:

"It's like Yin and Yang because I don't think anyone here has ever heard of Father Nature."

We all laughed. Gabrielle was good at that. Being human is a funny business and her curiosity and deep observation as to what it is to be a human being impressed me and moved me; so much so that I moved from the West Coast to the East Coast to become a member of her original "Mirrors" theater troupe. It was an exciting time, as the Moving Center, later to become 5Rhythms Global, was at its formative stage.

Jay met her for the first time later that same day in Big Sur at the opening evening session of his first Esalen workshop. Jay and I would become the best of friends as part of the "Mirrors." We danced together frequently in the group's Red Bank, NJ studio, and created and performed theater directed by Gabrielle, based on our life experience. A couple of years in, Jay was having a serious conversation with Gabrielle in her kitchen at her and Robert's "Tarot Farm," about his relationship with women, when I came into the room preparing to walk out the door to go grocery shopping. As I was leaving I heard her say,

"Jay, you need to be with someone not like yourself, but someone like…" (she hesitated) "like…like Amber."

We both laughed. She married us on May 17, 1984.

~ ~ ~

I lived at Tarot Farm with Gabrielle and Robert for three years as a nanny to Jonathan and a helpmate around the house. I was there to be part of the "Mirrors" and to help the Moving Center with its classes. I was there to heal my relationship between my body and my spirit. While standing one night in the kitchen,

with just the low light of the stovetop on overhead, I remember Gabrielle broaching the subject of my sharing my eating disorder publicly in an upcoming performance.

What I felt was worse than resistance. It felt like pulling teeth, and yet it ended up being liberating. It paved the way for me to create Priscilla Perfect who could talk endlessly about her diet plans, or Gladys Gorge who was finally willing to come out of the closet, and in a continual stream of cravings, list her favorite foods:

"Häagen-Dazs, two flavors on the same spoon…"

I knew this was making a difference when a few audience members approached me after the performances to share that they did the same thing. At that point in time, the late '70s, early '80s, eating disorders were rarely ever discussed and information about them was much less available.

~ ~ ~

I remember the first time I entered Gabrielle's home dance space, a separate little studio cottage on the property at Tarot Farm. It was her private domain where she would go to dance and write. A beautiful song was playing on her record player; it may have been called "God Is Truly Amazing," I'm not sure. We danced a bit in that space, but mostly that was her special domain.

Gregory Bateson visited Tarot Farm on a couple of occasions. He loved Gabrielle, and had attended her workshops at Esalen several times, and had co-taught with her, sharing some of the stories and photos of his work in Bali with Margaret Mead. In his honor, we had created the "Ritual of the Wise Old Man," colorful with its wondrous acknowledgment of sharing the dance floor with a whale of a mind, and we were celebrating and reflecting American ritual in the making. Gregory said on one of his visits that,

"Gabrielle's work is as close to 'It' as any I have ever experienced."

The mysterious "It."

On a sadder note, when Gabrielle's Dad was diagnosed with lung cancer, she took him to the Hippocrates Institute where they stayed for a bit, eating only a raw foods diet. A small group of us went there to visit for a couple of days, sitting around a community table to partake in this raw food experience. After returning home, we jumped into this fresh food challenge. Because Gabrielle was having some digestive issues, Robert went on to become an indoor farmer of wheat grass in order to make her special juices.

Downstairs in the basement, I remember soil with worms and trays of dirt that were then seeded and brought upstairs to grow green in the sunlight.

Her Mom and Dad returned to California, doing their best to continue their raw food diet, and Gabrielle felt that it had bought her dad the extra time he needed to pass through his fear and come to a place of beautiful peace as he neared his death. I answered the phone the day he died, and I knew Gabrielle was upstairs with Jonathan. As I walked up the stairs to impart the news, I overheard Gabrielle sharing the story with Jonathan about the day he was born, and I thought how remarkable it was that she was talking with him about his birth as I approached the room to share that her father had passed.

Tarot Farm also hosted a couple of epic parties where dancing and dining spiraled upward to a divinely decadent level. Funny enough, Gabrielle wasn't one to want to be the center of this kind of attention. Considering that she was such a public person, she was extremely private. The "Mirrors," both the band and theater, celebrated her anyway.

She also loved to have a hand in planning events like our friend Nirvesha's dream-come-true birthday party, celebrating Nirvesha's awakening sensuality. We bought a cake from a unique NYC bakery. On this chocolate fudge layer cake was a cream-filled penis with the words: "The Best Is Yet to Cum." I also remember Gabrielle orchestrating a treasure hunt of sorts, when the Mirrors went out into the night along Tarot Farm's rural landscape on a great adventure of riddles and whimsy.

One time, a plumber came over to the house for a repair and was awed so deeply by Gabrielle's presence, he ended up becoming very emotional and sharing his story of having served in the Vietnam War. He left with a twinkle in his eye, and I remember feeling very touched being a witness to this encounter. Her healing love was profound.

Of course, I have countless experiences as her student in classes, workshops and two Teacher Trainings. I remember her teaching through her dance at the Huxley space at Esalen, and always starting on time but then being willing to extend the session so we'd always be late to lunch, or sometimes we'd be working until the wee hours of the night.

Teacher Gabrielle gave me an A+ once after completing a theater piece on the sexual cycles, which my group tagged "Master Bator and the Sextettes." It was a "zone" piece where Patti Punk, an ego character Gabrielle shared with me, had her first coming out via my story:

"My name is Patti, I'm full of funk.

My name is Patti, Patti Punk.

Loving my body's not where I'm at,

instead I'm obsessed with my fear of fat."

As for our other shared ego characters, let it be on record: Gabrielle and I actually had an engaged disagreement on the patio at Westerbeke Ranch about who came up with the name "Sissy Spaceout":

She said she did; I said I did.

Leave it to Sissy!

Melissa Rosenberg
"Judy Judge"
Beverly Hills, CA

Melissa met Gabrielle when she was 16, and subsequently wrote her and asked to come to New York. Upon reading her letter, Gabrielle commented to Robert, "This girl is going to be a major writer someday."

Today Melissa is a multiple Emmy nominee and a much sought after show-runner and screenwriter in Hollywood who adapted Stephanie Meyers' five-part The Twilight Saga *films, created Marvel's* Jessica Jones *for television, which won a Peabody Award, and has written for and produced many other familiar titles.*

I'm nervous before a big pitch—I remember "feel your feet." Breath in through my nose, out through my mouth. Meet them, right eye to right eye. Or was it left? It doesn't matter. I meet their eyes and see them. I throw my entire being into it. Commit to the dance.

I'm speaking at a conference or a room full of students or to reporters and publicists—I remember how to improvise. Interact. Listen. How to command a stage. How to share a stage. To start a movement, carry a movement, take the movement in a new direction.

I lead a production. Other people's careers and money in my hands. I remember how to lead—simple movements, clear, decisive, across the floor. I'm comfortable out front. I turn around, I see my simple movement being executed as I envisioned. When it's not, I know my movement wasn't clear. I cross the floor again.

I work with creative people. I need their talents. I remember how to make a safe space for them. How to draft off their ideas, how to fuel the circle, be a part of something bigger than me.

I have writer's block. The demons are winning. I dive in, moving around obstacles like a porpoise, going for the open spaces. Making room for ideas, willing to suck, because another idea will be right behind it. I remember how to allow for inspiration.

I remember how to be courageous.

I tell stories. That's my job. I remember how to find my truth. How to dig into the darkest places for it, and how to expose it to the light. People hear it. Feel it. Tell me it has freed them just a little bit.

I am overwhelmed by that. Humbled, inspired, gratified. And grateful. To the woman who taught me those skills. Who helped shape and hone me. Every day, she's part of my story.

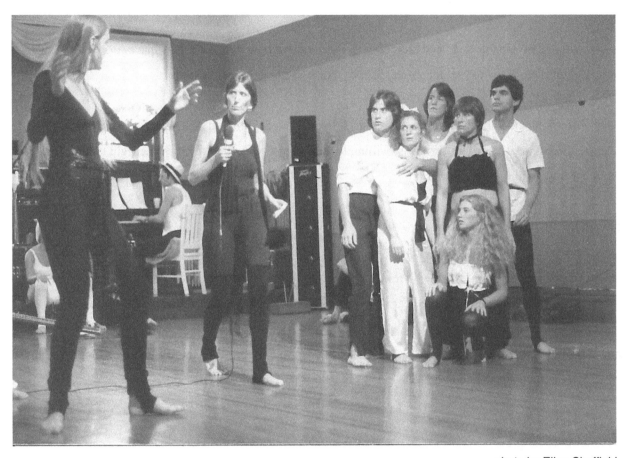

L to R: Half of Wendy Green (seated), Melissa Rosenberg, Raphael Sharpe (piano), Gabrielle, Jeffrey Hoffman, Bonita Mugnani, two unidentified women, Jay Kaplan in back, Martha Peabody kneeling.

Otto Richter
"Harry Helpless"
Freiburg, Germany

Otto is an author and workshop leader who was terribly infected with Gabrielle's wild heart syndrome in 1978 and spent the next six years in self-imposed quarantine with her circle of ritual renegades. [Note: Otto was also a lead vocalist in the Mirrors band.]

I remember one particular day when the small, core group of about 10 students, of which I was a part, came to a circle—as we often did. At one point during Gabrielle's talk,

> her head spun around,
>
> sending the ink black hair flying...scattering
>
> like the feathered wings of a raven in slow motion.
>
> Steel-blue eyes that locked onto mine like radar,
>
> shone from beneath,
>
> freezing my face...stopping my breath.

She cocked her head innocently and very simply said,

"Otto, you're a coward."

That was the end; my entire world shattered. How did she know? Although I thought I had found ways to cover it up, she somehow saw right through the pretentious act, revealing my darkest secret, exposing my deepest wound. It is an experience I will surely never forget, and one that initiated an incredible transformation in the years to come.

Yes, I was a coward. Pretending to be someone other than who I was, hiding behind a mask. That proved to be not only a waste of energy, but also extremely painful because the life force was blocked, the body contracted and the heart cramped. But even that wasn't enough to wake me up; only Gabrielle's slap in the face did the job. From this deafening moment of humiliation, came a mushroom cloud of freedom upon which I rose to the occasion of Truth, and the truth is, there is nothing wrong with me just because I have the tendency to be cowardly.

In fact, as I found out, there was everything right and healthy about becoming more aware of this tendency, because then I could become more aware of its advances, and more awake when it arrived. With the help of my beloved brothers and sisters in that group, and the guidance of Gabrielle in an explorative, theatrical process in which I embodied this coward in its many disguises, I learned the way the coward thought, felt, walked, talked, and breathed…or didn't.

Later, it got to the point that I could hear the coward a mile away! Its voice is easily recognizable because it constantly mumbles monotone and familiar phrases like, "I don't think I can do it. What if I completely fail? They won't like me anymore." It always says the same things, so it's not so difficult to tell who is doing the talking. But now I can speak to it directly: "Thanks anyway, but no thank you—and get lost!"

Thank you, Gabrielle, I'm forever grateful!

Excerpted from Otto's book *Partnership: Eight Steps Toward Happiness*
Published in German as, *Partnerschaft: acht Schritte auf dem Weg zum Glück* / Munich: Hugendubel, 1995

Erik Iversen
"Jerry the Jock"
Montreal, CA

Erik is a 5Rhythms teacher who became, among other things, Gabrielle's personal bodyworker, and helped her design the first Teacher Training.

Gabrielle Moments

Surfacing from a deep dive in the form of a near-death experience, I had spent a year integrating by a lake observing new life: my first son. As a former hockey-playing jock whose "movement home" had always been a hockey rink, staying home and changing diapers in 1980 defined me either as a trailblazer or unusually soft.

My wife at the time, Andree, had discovered Gabrielle in Quebec, and stories about her workshops and teaching discourses filtered back to me through her; I sensed a new adventure pushing me out of my comfort zone onto a dancing journey. Gabrielle had traveled to Montreal with her theater group and rock band, "The Mirrors," spring 1981. Andree participated and I stayed home. She returned each night on fire with new light and energy, and encouraged me to pick her up on the last day to meet Gabrielle. Arriving with one-year-old Nicholas, I handed him to Andree and she directed me to Gabrielle who was changing and packing up. She looked at me, opened her arms and her heart, hugged me and whispered in my ear,

"Oh you are well, you are fine."

And that felt so reassuring and real. The spiritual healing had begun. I believed her!

~ ~ ~

I had the opportunity to produce Gabrielle in Montreal, in 1985. Bring the mountain to me.

Wow, I found a backer and we managed to attract 40 people. Gabrielle, Robert and I had café au lait together, in bowls, exotic. Gabrielle had fun playing with a French accent and a few words, giggling, shapeshifting into a Parisian Diva. She enjoyed the cultural leap from New York that she found in Montreal, the lyrical city.

Some snapshots:

I remember that my first dances with her in Red Bank were clumsy and we bumped into each other and she stepped on my feet! I could only laugh then and now.

~ ~ ~

A February 14, 1982 Valentine's Day event in midtown Manhattan. The evening was soon to start and I went looking for Gabrielle. I searched everywhere. And then I pulled back the curtain of a storeroom and there she was in full lotus, meditating, preparing herself.

~ ~ ~

At Westerbeke, talking with a literal fence between us, and her joking,

"I have to keep up the boundaries between me and workshop participants.

59

~ ~ ~

On her 40th birthday, her wearing heart-shaped, rose-coloured glasses.

~ ~ ~

I co-produced a workshop with her for my bodywork association at a Seventh Day Adventist camp near LA. Not only was the food awful but, as she exclaimed,

"What a contradiction that a group of bodyworkers would pick a space with a cement floor for a weekend of dancing."

~ ~ ~

At the conclusion of the Red Bank training in 1982, Gabrielle called us as a group to Tarot Farm. Definitely felt like a *call*, not an invitation. Andree and I arrived to a large living room prepared for ritual. Candles, incense, and pillows in a circle. There was a sword in the middle. Gabrielle proceeded to "call out" Andree for trying to lure members of the circle away with the promise of payment. She accused Andree of wanting to copy and "steal" the 5Rhythms. *Her work.* Gabrielle cut the ritual with her sword-like tongue. She established her boundaries.

Note to Erik: "Don't mess with Gabrielle."

[See the rest of Erik's reminiscences in "The Final Journey" section, page 299.]

Eliezer Sobel
"Danny D. Presso"
Red Bank, NJ

Eliezer (then Elliot) is a writer and was extremely depressed when he met Gabrielle in 1978; she was utterly unable to help him, but that was irrelevant to their 34-year love affair, nor did it detract from his principal role: to make Gabrielle laugh.

[Editor's Note: This guy bugged me to give him extra space in this book and I couldn't bring myself to say no after all the time and energy he put into it for over three years.]

Our souls were stripped bare in Gabrielle's laser-sharp gaze. Each of us experienced a very real and personal, intimate and authentic soul-connection with her that felt very special. But often there lurked an imposter: a pernicious ego-character frequently took some of us over, named "Sam (or Samantha) Special." Ever since kindergarten, I had hungered for love and attention, to stand out, wanting my teachers to notice me and praise me in front of the class. Teacher's Pet.

I, however, was actually an exception; I really *was* special. I have written proof: my Mirrors Theater-mate and artist-extraordinaire Martha Peabody sent me the following item I wrote some 40 years ago that she found during a clean-up purge:

"Although they were sworn to secrecy, everyone in Gabrielle's immediate family and intimate circle of friends were well aware of the fact that she always considered the spirit of *my* creativity to be the source and inspiration of her entire life's work. Much like the Queen of England is only a figurehead, Gabrielle was merely the public face of the 5Rhythms world, while I was the driving force behind the scenes. My powerful place in her personal pantheon was first revealed to me in a "Mirrors" workshop, during which, for some reason I still haven't figured out, she kept referring to me as 'Gary Grandiose' and 'Ned Narcissist.'"

~ ~ ~

I had been unofficially teaching the 5Rhythms in creativity workshops since 1980, unwittingly doing the very thing that upset and irritated Gabrielle the most: someone taking a few classes and immediately going out and teaching her work. I was completely clueless, but I knew something was up when it was abruptly made clear to me that I was no longer welcome to attend her weekly theater class. I was totally

crushed, didn't know what I had done to warrant being banished, and went to speak with her. I think my utter ignorance and innocence must have touched the right chord, because she welcomed me back into the class, and I continued to teach my primitive version of the 5Rhythms for many years, with her blessing; or so I believed.

She once told me about a workshop I'd be leading,

"Well anyone is free to put music on and ask people to move."

But perhaps I *shouldn't* have interpreted that as "a blessing to teach her work"? In any case, I finally took the official Teacher's Training nearly 30 years later, in the fall of 2007.

At one point in the training, our group of 80 was divided into eight circles of 10, each with a Senior Teacher as facilitator. I was lucky enough to wind up in a group with Gabrielle as our guide. The purpose of the exercise was to give each aspiring teacher an experience of verbally responding to questions about the 5Rhythms practice. We went around the circle, one by one, and Gabrielle would choose a random card from a stack of pre-written questions. At age 55, I was the elder student among a group of 20-40-year-olds, and I listened as each one struggled to articulate their answers, and Gabrielle would gently—or sometimes fiercely—offer feedback regarding their level of authenticity, and a brief and sometimes difficult dialogue would ensue.

Despite 30+ years as both her friend and student, my heart was nevertheless pounding as I waited my turn, as if I were brand new to the teaching. My moment arrived, and she read from the card:

"What was the most challenging or fearful part of the 5Rhythms when you were first exposed to it?"

I thought for a moment. "Well..."—(thinking that I was about to give the most wrong answer possible)—"the truth is, I'm much more challenged and fearful *now*."

"Say more about that," Gabrielle said.

"When I first encountered this work I was in my 20s, full of energy, and I was ecstatic and excited that I had found 'my tribe,' so I wasn't actually fearful; in fact, I'd always be the first person to throw my hand up to volunteer for demonstrations in front of the room. I was up for anything. Now that I'm 55 and surrounded by all these young people, I feel like an old guy, physically and energetically; with all my aches and pains, I can't keep up with them on the dance floor, and it also seems that I've somehow grown *more* shy and timid over the years about exposing myself, rather than more brave and courageous."

I braced myself for her critique, my whole body tight and tensed, holding my breath.

"Beautiful," she said softly, gazing into my eyes; and *nothing more.*

Wow, what a powerful moment, to recognize for the hundredth time, that *simply being myself and speaking my truth was all that she was ever asking of me!* I was the only person in our group that had no further dialogue with her. The simplicity and obviousness of it blew me away, for nearly all of us are always struggling to be who we imagine we are supposed to be: someone more, better or different than who we simply *are.* And yet to simply be who we are, I learned time and again, was Gabrielle's most fundamental teaching. The power of even one simple word from her—"Beautiful"—given the timing, pierced my heart. Again.

~ ~ ~

I was at her apartment and mentioned that I was having physical discomfort in the center of my chest, around the diaphragm area. For the first and only time ever, I watched as she momentarily disappeared into a sort of semi-trance state, then shook her head and hair vigorously to come out of it and said,

"Oh my God, El, I just saw that you have a hiatal hernia."

My pain got better, and I ignored her "diagnosis," and never thought about it again until 30 years later, in April of 2018: I was in the recovery area after having a routine colonoscopy and endoscopy, awaiting the results. The doctor finally came and told me everything looked fine…except, he noticed that I had a *hiatal hernia*! "But," he said, "it looks like it has been there for about 30 years." Hmmm. Oh.

~ ~ ~

I was so thrilled one day in a workshop at Esalen after I expressed some anxiety about putting myself out in the world in a more powerful way, for fear of alienating others, and Gabrielle said,

"Listen, El: if you are a thousand-watt bulb, don't dim your light, let everyone else wear sunglasses." Brilliant line, I thought, and what an amazing acknowledgment. It was only years later that I heard her say the identical line to someone else. And then again to someone else. It was one of her "lines," I guess; yet at the same time, absolutely true in each case. True; just not "special."

~ ~ ~

I had pre-paid several thousand dollars to fly to Brazil and spend three weeks in the jungle, taking ayahuasca every three nights, for a total of seven psychedelic journeys. Just days before leaving, feeling very apprehensive, I happened upon a magazine article called "Drug Tourism" that scared the hell out of me. It described charlatans in South America cashing in on Americans hungry for a spiritual experience, and how sometimes these experiences would leave people in a severe depression for a year, "unable to read or write." I called Gabrielle in a panic, and she provided the simple words that allowed me to board the plane to Rio:

"You know you don't HAVE to drink the stuff when you're there; you're allowed to say 'no.' The worst-case scenario is you wind up having a three-week vacation in Brazil! Have a great time!"

Simple, true and reassuring. I went, I drank, I had a great time.

And I threw up a lot. A *lot.*

~ ~ ~

An email from G, in response to my inquiry about teaching in NYC:
One of the great headaches circling the globe is producers popping up out of nowhere and inviting teachers into communities where there are well-established teachers struggling to survive, often with no regard as to their schedules. Last year the problem was so out of hand i thought i would jump off the brooklyn bridge only i couldn't find it.

~ ~ ~

I had flown all the way across the country to attend a weeklong workshop with Gabrielle at Esalen, and on the very first night, something snapped in my back and I was completely sidelined, lying there feeling sorry for myself and contemplating the expense of the trip. Suddenly Gabrielle swooped over to me in a swirl of movement and simply said,

"Move what you can move," then spun away.

It was a remarkable teaching. I immediately realized I could easily move both my hands and all my fingers with no pain. The same was true for my wrists, elbows, shoulders, and head. It was clear I had a choice between self-pity about my back injury, or to focus instead on all the body parts that were without pain and able to move freely. With that positive attitude fueling my way, my back completely recovered in less than 24 hours and I was again dancing full out. I moved what I could move, and it got me moving.

~ ~ ~

I once approached Gabrielle and asked her directly if she thought I was gay. She looked at me thoughtfully for a moment, then said, choosing her words very carefully,

"No, I don't think you're gay; that's your 'father wound.'"

That short sentence gave me food for thought for, oh, say, nearly four decades. When my father fell down the stairs and suffered a Traumatic Brain Injury in 2013, I helped care for him until he passed three years later, so I had ample time to contemplate our relationship. Still, with him gone for over five years now, I still find myself contemplating that one sentence of Gabrielle's at times—"That's your father wound"—and all that that implied on every level of my being: my masculinity and sexuality, my adulthood, my being a "real" man; or not. She really *was* a catalyst; a few words from her were like a surgeon's scalpel, and could catalyze literally decades of reflection.

Of course, she asked me to turn my inner turmoil and identity crisis into an onstage monologue about my sex life; suffice it to say, I resolved my confusion by confessing on stage that

"I am a cross-dressing lesbian in a gay man's body whose sexual preference is women."

~ ~ ~

Dancing Toward The One
Gabrielle Roth and The Mirrors

photo by Robert Ansell

I met a woman in a "Mirrors" workshop, and a few months later we found ourselves high on magic mushrooms and dancing wildly in the open space of my converted barn in Virginia for five consecutive hours, playing Gabrielle's long-out-of-print, first rock & roll music cassette, "Dancing Toward the One."

This woman had never heard it, and insisted I play it 18 times in a row. By the end of this dance marathon we had agreed to get married. Ecstatic, we immediately called Gabrielle to share

the great news; she could barely contain her lack of enthusiasm as she firmly instructed us:

"Wait six months. Don't decide anything for six months."

It proved to be excellent advice, as our engagement ended almost exactly six months later, and in retrospect I realized it probably wasn't a great idea to agree to get married while high on mushrooms.

~ ~ ~

Gabrielle was always dressed to the nines. A fashionista with a closet known far and wide, she was a close friend of designer Donna Karan, and her public appearance was absolutely striking, causing heads to turn when she entered a room. In my youthful arrogance, I once publicly challenged her about this:

"Since you pay such careful attention to your clothes and how you present yourself in the world, how can I know whether that's a genuine part of your artist-soul, expressing itself in your outfits as an extension of the creative spirit, or merely, like many people, particularly women, calling attention to yourself in order to be seen and admired."

Without missing a beat, she replied,

"Put all your money on Choice #1 and run with it."

The people in this book will tell you that to go shopping for clothes with Gabrielle was an ecstatic spiritual experience, and after reading some of the stories herein, I realized that I clearly had to be her worst all-time shopping partner, which is why it only happened once:

Back in the early '80s, she grew weary of seeing me wear the same pair of jeans and flannel shirts every single day—a style which, I'm sorry to say, persists even today, some 40 years later—and finally, in a fit of fashion desperation, she dragged me to Barney's, a high-end store in New York.

But first, to properly prepare ourselves for this exotic exploration into unknown terrain, we sat in my parked car and shared a joint she produced from her purse, she being a full-fledged child of the '60s and a former California hippie. I exhaled the pungent smoke, which she considered to be a "Spirit Ally" at that time, and, as often happens to me when I use marijuana, I instantly entered a state of great confusion, deep fear and paranoia. She leaned back against the car door, totally relaxed, observing me like an interesting

specimen in a bad drug experiment, and said:

"I want you to remember and recognize this state: it's called 'psychic panic.'"

And yes, I *have* remembered and recognized that state many times over the years, and always her words remind me that it is just a state, just "psychic panic," and it will pass. With that pithy little life instruction, off we went on our shopping "spree," a futile attempt to transform my presentation in the world from that of a boring, backward buffoon, into a hip, sharp, conscious member of a contemporary theater troupe. Yet everything she took off the rack for me to try on cost more than I made in a month at the time. We finally agreed on a single pair of pants, with a thick belt and pockets in unfamiliar places, that still cost more than I had ever spent on pants, and even more astonishing, more than I ever *would* spend on pants again. (My big breakthrough in fashion was to move up in the world from the $12 jeans at K-Mart to the $29 pair at J.C. Penny's.)

Poor Gabrielle; I was her only fashion failure.

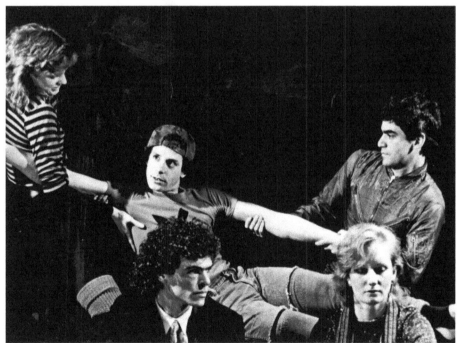

photo by Robert Ansell

**L. to R.: Melissa on one arm, Eliezer feeling torn, Otto seated in front,
Amber also sitting, and Jay pulling the other arm.**

Chatting over lunch in Greenwich Village one Friday afternoon, we were both scheduled to lead events that night: She would be speaking to about 1500 people at a conference, and I would be leading a Friday-Sunday residential workshop for 12 participants.

I have been in front of rooms hundreds of times in my life, and I have never gotten used to it. I always felt like throwing up for a week before a teaching event. So I asked G, "Are you scared?"

"About what?" She looked quizzical and had no idea what I was referring to.

"Well, you'll be standing in front of 1500 people tonight, most of them strangers."

She did one of her classic, dismissive hand movements and said, "Oh, no, not at all."

"Because I'm terrified," I said. "Every time I teach I get scared and sick to my stomach for a week beforehand."

"Oh," she said, as if it was the most obvious response in the world, "I would *never* do this work if I felt like that."

Boom. I got the message. Why was I continuously putting myself through such difficult and challenging moments? I decided right then and there to stop leading workshops, and I felt a great burden of anxiety lift. Yet a few years later, I noticed that without putting myself out there on my personal edge, with other people, my life felt like it was getting smaller and smaller. No growth. So I spent a year becoming a legitimate teacher, and began leading 5R classes and weekends again, with the same old block of cement in my belly before each one. I called Gabrielle to talk about it, and she said,

"We really need you to show up in that room, we need you to be teaching."

"But Gabrielle," I said, feeling ashamed, "sometimes I have to take two Valiums just to walk through the door."

"Well do whatever it takes for you to get yourself in the room; just don't pass them out to any of the participants."

In the twenty years since our lunch together in New York, she had moved from,

"I would never do this work if I felt that way," to

"Take Valium if you have to, just put your feet in that room!"

(As Gandhi once said, "My commitment is to truth, not to consistency." I think G. was like that as well, always being true to what the present moment called forth from her, even if she had said the exact opposite the day before, one minute ago, or 20 years earlier.)

~ ~ ~

I spent a few months in Israel in 1988, exploring my Jewish roots, and came back thinking that maybe I should become a rabbi. I saw Jonny at Esalen, and told him to tell his mom. To my surprise and delight, he did, and she sent me this precious and very cool letter a short time later: (See her letter on following page.)

[Eliezer continues on page 306.]

We dance to fall in love

with the spirit in all things.

—Gabrielle

My dear crazy talented Elliot but of course you should become a
Rabbi! This is indisputable. The first time I heard this concept
was when Jonathan returned from Camp Esalen this summer - he said,
"Elliot said to tell you he wants to be a Rabbi." And, I heard myself
say, "RIGHT ON!" And, I still feel this way. What an extraordinary
idea - I think you'd make the bestest Rabbi in the whole world and
plus I need some holy kind of dude on my side in case it's all true-
whatever it is and someday I might need a reference to God - you know-
and anyway what a lineup - a doctor, a lawyer and a rabbi - tell me
I'm not covered - of course this is not purely a personal cause 6or
celebration - think of those poor beleaguered parents who have been
waiting for a title that they can relate to - and most importantly
think of all those pretty costumes - you do get costumes ? and the
opportunity to sing live, as well as to do your standup schtick in an
authentic theater - I loves this idea - it perculates with possibilities
beyond my pea brain. And, I hate to say it but there's a real need
for the new jew to emerge and turn the tide - give the folks some real
support and inspiration - hey Ell - this is your context - I do believe.
I'm playing with it but I'm dead serious and every cell in my body
says yeah! GO FOR IT don't wait...do it now. Thanks for the western
union about the book - of course it's not good enough but I had to let
it go so I could move on. Tomorrow I'm on t.v. here in the biggest
apple pitted against me will be a Baptist Minister - they like tension
and conflict on these programs - I could've told them I was or am full
of that stuff and they didn't need nobody else but they didn't ask and
so I will be ...what will I be? Insecure, terrifeed, saying my mantra
and fundamentally speaking - Baptist are bad ass god fearing fire insurance
selling forked tongued creatures who don't let their kids fuck or dance-
pray for me in retro...I miss you fervently and wish you'd write the
continuation of those weirdo soap operas xx you like to star in - give
me some news ...I'm hungry.

I love you
Colenille

Meaghan Tiggrr Fearless
Dancer
Northern CA & NYC

Meaghan is a poet, performer, songwriter and creature whisperer, who teaches 5Rhythms in the spirit of coming home to our own wild nature.

Gabrielle plucked me out of an audition I had no business being at, for a professional dance troupe at a club called Spirit in New York City. I was not a professional, I wasn't even a "dancer"; I was a frustrated poet whose muse had to find a way to blast through an epic writer's block, and I arrived at last and by personal necessity on the dance floor.

This audition, the *only* dance audition of my life, was no 5Rhythms class. Everyone was beautifully poised and eager to perform whatever moves they were given, but most had trouble dancing freely for Gabrielle, "in the style of..." I, however, was a wild-eyed creature crazed by the urgency of the dance. I got the job, and looked forward to a journey of deep investigations into the ecstatic. Instead, for a year I spun into a state of near constant, thinly veiled panic as Gabrielle tuned her fascination into a group of amazing pro dancers, and inspired us to create and refine extended choreography.

Gabrielle somehow didn't understand that I didn't belong in that group. Or maybe she did, because over the years she invited me to dance for other projects, projects that broke off the stage and danced outside the boundaries of a score. She asked me to dance on a posh rooftop garden, balancing on the ledges of garden beds; to dance a Wave down a staircase; to dance on rollerblades in the streets (and on stage); to dance with my shadow in Central Park. The dance was everywhere and everything, where else can we dance?

I learned that Gabrielle loved to break rules, especially her own. She wanted to see what light spilled out when we danced on the bleeding edge of our comfort zone.

She wanted to see my balance tip, my hair dance, my arms extend, my soul catch flight; she wanted *that* dance, she wanted to watch how the world danced with us when we let ourselves be seen, be sung, be outside of our comfort zones enough to become the more electric soulful aspects of ourselves. I felt myself dance under Gabrielle's direction as if I was a poem being written by her.

I'm trying to make this memory about her and not me, but that's the true resonance of my memories of Gabrielle: the experience of being her muse, the generosity of her gift of attention, the alignment of our

mission when we entered that space. I put in many hours of dancing for her, often alone together in a room, with one camera, so she could watch the music she'd made.

After a long dance of Stillness on the 4th floor of the Joffrey in a film session with Jason Goodman and Gabrielle, on Mother's Day, I danced with Death for her. That wasn't the assignment, it was just what happened. I told her that I had danced with Death and she said,

"Well, that's what it's all about."

I hadn't realized at that moment that she had just been diagnosed.

~ ~ ~

She said she wanted to work with dancers who made this ecstatic movement "look good." We spent hundreds of hours, over a period of years, in that process, on camera and with booms overhead, trying to capture it. (Thankfully, so much of Gabrielle has been captured, right here in this book.)

And I really wish I could recount all her ways, all the intimate transformations that I witnessed her shepherd people through, in rehearsals and master classes, in workshops and Teacher Trainings. But like our practice, those experiences belonged to the moment, and it's the feeling of the quality of her attention that stays with me, maybe selfishly, and her celebrating sweetly the way others inspired her.

That, and her urging me to,

"Break the fucking rules."

I will never forget...

Your patient, generous attention. Your steadfast Refusal to accept anything that is Simply expected. Your blazing heart. Your magical display. A few blessed meetings when I

felt I was sitting with a titan. Your Unending gifts + your glorious, vibrant way of moving.

love, Meghan

Note from Robert: "Gabrielle was hired to create and direct a dance piece for the opening of a club in West Chelsea. She auditioned many and hired six or so, including Meaghan and Nilaya. It was fun for G to actually choreograph. We worked for six Saturday nights, from 10:00 PM to 4:00 AM: the piece would come in five-to-ten minute bursts every hour or so. There's a video of it on 5RRO™.org."

photographer unknown

Pray Body

by Gabrielle Roth and the Mirrors

THE MIRRORS BAND

The following people played and recorded with "Gabrielle Roth & The Mirrors" over the course of three decades. Many other astounding and talented musicians also joined Gabrielle and Robert in the studio over the years, including the amazing **Allison Cornell, Rocky Bryant,** *the late* **Delores Holmes, Boris Grebenshikov, Chris Botti** *and many more too numerous to mention.* **Otto Richter,** *already included earlier, was also a vital part of the band, singing vocals on the Mirrors' first two rock & roll albums, "Dancing Toward the One" and "Pray Body."* **Robert Ansell,** *the head of Raven Recording, was a constant presence on all of the 25 Mirrors CDs. More on his role in the band to follow.*

Sanga is originally from Trinidad and Tobago. "Working with Gabrielle, Robert, and Jonathan was some of my best work. LONG LIVE GABRIELLE THE RAVEN."

Okay here we go. I was at a workshop with Gabrielle in London. G was cursing up a storm, and she was cursing like a black woman. She turned and said to the producers,

"You need to get black people into the workshop, 'cause black people know this work."

Then she turned to me and said,

"You know Sanga, I used to talk like a home girl."

(That means black woman.) I asked her how, and she said,

"I used to live with some home girls."

Then she turned and said to the class,

"Shit, I wish I was black."

That was in 1993.

~ ~ ~

I went to London on a tour with Baba Olatunji. I met a beauty-full woman, who was in a wheelchair. We made a connection.

I returned to London with Gabrielle, and my friend attended. We went to her flat 'n made sweet love. A lot of 5Rhythms people were upset with my satisfaction. They thought it was a problem. Frankly I didn't give a damn. She wanted it, so I gave it to her. When they told Gabrielle about it, she simply said,

"Sanga is a generous lover."

Case closed. The Raven had spoken, and everyone chilled out.

Gordy Onayemi Ryan
Percussion
Vashon, WA

'G' Ryan, called "The Pulse of the Planet" by Coleman Barks, played for 'The Dance' for three decades with both Gabrielle and Babatunde Olatunji's Drums of Passion; he currently plays seven days a week for Dancing Feet: The Dance and the Drum are one.

The First Time I Ever Saw Her Dance

On a Friday evening in 1968, the fog has rolled in off the Pacific, it fills the atmosphere at Esalen in Big Sur with a misty shroud. Dick Horan and I are sitting on the stoop of my home, Cabin #10 at Hot Springs, playing our drums after work; the grooves float off into the unknown, we're feelin' good.

Suddenly, a shimmering vision appears out of the mist, dressed in black with long raven hair, eyes flashing as she moves with a graceful, fluid motion that reveals an intuitive connection to the rhythms we play. She becomes one with the song of the drum. After a timeless time the vision moves on into the night, down the path to the baths. I turn to my friend and say, "She's going to stay."

It was Gabrielle—she had found her new home. We both do the Massage Workshop with Bonnie Day Schackman. Soon, Gabrielle is leading "Experience Esalen" weekend workshops that include dance, massage, and sensory awareness as core elements. Gabrielle hires me and a crew of Big Sur musicians to play for the Friday night trance-dance/massage sessions in the lodge that are wild beyond wild.

This was the beginning of decades of playing the drum for Gabrielle in dance events in North America, the U.K. and Europe, as she awakened the Spirit of the Dance in countless fellow travelers seeking freedom and awareness through movement. She inspired Robert to found Raven Recording; then we —"The Mirrors"—played as Gabrielle danced in the studios, producing music that expressed her Shamanic energy and communicated her message to a worldwide audience.

Always at the Heart of this music was the Drum, reflecting the Shaman. Truly, Gabrielle and the Drum are One, eternally.

~ ~ ~

The Raven Lady Leads her Brother to his Destiny

Right after New Year's in 1989, Robert and I fly to London, then take the train to Devon where Gabrielle is leading her first Teacher Training in the U.K., at Grimstone Manor in Horrabridge. We will be playing music during the two-week event. As we walk into the Manor, a fine lady and I have a sudden, transcendent eye-to-eye moment that is beyond time.

As the session goes on we become friends but do not go further, although we recognize a mysteriously deep connection. After the training, I go to Llanberis in North Wales with two friends from the group, to visit Snowdonia, a legendary climbing region. Several days later, I travel by train back to London to catch my flight to New York. As I climb the stairs at Euston Station, to my surprise I see Gabrielle standing at the top of the stairs. We greet and she immediately says,

"You are going to call Zoe right now."

Being aware of my shyness, she frog-marches me to a red phone booth and stands there listening to make sure that I actually make the call. Then she rides with me in the cab to our friend Claire's flat where Zoe is staying, goes in with me, makes sure I stay, then leaves with a flash of the eye that says,

"Brother, recognize your Destiny."

Soon afterward, Zoe joins me in New York; we have been together on a magical journey ever since, and I give my utmost gratitude every day to my loving Raven Sister who swept the veil from my Heart so I could unite with my life's Soulmate.

~ ~ ~

*As mentioned earlier, **Robert Ansell** was an essential part of the band; in addition to concert toms and other percussion instruments, he held the vital bottom beat on all of the Mirrors' music, playing his large Sioux pony drum, affectionately known far and wide as "Bertha." As Gabrielle put it, "Robert's root drumming informs all of our music."*

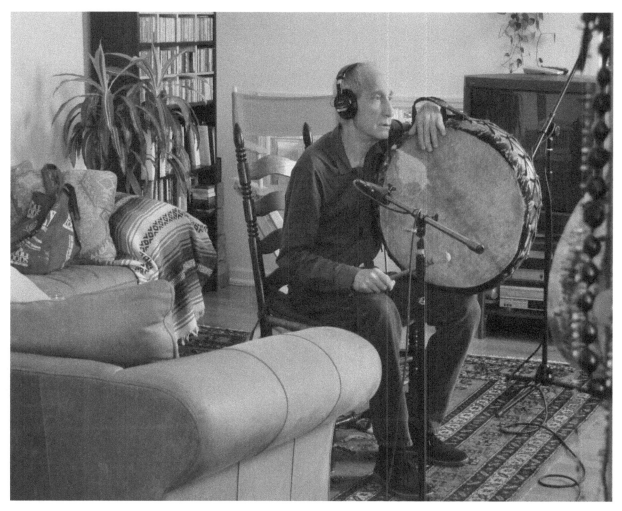

photo by Sara Carlson

Robert & Bertha

Raphael F. Sharpe
Piano and Keyboards
Haiku, Hawaii

Raphael was a principle shamanic musician and composer for Gabrielle for 12 years.

The Power of Tantra

A couple came to Gabrielle and said, "We can't make love anymore, what can we do?"
Gabrielle replied,

"For the next five days don't make love or even try. However, for ten minutes in the morning and ten minutes in the evening, hold each other and simply breathe together: when she breathes in, you breathe in, when she breathes out you breathe out, nothing else."

Within three days they were fucking like bunnies.

Sally "Lolita" Block
Flute
Sedona, AZ

Sally is a lifelong devotee of the Great Mystery, and it is there that she met fellow night-traveler Gabrielle.

It was late July of 1989, around the time of my birthday, when Gabrielle called me and asked if I would like to come into Manhattan for an overnight at her home. She was going to be interviewed at a local TV show in Hoboken, New Jersey the next day and I was invited to go along with her. What an offer. What a great birthday. I got on the Hampton Jitney for the two-hour drive into the city.

Her first book, *Maps to Ecstasy*, was just coming out. We were standing in her living room where there were many books. She gave me a copy but then asked for it back and started writing on the first blank page:

"Lolita,

Forever you dance in my light

— a beam of truth —

a woman of power.

I thank you for your contribution

to this book, to our music & mostly to my

life.

Dance your dreams awake Lolita!

I love you,

Gabrielle"

We took a walk to her favorite new bistro in the neighborhood where over coffee and tea we talked girl-talk and fashion, and to my surprise she confirmed my longtime wish: to write—to simply write. I knew not why, but only that I had to.

Early the next morning we were driven to the TV venue. The interviewer was nice. Gabrielle was her brilliant, empathic self. It was three minutes! We laughed about it on the ride home. Gabrielle explained to me that these local TV station shows are stepping-stones to see how articulate and ready you are to eventually sit down with the likes of Oprah.

I wrote this later: "The TV show was funny. Time is money, so no time for depth. Give us your life's work in three minutes (or less)."

Twenty-four hours in Manhattan was good for me. It wasn't the city, the little bistro and restaurant (although very important to us), it was Gabrielle's massive love she poured over me. I walked off the Jitney going home realizing that love truly is the most important gift of life.

I will never forget…
that after Gabrielle and I
saw Raphael's Tantric
Wedding video she said
to me "Lolita, that could
have been you!"

Jeffrey Hoffman
Guitar, Sitar
Holmdel, NJ

Jeff was co-author with Gabrielle on several of the original Mirrors songs and was actually the first member of the Mirrors during their Red Bank, NJ/Tarot Farm days.

I remember a time in the early '80s when we were dancing in our studio in Red Bank, New Jersey, and I had to leave early for my Gurdjieff meeting in New York; if I was literally one minute late, they would not let me in. As I was leaving the room, Gabrielle danced over to me, grabbed me, and whispered in my ear,

"You DO know that he is dead, don't you?"

Then she went back to dancing, and after that night I never again went to a Gurdjieff meeting.

George Ivanovitch Gurdjieff
January 13, 1866 – October 29, 1949

George Gurdjieff, an Armenian mystic, is thought to have transmitted the teachings of the Enneagram to the founder of the ARICA School, Oscar Ichazo, from whom Gabrielle received it when studying with him in Chile. Few 5R people recognize that much of her work with ego-characters in Mirrors was derived from the Enneagram, which is a system of identifying personality types.

[Editor's Note: In the request I sent to invite people to contribute to this book, I used this story of Jeffrey's as a perfect example of the type of moment I was looking for. Someone responded:

"You DO know she's dead, don't you?"]

Jaime Segel Estes
Vocals
Rustic Canyon, CA

Jaime is a blues rock 'n roller who sang with the Mirrors and danced with the original troupe. "Gabrielle was an auntie, a mentor, a guru and a savior in my life!"

Mentor. Hero. Sister. Friend.

Gabrielle. I called her Gabriella. She was completely instrumental in initiating me into adulthood, performance, Goddess-ness!

When we first met I was just fifteen. She was the most enchanting and magical creature I'd ever seen. Tall, dark, mysterious, with wild animal eyes. She told me that I could!!!!!!! And I believed her! Still do.

I attended my first workshop with her at Esalen in '77, at age 17. I remember groaning and moaning our prayers as we crawled along the floor in Huxley, then all ending up naked and chanting in the smelly sulphur baths.

So of course I thought to myself, "GET ME THE FUCK OUT OF HERE! This is my mother's 'thing' not mine!" I wanted to pack up and split as fast as legs would carry. See, my mother was a Gestalt Dance Therapist, and I, as a teenager, was very wary of anything that smelled too "woo woo-y, " or that smacked of therapy or "working on myself."

Gabrielle found me before I could escape. She asked me to,

"Give it another try, one more day. We are about to go further into our dance and deep into our personal emotional stories. It will be all right."

Sooo…I agreed. One more day.

Of course, she was right.

From that next day on, I was transformed. Forever hooked. A devotee and a dancer, so eager to follow, to navigate her "Maps to Ecstasy."

In some workshops, she'd ask me to sing along with the passionate, driving, spiritual beats of Robert and Sanga of the Valley on their drums, the room filled with orgiastic dancers rediscovering their secrets in the movements of the 5Rhythms. I learned SO MUCH about my voice, singing, dynamics, emotional impact.

It was my education. Invaluable. So completely different from my rock n' roll training. It made me feel present, immediate, connected, tuned in to the moment.

Just like Gabriella always seemed.

Later still, singing with and for her in the recording studio. Another experience so completely different than any I'd had. Unlike the hundreds of sessions where I'd sung previously. It was the early days of the mystical, magical, musical Mirrors! She'd give me a track and instruct me to,

"JUST GO FOR IT!"

while she danced and slithered on the other side of the sound booth glass, as if we could merge our musical intentions. And we DID! I can still see her face so clearly when she felt happy with what we were achieving. Never really making eye contact. Just two wild panthers, gliding all around. Stalking each other. Drawing each other out.

Or perhaps just a couple of Ravens?

A Southern California girl in the ridiculously hot and humid summer in Red Bank, NJ, with Gabrielle and the cast and crew of "The Production of Our Lives," as directed by Her Majesty, her own bad self. For me, yet another vital coming of age initiation. Am now 18.

Such a powerful force, we were in awe of her—motivated by our desires to please, or a wish to be discovered, or the hope and prayer we might transform our very selves. We tried with all of our beings to be her devoted "troupe." We wrote songs and danced and acted and bared our souls, stripped metaphorically naked in front of her and each other. It was challenging, exciting, provoking, intense. Did I mention exciting? She was driven and passionate and wild and frustrated. At times encouraging. Always committed.

I remember that entire time in Red Bank with such delicious fondness. One day, angry with the troupe, I think in an attempt to push everyone further and deeper, she shouted,

"JAIME IS THE ONLY TRUE PERFORMER!"

While I was embarrassed and uncomfortable with the timing of her delivery, those words, no matter her intent, have impacted me until this day.

I will forever cherish every smile, each nod of approval. Will carry them with me as "Medals of Honor" presented to me, for as long as I shall live.

I miss you Gabriella…

I'm not interested in enlightenment.

I want to be delighted, not enlightened.

—Gabrielle

Jai Uttal
Vocals, Dotar, Guitar, Keyboard
Fairfax, CA.

Jai is a popular, Grammy-nominated recording artist and composer of Sacred Music. He has released upward of 15 CDs, in addition to playing on several Mirrors CDs as well as live at 5Rhythms workshops.

I worked with Gabrielle in the recording studio many times and she taught me a new way of composing, creating, intuiting and recording music. Robert and Gabrielle would send me drum tracks and I would listen to them and daydream about what would sound good floating on top. Then, when I came to New York, we would go into the studio to record.

I thought I had a pretty good idea of what I wanted to play and/or sing on each track, but then Gabrielle would walk into the room and her whole body would become a conductor's stick! As she danced to the left, my music would dance with her; as she would squat down and scrunch herself into a tight ball, the anguish in my heart would pour out of me; and when she stood up and waved her arms wide, my voice would rise free like a bird experiencing the joy of first flight. It was a constant rainbow of movement, music, and emotion—and always super fun. On top of all that, Gabrielle always brought a lot of great food!!! She completely transformed the way I experienced recording sessions, from something contracted and stressful to something expansive and awesome.

Chloë Goodchild
Vocals
Bristol, England

Chloë is the founder of "The Naked Voice" and the author of a book by the same name. She sings on Gabrielle's "Stillness," "Surya," and "Jhoom."

Gabrielle was not only an extraordinary angel of awakening, she was a truly generous-hearted presence in my life—both as friend and teacher—with her spell-binding, wild, innovative and courageous way of being.

I was in a New York recording studio with her once, just coming to the end of a vocal session for her next CD, "Jhoom." After we were complete, Gabrielle looked at her watch and said,

"Well Chloë, we still have some recording time left. We finished earlier than I thought. How about you just improvise freely and we'll leave the Record button on?"

"Sure," I replied.

This was my favorite recording style. This was also the last time I recorded for Gabrielle before she passed. She had been a remarkable and loyal friend and passionate champion of my music ever since we met. Gabrielle's last words to me, on the phone, before her "wedding with Eternity," were,

"Have I heard all your latest music? Your sound brings me so very close to Heaven."

I treasure her dancing soul. The intensity of her tireless commitment and service continues to illumine the evolution of movement and music as a spiritual art form, and a metaphor for life. May the unique legacy of her mighty calling continue to rock the world.

Deepest loving gratitude Gabrielle…

To sweat is to pray,

to make an offering of your innermost self.

Sweat is holy water, prayer beads,

pearls of liquid that release your past.

The more you dance, the more you sweat;

the more your sweat, the more you pray;

the more you pray,

the closer you are to ecstasy.

—Gabrielle

Andrea Juhan, Lori Saltzman, and half of Kathy Altman (the good half)

THE POSSE

There were so many people who showed up to help Gabrielle navigate her global world of workshops, music and CDs, books, Teacher Trainings, theater performances, correspondence, appearances, radio and magazine interviews, not to mention her worldwide Tribe of 5Rhythms teachers. She received over 700 emails every day, and did her best to respond to all of the personal ones.

When Robert and I tried to figure out who was in the "Posse" for this book, we realized it really is ALL OF YOU here, and countless others who are not here, for Gabrielle was always surrounded by so many devoted dedicated divine dancers and beloveds. But along with Jonathan, Robert and her close-knit NYC circle, Kathy, Lori and Andrea were truly her principal support team for over 30 years. Yet she was always immensely grateful to everyone who turned up in her circle, or, as she put it:

"Thank you for showing up so I don't have to do this by myself!"

Kathy Altman
Mill Valley, CA.

Kathy was Gabrielle's right hand for nearly 40 years.

I remember a day we were working in St. Helena, California. We were there for a long retreat and had an afternoon off, so we headed to town to shop. What else do you do with Gabrielle when she had time off, except maybe the movies?

St. Helena is a very small town, and at that time, pretty conservative. Women in matching sweater sets, tourists from the middle of somewhere, a bit drunk from afternoon wine tasting.

As we were crossing the street there was this massive truck with those tires that look like they came out of a *Mad Max* movie, slowly crossing the road, blaring Latin music. Everyone on the street stopped dead in their tracks looking at this anomaly, except for Gabrielle, who danced her hippest Latin swing moves right across the street in front of the truck.

The driver smiled, I laughed out loud at the faces in that small town and Gabrielle, well, she proceeded to go into some swanky shop to have a look-see. That day I bought my first, new, expensive cashmere sweater with her seal of approval. I still wear it to this day.

Lori Saltzman
Mill Valley, CA

Lori is the co-founder of Open Floor International, and spent over three decades riding shotgun with Gabrielle on her magic carpet ride.

Sweet Story:

I learned almost as much from Gabrielle in our time off the dance floor as on. In the early days she spent many weeks of the year in our guestroom. We'd hang out, talk, drink tea, shop, see a lot of movies, and go out to eat every night. (I gave up trying to cook for her.) In between we'd write and create together.

One time Gabrielle happened to be staying with us on my birthday; she picked up the phone and asked for my parents' number.

"Why?" I asked.

"Because it's their day of birth every bit as much as it is yours," Gabrielle said. "You know, it's not all about you, babe."

She called them and wished them a happy birthday. She talked on and on, with these two relative strangers who were probably confused as hell, describing in detail the ways she could feel the quality of the love, humor and intelligence in their parenting. How she wanted to honor this day that marked the start of a whole chapter of their lives. She thanked them for giving birth to me.

I could picture my mom and dad in Florida on their two separate phones, pointing at their handsets and shrugging their shoulders at each other, a Jewish "What-the-hell-is-this?" pantomime. They had to call me later that day to ask "Who was that? How sweet, how kind."

This was Gabrielle's ritual. She called my parents every year. And Kathy's parents. And countless others. I became accustomed to hearing her make these calls all the time. Most people in her circle didn't even know she was doing it.

It so touched me that birthday calls to parents became my ritual as well. I started with Gabrielle's mom, Jeannie. And Kathy's parents. I called Gabrielle on Jonathan's birthday. Then lots of my other friends. I called my parents every year and thanked them for my sister.

[Editor's Note: Gabrielle never called MY parents. Neither did Lori.]

Kind of a sweet story, in retrospect!

Gabrielle had many identities. One of them was a street girl dressed in Armani. This is a nice way of saying she cursed like a sailor when she was teaching.

For 20 or so years Kathy and I would drive her down from our house in Mill Valley to Esalen Institute to support her at her annual workshop. One particular year, at the height of her fame, she had just gotten an email from a couple of women who had brought their daughters to a large event she'd done. They loved her work but chastised her "inappropriate language."

Knowing Gabrielle's rebel character all too well, I assumed she would just ignore it. But Gabrielle always went toward a challenge, whether it was giving up cigarettes, or writing books and producing videos, or transforming herself from a wordless dancer who mostly spoke in movement to someone who lectured to thousands.

Driving down to the workshop in our battered old red Montero, Gabrielle announced that she was going to stop cursing. Kathy and I had our doubts, but she was insistent. She was going to stay completely aware, drop her automatic mode, and not utter a single foul word for the next seven days.

That evening, opening night of her workshop, she started with:

"Face it. We're all fucked up. But there's hope."

Kathy and I stole a glance at each other, rolled our eyes and giggled. We really didn't expect anything different. Gabrielle proceeded in her usual flow, regularly cursing in every session to make a point. The workshop was profoundly magical, as always.

Seven days later I was driving us home on Highway 1, a gorgeous stretch of road on the coast of California. Gabrielle rode shotgun. Kathy was sitting in the back. The sun was setting over the ocean to our left, as we looked for a dinner spot on the right.

Gabrielle said:

"I did great with the cursing thing, didn't I?"

Pause.

"Well, not really, Gabrielle," I said.

"What do you mean?"

"You did curse."

"No I didn't."

"Well, actually you did."

"No I didn't."

"Yeah, you did."

"When?"

"All week."

"You're full of shit, Lori, I did not!"

"Yeah, you kinda did."

"You're stuck in the past. In your old ego image of me."

"Well, not really Gabrielle, you really did curse."

"I know I didn't. Absolutely positive. Fuck you and your assumptions about me!"

I looked in the rearview mirror, silently begging Kathy to say something, to back me up. She averted her gaze.

That's when I saw the flashing red lights. The police pulled me over and gave me a ticket for speeding.

We drove in silence for the next hour, and never mentioned it again.

If you're not living on the edge,

you're taking up too much space.

—Gabrielle

Andrea Juhan
Big Sur/South Pasadena, CA

Andrea was a Senior Teacher and among the first group that Gabrielle trained to share the 5Rhythms. She was a Core Faculty person until the end of Gabrielle's life.

Things I remember about G:

I remember after an unusually long dance session, her singing "Row Row Your Boat" with all of us in rounds and it felt like a song to God—Alhamdulillah too!

~ ~ ~

I remember her wearing a pink unitard—something other than black.

~ ~ ~

I remember her ferocious funny flirty ways leading the group but always somehow the last to be seen on the dance floor.

~ ~ ~

I remember her teaching one day. We were doing some sort of Ritual Theater and she was frustrated, not getting what she wanted, irritated, not being nice about it…so she sent us back to dancing Wave upon Wave, drums and more drums, then back again to the Ritual Theater. We were clumsy, trying, but still not in alignment with what or where she was going.

So more dancing, hours more dancing;

we were in drop-dead mode, and for a third time she formed the Ritual Theater experiment.

Finally, a dancer—I don't even remember who—

came out with a gut-wrenching, exquisitely beautiful dance/poetry lament about the angst of not being in a body she liked—an emotionally naked, wholly embodied movement piece.

It was a devastatingly real and deeply touching, archetypal work of art never to be repeated—and Gabrielle said:

> "That's it!"

There is a dance that only you can do.

Mikhail Baryshnikov can't do it.

Alvin Ailey couldn't have done it.

It's your dance.

And, if you don't do your dance, who will?

—Gabrielle

Nilaya Sabnis
New York, NY

Nilaya served as Gabrielle's creative assistant, confidante, editor, and performer in her theater productions from 2002-2012. She also assisted in a caregiving capacity, in support of both Robert and Gabrielle in the final months.

October 22, 2017:

Five years ago today, I acquired a Gabrielle-shaped hole, a hole the size and shape of the universe, unconditional love contained in a skinny white body who could rage and dance and bitch and moan and shop, spill poetry like water, see with laser-sharp accuracy into the soul-truth of any human before her, and hug your hurts away with the gentleness of a small white feather landing on a lake. She has taught me in her leaving how to feel her in the formless, where she lives now, everywhere, in so many butterflies landing on my arm, ravens appearing to say yes, cold waves slapping me across the face, whispers in my ear, knowings in my belly. I'd still rather talk to her like a human, ask her what to do with all the pain in the world, and what to wear to the party. She'd know exactly what to say. Five years ago today she danced so gently into the

eternal quiet. I feel grateful to stand in a worldwide chorus of amazing people who miss and love this woman profoundly.

She continues to midwife the birth of the wounded artist-healer in me and hundreds of thousands of other dancing bodies healing this planet one sweaty footstep at a time.

Gabrielle, I still miss you and feel you telling me to stop being so damn sentimental right now. Okay fine. Happy Re-Birthday.

~ ~ ~

I was at her computer working quietly. She was on the phone pacing back and forth nearby, supporting a loved one through a tough moment in a bitter divorce. I could hear the other person going on and on and on from the other end as she listened patiently, assuaging their pain with compassionate encouragement and sage perspective:

"No honey, you have to speak to the part of her you want to see."

Her voice was so sweet, lulling me into a gentle trance. Until all of a sudden, she cut him off mid-sentence with,

"FUCK GOD! *LIVE* YOUR PRAYER!"

I almost fell out of my chair.

~ ~ ~

Some of my most life-altering moments with her were the most irritating or angering things she said to me, containing wisdom I'd only understand years later. Like the time I was a few months into complaining about a toxic relationship from which I was trying to disentangle myself, and she'd been there for me with an ever-patient ear and good advice all along, until one day, while in tears of hopeless frustration I implored her to tell me how to just freaking let go of him already. She looked at me calmly and just said,

"Nil, get over yourself!"

Which, like a bucket of ice water to my face, shocked me awake and pissed me off, but also shook me out of my ego spin-cycle once and for all. I was hurt for awhile, but over time grew to understand how much love was actually in that statement. Because what does it mean to "get over" oneself? She created the conditions for me to release myself from my own solipsistic point of view and look at the situation from a distance. I

97

hold this little gem of her voice in my back pocket for when I get whipped up into self-defeating frenzies about things. It always snaps me out of it and helps me stay moving forward.

~ ~ ~

We were walking somewhere one day and passed a homeless man with a cup out for money. The block after we passed him, I told her, "You know, I really wanted to give that man back there something, but I only have a couple of coins in my pocket. I wish I had some cash on me. I feel bad." She replied,

"Honey, money is just energy. If you feel the urge to give, give something, even if you only have a coin. It's not about how much, but that you move the energy. See, now it's stuck and you're carrying it with you."

I've never forgotten this. It applies to everything.

~ ~ ~

I'd been apartment hunting all over the city for seven months straight, to no avail. One day, I get a call from Gabrielle.

"Nil, call off your search. I found your apartment."

Lucia was moving out of her place in a couple of months and needed to find a new tenant. Only a ten-minute walk from Gabrielle's house; it was perfect. But it was also $300/month over my budget. At that stage in my life, I was still taking all my life advice from my dad and big brother, who both unequivocally informed me that signing a one-year lease on a place, with no job and only six months of rent in the bank, was the stupidest thing I could ever do. It was hard to argue with this logic, and I was devastated. I struggled internally over whether or not to take the apartment, my head battling my heart, and finally turned to Gabrielle for help in how to navigate the crossroads. I told her, "My dad and brother say I'd be shooting myself in the foot if I take this apartment." Immediately, she responded:

"Nil, when the universe lines something up so perfectly for you like this, you'd be shooting yourself in the foot to NOT step into the empty space."

I couldn't exactly argue with that either. I took the apartment. That decision changed the trajectory of my life in ways I could never have possibly imagined. Since then I've learned to trust the empty space the

universe places in front of me even if it doesn't make sense at the time. It always puts me exactly where I need to be.

~ ~ ~

I was having a really hard time letting go of another toxic relationship. I asked her desperately one day, "How do you let things go?" She told me,

"Letting go isn't about pushing something away or making it disappear. It's about integrating it into yourself. Accepting it."

That turned my young mind inside out, and is still something I have to remind myself of to this day.

~ ~ ~

Not to mention the countless times I'd go to her with a personal crisis, weeping in despair, blubbering through some story about how my life was falling apart or my heart was breaking or I'd never find god or get over the guy or forgive myself for whatever, looking for her to respond with sympathy and a hug and some deep, calming words of Gabrielle wisdom, only to be met instead with a triumphant smile, a gasp of glee, and,

"Nil! Grab a pen and write all that down! This is gonna make a great theater piece!"

She was dead serious. And she was right. We actually followed through on two of my sob stories—one about a spiritual crisis, and the other about a very complicated love situation. She directed and I performed them in her final theater production at P.S. 122, just a few months before she died. It turned out, the process of turning my pain and shame into a refined piece of art and performing it for an audience was an exercise in vulnerability that proved infinitely more healing and transformative than any amount of sympathy could ever have been.

~ ~ ~

I was with her while she shopped at a high-end clothing store. Like everywhere she frequented, Gabrielle was buddies with the salesclerk who you could see adored and respected her. She caught me admiring a skirt, and told me to try it on. I resisted because there was no way in hell I was ever going to be able to buy the thing and was afraid to fall in love with it, but she pressed and I caved, and couldn't help lighting up in it and twirling around. She loved it on me, and even the sales clerk got swept up in the

excitement and offered me her employee discount to help. After the clerk stepped away, I told Gabrielle there was no way, even with the gracious discount, that I could justify spending this kind of money on a skirt right now. But she wasn't having it. She strong-armed me with spirit:

"Honey! You can't think about this linearly. This skirt looks great on you. Yeah, it might feel expensive now, but how often do you get offered an employee discount? It's not just a skirt. One day you'll wear it to one of your photo shoots. The way you'll carry yourself in it will affect the way you shoot and the way your client sees you and who knows, someone might come up to you and hire you for a huge job that will pay your way more than the skirt costs? You have to buy the skirt."

I bought the skirt. It never got me a huge job, but it's still gorgeous and I think the moral of this story is that Gabrielle really just loved clothes.

Whenever something didn't work out the way I wanted it to, she'd always remind me,

"Don't worry, Nil. If you don't get what you want, it's because you're being protected from something you might not be able to see."

In hindsight, this has never once failed to be true.

~ ~ ~

This story is actually about what Gabrielle *didn't* say, which demonstrates her wisdom and compassion just as much as all the things she did say. Here was a woman whose creative life revolved around teaching others how to have an embodied experience; and here I was, her assistant, this young little thing who intellectualized everything to the point where any time Gabrielle offered me a different way to approach something, my response was always, "That's great advice, G, I'll think about that." Every single time: "I'll think about that." And every single time, this creator of a global movement practice would respond with the same loving chuckle and simply say,

"Don't think about it, Nil. Move it."

Beyond that, she never pushed. Not once. Sure, we took dance breaks from our work all the time, and I did a good amount of theater with her, but she never once pressured me to attend 5Rhythms classes or workshops, even though that was all we thought about, wrote about, made decisions about, and we moved through the rhythms together daily.

Robert recently told me that over the years, he would tell her every so often that he thought I should do the 5Rhythms Teacher Training, that I would make a good teacher. And that her response to him was this:

"You're right, she should. And I want her to. But don't you EVER tell her so. If you tell her that you think she should be a teacher, or that I want her to be a teacher, she'll do it for me. If she ever decides to do it, it needs to come from her."

To hear this from him so many years after her death floored me. To think that in all of our time together, she never once pushed me toward what she could see in me. She knew better. She knew process. She knew timing. She knew when to let go. She trusted and respected the organic unfolding of the universe. Gabrielle didn't just talk about surrendering control, she lived it too.

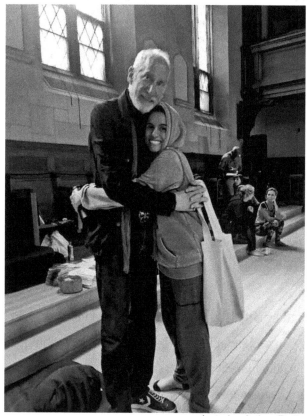

photo by Arthur Retiz
Robert & Nilaya

101

Tammy Burstein
Brooklyn, N.Y.

Tammy is an urban life form and itinerant wonderer, just one of many who happened, through some alignment or misalignment of stars, to end up dancing next to Gabrielle.

The first time I was in Gabrielle's presence was at a class she taught, through the Learning Annex in NYC in 1997 or so, as part of a book-signing tour for *Sweat Your Prayers*. I'd already been going to regular classes and had fallen in love with dancing again (after many years away from dance studios), hand-in-hand with falling in love with my "new" man, Jason Goodman, who introduced me to the 5Rhythms.

Jason got us tickets so that we could take a class with Gabrielle. Held in a loft that apparently was also used for Learning Annex cooking classes (!), the majority of the group were very much 9-5ers arriving in suits and ties, heels and handbags. After the class, the group was all soft and mushy, shoeless and tieless, as we all sat down in front of Gabrielle. She probably said all sorts of things but the one I remember was her opening up her arms to reference the whole group and saying,

"All this is bullshit if you can't take it out into the street."

And that—not the dancing, not the soft and mushy, not that I had come to her through the love of my life—was what moved me to stick around and fall in love.

~ ~ ~

The second time I met Gabrielle was at one of the periodic classes she would teach at Jivamukti Yoga in NYC. Totally pumped to be one of the "in-crowd," one of the regular dancers, and not just one of the yogi/nis sitting in lotus position waiting for instructions; I was there to dance, and even better, to dance with Gabrielle and "live" drummers.

We danced. We were transported, transcended, transfixed in her presence. I was no longer "anything," yet completely my own vulnerable self. I went up to her and blurted out, "I have to talk to you because I am afraid of you." Without missing a beat, she raised her arms and morphed into a spindly monster and chased me around the room, leaving no room for words, only breath in motion.

~ ~ ~

At the 2010 Teacher's Refresh, the leaders (Kathy Altman, Lori Salzman and Andrea Juhan, or perhaps only two of them) were each explaining to the group how they had addressed a difficult situation with someone in their local tribe. After they had shared their different perspectives, one of them asked Gabrielle for her input on what they had each done, to which Gabrielle replied.

"Or not."

~ ~ ~

I always seemed to bump into Gabrielle in the bathroom during breaks, sometimes before or after sessions. And we'd have these everyday chats, facing the mirrors over the sinks, speaking to each other's reflections: "I like your hair that way"—that kind of stuff. One of those "meetings" happened at the Omega Institute before the Saturday afternoon session of a Waves weekend, probably in 2001 or so.

We had ended the morning session with Gabrielle riffing on death, how we weren't going to be here forever, it was all going to end for all of us sooner or later. As we spoke into the mirror to each other she asked,

"Do you think I was too hard on them?"
And I probably answered "No"—(what did I know? It worked for me!) And of course, her sense was right on point, as there were definitely some people who didn't come back after lunch. (But as I recall, they were back by the next morning.)

~ ~ ~

Someone asked me if I had had the opportunity to spend time with Gabrielle off the dance floor and what was she like, and I responded that I was lucky enough to have done so and that she was an extraordinary visionary whose impact was magnified by her also being such an ordinary person. One of my favorite memories was going by her apartment to drop off a DVD with footage of a recent workshop she had taught (that Jason had filmed) and her asking me to help her put the slipcovers on the couch cushions. The absolute best moment was when she asked,

"Do you know which end of the pillows the zipper should be on?"

(Which, by the way, I *did* know because my mother had taught me well.) There it was—that beautiful reality of being a human being with a couch with cushions, and a preference for having those cushions put on in the correct way. The wisdom of the mundane.

If you have a body,

you are a dancer.

—Gabrielle

Peter Fodera
New York, New York

Peter is a visual artist and paintings conservator who met Gabrielle before the turn of the century (1999) and she inspired him to turn the visual into movement and the movement into art...and now the 5Rhythms inform every part of his creative being.

My first 5Rhythms experience was with Jonathan, and although my body knew I was home, I didn't have a clue who this woman was when she asked me,

"Who are you? And how long have you been dancing?"

Gabrielle was the embodiment of curiosity. She often said that life was not a spectator sport and that's truly how she lived. She not only asked questions, she connected the dots.

Years later, I was asked to hold a class at a local Senior Center that was starting an Alzheimer's group. At that time Gabrielle was laying the groundwork for the 5RRO (5Rhythms Reach Out) and she encouraged me to take it on. After my first class I realized that this was a whole new ballgame. In typical fashion, she wanted to know how my class went. When I shared with G that I had no idea how to even get them into Flowing, she gave me one of her lyrical, playful laughs and said,

"Pay attention Peter, they will show you how they flow."

This simple but profound offering has guided me ever since. It's the essential element on how to be of service to any population:

Pay Attention.

hanna k. lipp
Hamburg, Germany

hanna was many things to Gabrielle: her German producer, her "little" assistant, co-creator of the 5Rhythms Teachers Association (which she ran for seven years), and always felt like a daughter to her.

we had dinner with friends, someone fixed chicken breast. especially for her. when she cut the first piece of it she realized it wasn't well-done yet. she shrieked as if someone had stabbed her with a knife. none of us had chicken, but full-bodied red wine.

~ ~ ~

at a workshop. someone had made her tea. it was not hot enough, not strong enough and had too much milk in it. she looked at me in despair. "save me," she whispered, "get me some real tea."

~ ~ ~

one of our many home office days. "now *that* is the problem," she said to me. "you write *exited* when you mean *excited*."

~ ~ ~

it's been another rough day in the gabrielle universe. too many people wanting something from her. way too many things she didn't want to do but that needed to be done. so much responsibility. argh. she looks at me, the way only she could look at me, smiling:
"i know. let's go to the movies. I think 'marie-antoinette' is still on."

~ ~ ~

my first workshop ever outside of germany, in devon, england. i hardly know anyone of the 250 people on the dance floor. after the session I go to say hi to her, very shyly, totally insecure, not knowing if she'd care to see me. but she sees me walking across the room. really sees me: "look at her," she tells the people around her, "how cool she looks. i love that hat." and she took all that shyness, all that insecurity away with one embrace.

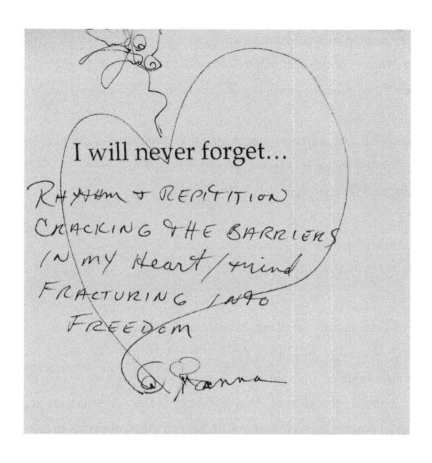

I will never forget...

RHYTHM & REPITITION
CRACKING THE BARRIERS
IN MY HEART/MIND
FRACTURING INTO
FREEDOM

Gianna

Arthur Retiz
Santa Monica, CA

Arthur has been the Business Manager for the 5Rhythms since 2005, working closely with Gabrielle, Robert, and Jonathan. According to Robert, "He's our everything!"

In early 2010 I was going through a rough breakup and needed some clarity. Gabrielle listened to me ramble over lunch for 20 minutes about the pros and cons of being with this woman and never said a word, just listened.

After I was done, Gabrielle asked,

"How's the conversation with your girlfriend?"

Before I could answer, Gabrielle interrupted,

"Because after all the sex and romance is gone, that's all you have left. If you're not talking, this relationship isn't going anywhere."

Gabrielle's question bounced around in my head for the remainder of our meal and the remainder of the week. It was a simple question, but it changed the course of my life forever.

I ended that relationship soon after.

Jason Goodman
Brooklyn, NY

Jason is a 5R teacher and videotaped everything Gabrielle did for many years.

I first came to the 5Rhythms in March 1994. Gabrielle was doing a demo on a Saturday afternoon for a New Age convention at the Marriot Marquis Hotel in Times Square—she was there to promote her summer workshop at the Omega Institute. That same weekend, I had two different parties to go to, with two different girlfriends, two entirely separate worlds I was traveling in at the time—and Gabrielle and Robert showed up at *both* parties!

It was the clearest sign I had ever received—and maybe *will* ever receive—from the universe. One particular conversation we had that very first night stands out in my mind. I was telling Gabrielle how much I had loved the experience at the Marriott, and asked if she had a center in New York where I could continue the practice. Her answer?

"Oh, no, I don't want to be famous in New York, I want to be *anonymous* in New York. I just want to be famous everywhere else!"

When I told Robert this story, he insisted that, "She ran from personal fame. She wouldn't even let me use her name in our branding and promoting the 5Rhythms. But she *did* want her *work* to be known worldwide."

So he believed she was joking. But for me, there was, as there often is, a hard staccato truth amid her sweet lyrical mirth. One thing I learned from Gabrielle and the 5Rhythms was about the simultaneous desires people often have to both hide and be seen—certainly that duality has been a running struggle in my own life. Gabrielle used to say,

"When people first come to a 5Rhythms class, they usually walk in saying 'I hope no one looks at me!' And after 15 minutes, they're thinking, 'I am such a fabulous dancer, why isn't everyone looking at me?'"

Gabrielle managed to put her finger on that basic human internal conflict, first for herself, and then for the rest of us. I know for me, it hit home like an arrow. We all want to love, and sometimes we want to hide our love away. And over the years, I've heard countless people say they keep the 5Rhythms as their own little secret practice, not wanting to tell their friends because they want to keep it to themselves.

So in that very first conversation we had, Gabrielle showed me a path that has become a lifelong exploration that I believe she would relate to: How can we simultaneously both go big *and* go home? Sometimes people are just bantering at a party, and maybe that's all that exchange was. But for me, it held lifelong immutable truths.

~ ~ ~

I was told this story:

After she went into remission in 2010, she realized she was well enough to teach the August intensive in California and really step back into her teaching path. When she called her producers out there, Kathy and Lori, to tell them, they reasonably asked,

"Okay, what's the workshop? And what are the prerequisites?"
And Gabrielle, flushed with being alive, said,

"I want to teach everybody! There are no prerequisites!"
Cut to the post-mortem after the first day of the workshop, and G was immediately in Kathy and Lori's faces:

"Who *are* these people? What were the prerequisites??????"

On about the fourth day of that workshop, Gabrielle finally connected to what the workshop was about: intuition.

"Can you learn to trust your intuition like your bicep? When you go to the grocery store, you don't wonder if the bag is going with you, of course it is. Can you come to trust your gut with the same certainty?"

She did live her life largely through dowsing her own entrails, and that workshop changed my life in ways I really can't completely express. G taught me, and countless others, how to trust ourselves…like we trust our biceps.

~ ~ ~

Even before she got sick, she quite openly had an uneasy relationship with her own body, and it was easy to see that oh-so-skinny being as frail, and that obviously increases exponentially with a cancer diagnosis. But in the three years between the diagnosis and her death, I can't tell you how many times I saw her getting out of her sickbed and teaching a class, and almost no one in those 100 odd dancers ever had a glimpse of the pain and gravity of her situation. I have had my own wars with and within my body, and witnessing her ability to stay present with what she loved was magnificent and heartbreaking, as are all of our battles to hold on to what we know and love and live.

~ ~ ~

It was a huge challenge trying to get Gabrielle to give me a sound bite for a video. With most people, you might say something like, "Can you just say that again?" and ask them to end it in a certain place, or switch it around, or whatever, to nail the perfect sound bite. G was incapable of that. In a profound way. Every time she went to find her answer, she was starting completely fresh, and her answer would be completely different.

Her ferocity will always be my touchstone as I move toward my own battles, remembering, as G's t-shirt once taught me,

"What remains is future."

Hans was Gabrielle's weekly dinner companion, close friend and confidante for many years, working on many projects together. They also shared a fondness for Magnolia's cupcakes.

Time: early 1990s

The day after I got hit by a car, which broke my humerus completely, I called Gabrielle wondering how the hell I would be able to dance in her upcoming Kripalu workshop. She assured me,

"Sure you can. Come!"

Three weeks later, just before the warm-up in her workshop, she lent me her black and white silk scarf of Skulls and Bones. She explained,

"This was my sling when I broke my arm a couple of years ago. Put it on!"

Gabrielle then got the whole group together and pointed at me,

"This is Hans Li and he has a broken arm, DON'T FUCK WITH HIM!"

Somehow, throughout the entire weekend, I was surrounded by an eight-foot bubble. Nobody fucked with me then, nobody fucked with me ever. Looking back, I am truly grateful for her transmission of invincibility, turning adversity into advantage.

~ ~ ~

For years I had dinner together with her and Robert once a week, and at the end of each meal Robert would go back to the apartment while Gabrielle and I would continue our conversations and I'd walk her home, often stopping at Magnolia for a sweet moment together, sharing their wonderful cupcakes. When my wife Jennifer came into my life, those dinners would include her as well.

We spent nearly all of our Thanksgivings together, and I was very moved when Gabrielle decided to come to our farm and teach Jennifer how to cook a proper Thanksgiving meal, Gabrielle style. Just the three of us together, enjoying a very delicious feast. (Robert was celebrating with his brothers that day.) Regrettably, that was our last Thanksgiving together. I guess Gabrielle knew she had to pass on her special

knowledge to Jennifer and for that I am truly grateful. I can testify that Gabrielle's sense of palette, her ability to juggle all the components in perfect timing made her a very good cook indeed.

With Love,
Hans Li

Lorca Simons
Chalford, ENG

Lorca is a performer and 5Rhythms teacher who collaborated with Gabrielle on multiple theater projects over the years. Gabrielle entrusted her with her 5Rhythms Ritual Theater Vision, and Lorca's Live Wire workshops around the world are the result.

I'm Speechless

I've never had a more challenging time coming up with something to share.

"I'm speechless," Gabrielle would say to me. She said that often and we'd burst out laughing at the absurdity of whatever the moment was that she'd be speechless about. She used that phrase often.

Turkey Dinner

It was Thanksgiving morning and that year we would be at Hans' apartment for the feast. Gabrielle would be cooking for 12 of us. Hans and I had gathered all the necessary supplies from the extensive shopping list Gabrielle provided us with. We were ready for her arrival when I got a call. G was on the other end of the line with the flu and wasn't going to be able to come uptown and cook the Thanksgiving dinner! She told me I'd have to do it. I'd never cooked a turkey in my life! So she talked me through the whole

creation process until that bird was cooked and on the table.

Uta Hagen

I was at Uta's house holding her feet shortly after she died. My phone rang. I picked it up, just *knowing* it was Gabrielle. She said,

"Come see me after you're done there."

I hadn't told her where I was or what was happening. Uta lived at Washington Square Park and G was on 13th Street. I just ran as fast as I could up University Place, straight onto that elevator and into her arms. She knew, she totally knew.

From: Gabrielle Roth <gabraven@panix.com>
Subject: theater
Date: 21 February 2006 02:15:13 GMT
To: LorcaYes@aol.com

dearest most beloved lorca,

here is the deal. right now i want to pour all my theater energy, dreams, time, thoughts, into you, just you. whatever i see, whatever i feel, whatever i know that the world needs at this moment, i want to pour into you. you will match me. you will live up to all my expectations. you are my muse. so let's fucking do it. you and me. and we are enough. and we are mighty. and we will…prevail. yes, i see bigger pictures and epic situations but i am in spirit from the lone star state.

we are destiny.

are you ready to rock?

me loves u

I will never forget...
the look on your
face when we
waved goodbye.

- LORCA

photo by Julie Skarratt

G & L

Gregory Wittrock
New York, NY

Greg Wittrock co-created theater art with Gabrielle.

We had just finished a weeklong residential "Mirrors" workshop in California. Sinead O'Connor's song "Thank You For Hearing Me" was still pulsing through my body. My eyes were a watery pool as we all made our way out of the hall. Gabrielle moved toward me and must have said "I love you." I can't remember her saying those words, but she must have because what I remember her saying was,

"You don't know what to do with my love."
She paused, continuing to take in more of my reaction, and finished with,

"Just put it in your back pocket."

I was mute. I didn't know what to do, but at that very moment someone directed us to pose for a picture, which gave me a snapshot to mark a moment where being truly seen by a friend was a wonderful relief. My comfort with Gabrielle initiated a big thrust in my creativity. With her, there was a time and place where everything could be explored. Over the years I had the opportunity to open up my rage, shame and sorrowful, gay sexuality with such a feeling of grace that I could trust Gabrielle with *all* of it. Everything.

I asked her to direct me in a video audition piece for a movie tentatively titled *The Sex Film Project,* directed by John Cameron Mitchell. She accepted. The film would require me to engage in sex on camera, so I shared with her various video clips of me masturbating. She looked at the footage and took the time to quietly reflect, then said with tender honesty,

"This is hard to look at."

I sat there in raw innocence, curious how my permission-giving mentor would direct me. Both of us leaned toward the tiny screen on my video camera. The muted glow of my sex footage colored our faces with a unique, dancing light. After letting all of the clips form a shape in her imagination, she said,

"If you want to use that footage, you should only show it for a split-second. Let them wonder if they really saw it or not."

She made us some tea and I witnessed her effortlessly settle into allowing the project to guide her. Moments later, she picked up the camera and gently directed me to lie face-down on her white-sheeted bed, my naked butt cheeks softly illuminated. Her voice spoke with a quiet gentleness,

"Grind more slowly. Slower… slower…more slowly."

As my hips moved in Stillness, our imaginations had space to fall in love with the essence and sensuality of the human body. We both got to explore this nuanced state of being together and set in motion a reverie of respect for a facet of humanity that has been cornered, shredded, and disowned. Representing the sexual body of movement-as-art was our edge to dance on together, whether the world wanted to dance with it or not. We entered into a co-creative venture that embraced sexuality as a wild force of nature, one that moves us in a perpetual hypnotic trance.

photo by Ruth Pontvianne

Gabrielle & Gregory

Adam Barley
The Cotswolds, UK

Adam is the founder of ZeroOne movement practice, and was among the early wave of Gabrielle's students and trained teachers, assisting her in developing the "Heartbeat" training.

It is 2009, twenty-one years from the moment when I'd fallen into a trance on hearing the first notes of "Initiation" by some strange band called "Gabrielle Roth and the Mirrors." The 5Rhythms teacher's event I was attending was coming to a close that afternoon, and without warning, I found myself overwhelmed with grief that it was our last day with Gabrielle. I loved being around her, like we all did, and it had been an electric, inspiring, deeply moving week with her, as always.

I poured my sadness into the dance, and before I knew it she was there beside me. We danced around each other's footsteps while I wept aloud, inconsolably. As if from nowhere, rose petals began falling on us both, like confetti, and I was dimly aware of Martha showering us with the petals. I was taken aback by the force of my grieving, seemingly out of proportion to the circumstance. It wasn't until some years later that I realized: although I saw Gabrielle several more times before her passing, that was the last dance I ever had with her.

Adina Roth
South Africa

Adina discovered the 5Rhythms in 2002 and met Gabrielle one night in a NYC class and dancing became part of her healing.

The third 5Rhythms class I ever attended was a small group in New York, and Jonathan was scheduled to lead it. But he wasn't there, and instead…could it be? It was Gabrielle herself. Halfway through the class she introduced herself. She said, with a big grin on her face,

"Hi…my name is Gabrielle and I'm the substitute for the teacher tonight."

She was tickled pink by the irony. She took us through a beautiful class, and I continued dancing throughout my time in New York, and when I returned to South Africa I continued dancing with a small, private group of

friends.

<center>~ ~ ~</center>

One time she spoke about a giraffe dying in a Tel Aviv zoo from the sounds of the bombs and the guns and she said,

"We need to look after our animals *and* our animal body."

Thank you Gabrielle.

<div align="right">

Alain Allard
Cymru, Wales

</div>

Alain is the founder of Moves Into Consciousness, and feels fortunate to have had Gabrielle as a fantastically inspiring teacher. He misses her wit, her wisdom and her wild intelligence.

I attended the Teacher Training with Gabrielle in the late '90s.

Pre-millennium was a time when the nineties naughtiness had only just begun the "cult of me." The coming new thousand-year cycle was to make reality TV, personal trademarking and the pressure to present a perfect public persona the new normal.

We, however, were being trained to be *teachings*, not teachers. As individual, creative representatives of a *way of being*, rather than mere operators of a system of *doing*. Body and Heart were more in the frame than mental knowledge and standardised models. It was a far looser time, a less branded "me, not them" time.

And whilst Gabrielle's fierce wisdom was truly active, the generous empathy of her heart's attunement to whomever she was with shone through clearly to me. My respect/admiration/love for her clear seeing was as near to "Guru love" as I might be capable of.

I was leading a "practice class" for our training posse in some big, central New York building. It was supposed to be a class about the rhythm called "Staccato," that yang one which viewed superficially seems brutal, and can promote, without a certain willingness to see the heart of the beast, yet more crude macho stereotypes.

And indeed, I was still at that simplistic stage of my own map-learning, and so the class was all sharp thumps, bangs and tension. And above all it was LOUD. The music was loud the stomping was loud and the yelling was loud. And reactive reflex shot round the classroom, the storey and the whole of the building.

Before too long we were threatened with eviction and I stood accused by "them"—the production gang. Loudness had begotten anger that begat fear that begat anger and I stood inelegantly and summarily accused. We were being "thrown out" and it was "all your (my) fault." It didn't feel good in my body nor my heart nor what mind I still possessed.

And then this gentleness of soft arms from the back of me encircled my waist—I had one in those days—with whispered words of shared truth and long experience spoken as only Gabrielle could speak:

"This has been happening to me all my life Alain."

The Presence in her voice was palpable. The soothing of her tone stroking its way directly to my Heart. Everything in me calmed. This was one of those moments of transmission that has guided my teaching and my respect for Gabrielle over all these years. Seeing and Healing at the right time at the perfect moment. She was a true artist and a true healer.

May I have the

courage to trust

that there is some enormous amazing

purpose to my existence,

that I wasn't thrown here

as some accidental afterthought

of some mean cowboy.

—Gabrielle

Alex Mackay
Cardigan, Wales

Alex was Gabrielle's raven sister, and apprenticed to her for 20 years.

1994—I was 24, London:

I'd started a dance class with my friend Vicky, and every time I taught it, it turned into a 5Rhythms class, which I was passionately dancing myself after taking "Cycles" and "Mirrors" with Gabrielle the year before. At the end of the London workshop, there was a queue to talk to Gabrielle and I really wanted to catch a few words with her, but the last thing I wanted was to be a drain on her resources—it seemed like many people wanted something from her—and she had just finished holding the space for 120 dancers. I decided to leave, but as I turned, she caught my eye and signaled for me to stay. Suddenly I got nervous! I'd written to her over the winter, and I wasn't sure if she knew who I was or not. It was a time when people were very interested in teaching, and "making deals" with her about how they would use their training to serve their communities, with children, elders, and so forth.

When it got to my turn, I looked into Gabrielle's eyes and she said,

"Alex, I love you, I'm honoured. Keep doing what you are doing, I'm hearing only good things about your classes."

We had a few minutes and I felt so seen and accepted and welcomed; in a way, that was the *one* conversation of my life. That was it, and from then on I've been on this dancing path with all my heart.

1997—I was 27, California:

First module of the Teacher Training, a bit overwhelmed by meeting such great people from around the world and feeling the power of the practice. I start to shrink into myself and then bump into Gabrielle coming out of the bathroom. She asks how I am, and I say, "Feeling like such a little fledgling." She put her head to one side and says,

"No, not you," and smiles as she walks off. My whole ego state disappears in a moment, and I've called on that moment a lot over the years.

Mirrors:

Gabrielle gives my partner in the Repetitions exercise a line to feed to me:

"You swallow your power."

That goes along with another phrase of hers I've called on when my soft voice was not the one needed:

"Speak from your boots, not your hairdo."

2010—I was 40, New York:

Gabrielle had recovered from her first dance with lung cancer, and had returned from a heat treatment in Germany. She told us,

"I've been sitting with the will to live, but a willingness to die."

She was so delicate and we had been asked to give her some space, and not touch or hug her. I was with Emma and Davida, dancing a very spacious and still repetition, and G joined our group for a while.

On the last lunch break of the Teacher's Refresh, Gabrielle asked me to have lunch together. As soon as we were on our own, she reached out for a hug and we held each other for a long time. She insisted on giving me some money in exchange for a copy of my notes, and when I tried to refuse, she said,

"I can't go shopping for a present for you—can you imagine how hard that is for me? Buy something just for you and tell me about it later."

That was the last time we saw each other, except for dreams and endless love.

> I will never forget...
>
> Gabrielle's eyes full of love as she spoke the most challenging words~ straight past the ego + to the individual soul
>
> raven-sister
> Alex Mackay

Amara Pagano
Makawao, Hawaii

Amara is the founder of The Path of Azul and studied intensively with Gabrielle and taught 5Rhythms for 16 years.

I remember a moment in one of the August month-long intensives—you can imagine dancing together for one month and the ups and downs, ins and outs of that!—and the group did not have a lot of spark that night. It was an "odd" session and nothing Gabrielle tried seemed to work. Later we were walking outside together and, as I was already teaching the 5Rhythms, I asked her, "So what do you do when that happens?" And she looked at me and said,

"I never look back," and waved her hand like it was already gone.

<center>~ ~ ~</center>

Another moment:

We were having dinner at a little place in her neighborhood. I forget what I was sharing, but I clearly remember she turned to me and said,

"Always leave some mystery Amara; there needs to be mystery in the way we move."

I have never forgotten that moment.

<div align="right">

Andrea Davis
Paris, FR

</div>

Andi asked Gabrielle a life-changing question in 1989 at her very first workshop, "Heartbeat": "Will you be my teacher?" G's reply was, "Go where I go…" And she did.

Gabrielle told me that,

"I will dance you out of your eating disorder," which she did. I turned it into Ritual Theater and it became art. She said,

"Words and therapy are not the best therapy," a radical idea at the time.

<div align="right">

Andreas Tröndle
Frauenfeld, Switzerland

</div>

Andreas met Gabrielle when he was a youth chaplain in a Catholic church. She was the dangerous black Raven who changed his spiritual search into a wild and never-ending journey to inner freedom.

I want to write about one moment with Gabrielle that touched me in the bottom of my heart, and also deeply touched the other 150 participants in a "God, Sex & the Body" workshop that Gabrielle taught in Hamburg, in the autumn of 2004 (I think).

<center>123</center>

Gabrielle facing the darkest of Germany: Hitler's shadow

This happened in a Ritual Theatre exercise, when we were asked to present "The Father's Shadow." We had so much fun acting out all the hard-working, commanding, emotionless or stonehearted fathers that we experienced in our childhood. Suddenly I heard a clear voice in me that told me to stand up and put myself in the first row, in front of the audience, and to shout with my whole heart the Hitler salute:

"HEIL!"

I was shocked by myself, by how decisive, clear and absolutely fearless I felt myself to be in that moment. It was as if my body had been taken over by a bigger power that was not me anymore. From one moment to the next, all the laughter was gone. And it changed into real fear and shock when Gabrielle asked ten people to stand behind me and support me in repeating full-on: "HEIL!" (The German meaning of "heil" is also "healing"). It was as if we traveled 70 years in a time-capsule back to the year 1934, when Hitler visited Hamburg for the first time.

I could totally feel in my body what was going on in all those people (my parents and grandparents) at that time, when they jubilated and applauded Hitler: All that hope to have a better future, all that superb grandiosity to belong to the chosen Aryan race of the Germans who were determined to rule the world. And especially to have in Hitler the real leader and father who would let them forget all the humiliations that Germany suffered after the first World War.

With the repeating Heil-shouting in the room, some people got to the point of freaking out. They wanted Gabrielle to stop the whole thing: "It´s enough now…please can we stop it?" But Gabrielle, with her brave warrior heart, did the opposite. She told those anxious people to stand right in front of us and tell us to stop. So some brave hearts stepped out of the audience in front of us and asked with their fearful, polite, smiling faces, as if they would own all the morality and justice in the world: "Please stop this, we don´t want it anymore…"

In that moment my body felt even more energized by a strange destructive power. I started to enjoy their weak wailing and whining. It felt like an injection of superiority and power in my veins. Suddenly I could understand all the Neo-Nazis in the world. They are longing for rejection and moral condemnation. So

they know that they are finally seen and not refused or neglected as they always were in their childhood of absent fathers or overprotecting mothers.

For all of us Germans in the room, it became totally clear that this shadow is still absolutely alive in us and is yearning for salvation. Our parents could not express their shock, their confusion, their grief and their traumas that they suffered in Hitler's regime. And we as their children took everything from them. It lives in our bodies and cells. Gabrielle was brave enough to lift the veil and give us the opportunity to really face the darkest collective shadow of us Germans. And it showed me again how this tiny, fragile woman knew how to deal with the most powerful shadows in our lives. It was one of the toughest healing lessons I ever had with Gabrielle.

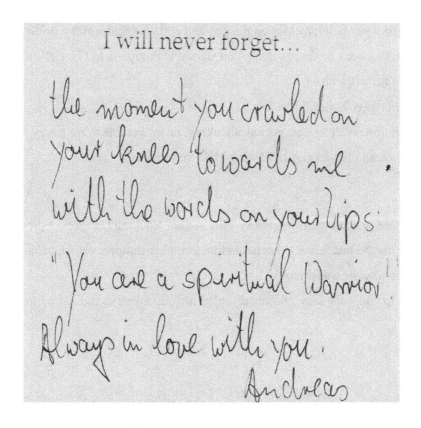

I will never forget...

the moment you crawled on your knees towards me with the words on your lips: "You are a spiritual Warrior" Always in love with you. Andreas

Andrew Holmes
Stroud, ENG

Andrew first danced with Gabrielle in 1994, was trained to teach by her in 1997, and has been devoted to her work ever since.

On hearing that I was a theatre director, sometime in the '90s, Gabrielle said,

"You know that's really what I am too. All this other stuff just happened. But my real work is directing—I just don't often have time to do it anymore."

~ ~ ~

At a residential "Mirrors" workshop, a kiss of the hand we were holding was being sent round the circle. Someone changed it into a sloppy kiss on the ear, and it stayed that way for a few passes. The next morning, a woman who had been on the receiving end started to complain to Gabrielle about what had happened. Gabrielle cut her off with,

"We've all been raped, honey."

It seemed then, and still now, such an unexpected, shocking, unanswerable thing to say—confirming my sense that she operated on another level than anyone I had met before.

~ ~ ~

Someone who had danced with Gabrielle a little started teaching her work. Sometime later, perhaps feeling bad about it, or maybe just hearing that he had incurred her disapproval, he came to ask if she would give him permission for what he was doing.

"I can't give it to you," she said, "because you've already taken it, and it's no longer there to give."

Anna Vitalia
London, ENG

Anna began dancing the 5Rhythms in London at the age of 16, and went on to train and dance closely with Gabrielle around the world for many years, completing her Teacher Training in 2008.

I remember being with Gabrielle in Devon, England, and making her a bowl of raw, green soup. She remarked how she loved it, but that the vibration was too high for her, because she was already so light and ethereal, she needed more earthy and grounding foods. I could certainly relate to this. During the same trip, she mentioned to me how she found me mysterious; I think we were reflections of each other in some ways.

There was another time at a workshop when she was having a portrait photo taken of her and the photographer asked her to relax and be sensual, and she said,

"Well I'll just look at Anna then."

Anne (Downes) Ribolow
New York, NY

Anne is the creator of Radiant Aging and often supported Gabrielle as her personal intuitive body worker.

1989: New York was a far cry from my life in New Zealand where I had spent my first 33 years, living in a small beach town. Four years later, I came across Gabrielle Roth's music, its essential essence anchoring me to a semblance of earthliness in a city that vibrated at a million miles an hour. I allowed myself to surrender to the Great Spirit flowing through me, massaging my clients as her sacred tribal music wove its magic spells. Little did I know that through this connection, the web of life was set in motion.

I saw her speak with Louise Hay, all of us arising from our seats to dance, captured in the dynamic wave of the 5Rhythms. Two years later, laughing hysterically while playing a game called "Silly Buggers" with my husband (which entailed crushing each other's rice cakes to smithereens and stealing each other's prized chocolates) on a plane from California, bound for New York City, I turned to my left and to my great

surprise, Gabrielle was sitting next to me, reading a Vogue magazine. I overflowed with genuine outpourings of my admiration for her, lighting up those dark chasmic ("chasm" meets "cosmic") eyes she bore. She asked me what I did and I replied, "Massage." She said,

"I love massage, do you have a card?"

When we parted at the airport in New York, I shook her hand and she said,

"I'll call you next week."

I learned later that the reason she contacted me for a massage was the feel of my hand. The following week began what continued for many years, my relationship with Gabrielle as her masseuse. For me it was the pinnacle of my career, being transported to nirvana on a weekly basis as music boomed and Spirit healed. Dancing the 5Rhythms came next. One evening I brought my son, Douglas Drummond, along to COSM (Chapel of Sacred Mirrors), where her son Jonathan taught. By chance, Gabrielle was teaching that evening. Doug danced so hard he ripped the backside of his pants! An introduction followed and so began their close bond, and our two sons became good friends.

Jonathan introduced Doug to his beautiful sister, Lucia Horan, and sparks flew! She had my blessing the first time we met, both of us resonating together in a soulful connection. Doug went on to become a 5Rhythms teacher. Seven years later, they were married in Hawaii. Today, December 12th, 2018, is the 1st Birthday of their daughter, Olivia.

The last time I massaged Gabrielle was at Esalen, her final workshop before she passed. Over dinner one evening, she looked across the table at me and said,

"The most important thing in this life is to be of service."

My heart is full of absolute love for this powerhouse of a woman, Gabrielle Roth; her legacy continues to live on in the web of my life.

Forever grateful,

Anne

Anne Marie Hogya
Victoria, BC

Anne Marie began her dancing path with Gabrielle Roth in 1999 and has been teaching the 5Rhythms since 2008.

I completed my Master's degree in 2004, and my thesis investigation was on how to introduce the 5Rhythms into organizations. On January 5, 2004 I interviewed Gabrielle about this subject and I later transcribed the interview.

What I still remember about that conversation, which was 17 years ago, was her ability to simply, clearly, fiercely and profoundly get right to the heart of the matter. After a lengthy phone call, her last words to me were:

"What is most important is to get over yourself; it is not about *you*, it is not about you at all, it is about communicating *with* who you are in a context that they understand you. It is so NOT about being rejected; it is service, it is about community service. Period. End of sentence. 'How do I serve this particular community and enhance their ability and, using the 5Rhythms, give them whatever tools they need? I am sharing my toolbox with you so that you can have a better time.' If that is my intention, then I will go about sorting out how to do that, but if my intention is something about myself, then I am in trouble. If my intention is that I want you to like me or I want you to pay me a lot or I want you to whatever, if my intention is *anything* other than serving the community that I am being invited into or that I am approaching, then forget it, it is all about you and you may just as well go back to ground zero."

Amen, Gabrielle.

Laying it down.

Those words still influence me.

Ariel Karass
New York, NY

Ariel is an Israeli immigrant who discovered community and belonging when he met Gabrielle, and was eventually certified as a 5Rhythms teacher.

Gabrielle was unlike anyone I had ever met before. She was radical, charismatic, and hypnotic, and was a force of nature who was both humble and relatable. She never stood above anyone and always made her students feel connected and equal.

In February of 2008, I was helping Jonny & Amber Ryan (Jonny's wife at the time) move out of their Williamsburg apartment. Gabrielle was there too.

"Jonny, don't forget the…"

"Ariel, you're probably so hungry, can I go get you something to eat?"

"Jonny, are you gonna be okay driving the U-Haul truck into the city?"

That was the first time I saw Gabrielle, my teacher, as a normal, loving and attending mother. Just like my mother.

This new perspective of Gabrielle, outside of her role as a teacher, was a little "Aha!" moment for me. I saw her as a loving mother and vulnerable, and it reminded me that we are all human beings after all.

I'm so grateful to have known her and to have been shaped by her teachings.

Vincent "Arjuna" Martinez-Grieco
Portland, OR

Vincent is the designer of Soul Motion, a conscious dance practice, and was there with Gabrielle in the early days as a Core Faculty Teacher and ambassador of the 5Rhythms.

I remember a time in the early '90s at Esalen, at the end of a workshop. I had this gift that I wanted to present to Gabrielle, so we went off to the side alone. It was a wooden figure, about three inches high, of a medicine person. It wore a black outfit and was slight of build with long black hair. You get the picture, right?! It was so reminiscent of the Raven. I recall being all excited and thrilled that she was going to open it and see what I had found for her. She opened the box and took the figure out and its left arm was broken, probably from the flight there from my home. Shit—imagine my crestfallen energy. She saw this and whispered to me,

"No problem Vinnie, we all come with broken parts."

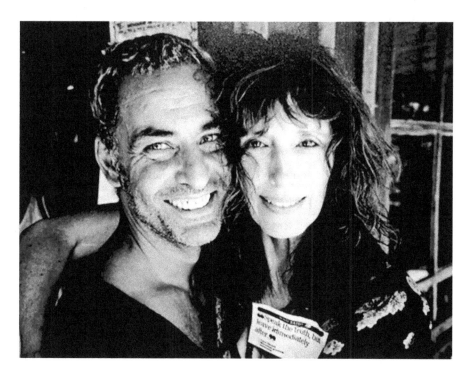

V & G!

Bella Dreizler
Sacramento, CA

Bella began dancing with Gabrielle in 2002, was certified to teach in 2008, and continues to enjoy visits with her in the dreamworld.

Only been dancing a year…really, I just wanna dance but there's this exercise they make us do every day called "Repetitions," and best I can figure, you and someone else get up in front of 25 people and say meaningful stuff to each other…I am entirely clueless…when it's my turn I stumble up there, breathless and scared shitless…the expression "deer in the headlights" would be totally apropos here…I stare at my poor, also-clueless partner, and I can't even remember if even one cogent thing emerged...from my mouth or hers.

Gabrielle, this woman who holds some keys to a kingdom I am desperate to enter, this woman who has moved me light years in one short year of practice…she just languishes there, draped in black, stillness personified, bored to tears...and when the torture episode reaches its conclusion, I look over at her, just wanting permission to slink back into the group, and those eyes, those eyes pierce right through my ancient armor and she says two words that take me on a journey that is still unfolding now, 16 years later; two words that sum up a lifetime, two words that outline my healing path. She says,

"You're defensive."

It is an astounding, life-changing experience, leading to a painful year of humility as that message truly sank in, even though I immediately knew it to be true. It had just never been named. As the years went by and I danced weekly and moved through one workshop after the next, the root of this defensiveness became utterly clear. How else does one survive a raging-father childhood? Coping strategies get established at such a tender age. Without well-developed fortification I would never have made it through, nor embarked on the ongoing healing of this relationship with my papa.

Bettina shares the same last name (plus an e) as her teacher and spirit sister Gabrielle, and the love of black. She offers her passion of the dancing path worldwide.

This came at a time when I was at a big crossroads in my life. I still hear her voice in my being.

August 2000: I was still living in Berlin at the time and had met a man in California who asked me to marry him and move to Vancouver, Canada. During the month-long 5Rhythms program in California, Gabrielle watched me struggle on the dance floor: my body was throwing itself back and forth, my heart was terrified and excited at the same time, and my head was trying to stay in control. "To leave Berlin and follow him to Vancouver or not" was the question of the moment.

After the dance, she pulled me aside and said to me with her very amused voice, chuckling,

"Baby"…that's what she called me often…long pause and giggle…"This is not a head decision, trust your heart for this and follow where it wants to go. Don't work so hard"…more giggles.

As soon as she said those words, I started sobbing and felt the longing and love for the man. My head surrendered, my body softened. I booked a ticket to see him in Vancouver the next day. I moved for good within a few months. I still live and work in Vancouver even though he and I are no longer together. We have two beautiful children and Vancouver became my home.

Many times in my teaching career I have been mistaken for being Gabrielle's daughter. We share the same last name (even though mine proudly ends with "e"), a petite body frame, a love of black, a sultry voice, and a slender, cat-like way of moving.

When I asked her how she would like me to respond, she whispered:

"You can say I am your mother, yes—or even better, your sister, or that we are related in spirit. You pick. It's all true."

She then gazed into my eyes and rested there for a few moments. I felt the kinship, the sameness, the void, the power of her being.

Shortly after she died, I traveled to teach at Hollyhock, a retreat centre on Cortes Island, BC, Canada. When I arrived, the lovely blond woman at registration burst out:

"Oh welcome Ms. Rothe…how is your dear mother doing?" I gasped, then found my voice and replied quietly: "Thank you for asking. She passed a few months ago and she is doing well."

I left it at that.

~ ~ ~

I met Gabrielle at Esalen Institute in the mid '90s. Whenever she would teach at Esalen, I did my best to be there. After we found out that she was progressing in her illness, someone at Esalen tipped me off that she was expected to teach for the 50-year Esalen Anniversary in May, 2012.

I was one of the first people to sign up as soon as registration opened. I called my mother in Germany and begged her to come too. There was no question in my mind that we would be there together with my two daughters, three generations of Rothe women to honour Gabrielle.

One week before the Esalen retreat I called their office to check in about our accommodations. To my horror, I was told rather harshly that my mom and I were not registered and that the workshop was sold out. After hours of talking to what seemed like dozens of fairly incompetent office workers trying to troubleshoot, I called a 5Rhythms friend of mine who was close to Gabrielle. He said: "Contact her, you need to be there. This may be her last workshop."

I hesitantly reached out to her explaining the situation. Within hours she got back to me. Her email read:

"I added two to the number of participants. Cool huh! You should be hearing from them. Keep me posted and see you there. Love you, G."

It was the last time I saw her.

Brian Simerson
East Hampton, NY

Brian is a globalist performer, choreographer, composer, and director, having met Gabrielle in 1994, forever blessed by her wings of unconditional spirit, soul, and love.

Gabrielle in a "New York Minute"

I can remember always having "Meetings in a New York Minute with Gabrielle." Many times I would travel across New York City just to have five minutes with her, to share a hug and a chat. One time I remember meeting her in the East Village, just as she was leaving her son Jonathan's apartment, because they were doing work on her and Robert's loft in the West Village.

She said that we only had ten minutes to chat because she was catching a flight to Los Angeles for a 5Rhythms workshop. I hopped into the taxi with Gabrielle and rode with her to the next destination for our catch-up meeting. One question stands out clearly in my mind. I asked, "Gabrielle, you're going to Los Angeles for a week and all you have is this little black bag that you carry on your shoulder? Where is all your stuff?" She responded,

"When you pack light, your life is a lot easier. I have one change of clothes, a black pair of dance shoes and a little lipstick. That's all one ever really needs."

Sage words from a master.

Gabrielle, Donna and Passion

I was performing with MOMIX in New York City, and I invited Gabrielle to our show, "Passion." She told me that she was bringing a surprise guest and would see me afterward in my dressing room. In this particular piece I would interpret Jesus and actually get ceremoniously crucified, naked on a rope 20 feet in the air, so you can imagine how very dramatic a show it was for me. But knowing Gabrielle was in the audience always brought light, ease and grace to my performances, and a sense of calmness and healing flooded the theater and my work that night. I felt like I was dancing for one of the highest spiritual beings I'd ever known—an unforgettable moment of my career.

After the show, Gabrielle made her way backstage to my dressing room and knocked on the door.

"Brian, it's Gabrielle, may I come in? I have someone I want to introduce to you."

I responded,

"Gabrielle, I'm completely naked, but of course come in, I want to see you."

So there I am, completely naked, standing in a dance belt, sweating from the show, makeup running down my face and my hair full of gold, shimmering glitter. Gabrielle says,

"I'd like to introduce you to Donna Karan."

I gasped, completely in shock. Donna says,

"Brian you are amazing. You are a rock star."

Gabrielle and Donna came over, completely hugged my sweaty, glistening, naked body, and I completely surrendered as Gabrielle insisted on embracing me closely. She accepted everyone for exactly who they were and in every moment of their lives. Donna explained how she had never seen a performance like the "Golden Crucifixion" and spoke of the radiance I had sent out to the audience. It was one of those moments in my life I remember strongly, a complete honoring and recognition of not only me as an artist in my most vulnerable state, but also the acceptance of true spiritual beings and soul family, connected and reunited.

Are Those Tears Real?

At another workshop with Gabrielle there were about 200 people dancing together on our first day. After about two hours, I noticed a woman pull away from the group, go off to the side, and begin to hold her head and cry. Gabrielle stopped the entire workshop and went over to the woman and asked her,

"Are those tears you are crying real?"

The woman looked completely aghast and surprised as she pulled her head up from her hands and found Gabrielle looking at her. Gabrielle said,

"If those tears you are crying are real, then okay, cry as much as you need to, but if those tears are not real and you're just calling attention to yourself, then get up and dance it out."

A gasp of 200 people was heard throughout the entire room, reacting to Gabrielle's bold statement to this woman who was obviously in turmoil. Gabrielle's words, though, came from a place of observation and non-judgment—only love. You realized she cared for every single person in that room and knew that all that the woman needed was an acknowledgment and nudge to get up and dance her feelings out.

Amazingly enough, the woman smiled, pulled herself together, and returned to the dance floor. The drums started up again, and this woman moved and sweated through her tears and pain and danced her ass off for two days. It was an amazing moment to witness and experience, and recognize that Gabrielle was aware of everyone, and made each person feel unique in who they are and what they contribute to the world.

photo by Robert Ansell

Bruce Werner
Muir Beach, CA

Bruce met Gabrielle in the late 80s, traveled continents together, and, as he put it, "We vibed well."

I met Gabrielle in 1987 or so, in Cambridge, Ma., after she spoke at a bookstore. While lingering outside she asked me if I knew of any good restaurants. I did. On the way there, she reached into her handbag and took out a joint. I looked over at her and said, "I think we are going to be good friends." Two post-Punk rebels dressed in black leather and sunglasses, we would delight each other in new music and fiction as we slouched toward middle age. This continued until her untimely passing.

One time I had just repaired Robert's drum, Bertha, for the second time, and drove it to New York. They took me to dinner in midtown. As we walked back to their place on a beautiful summer evening, we passed an outdoor cafe with people sitting, eating and enjoying the weather. Suddenly Robert got animated and said, "Did you hear that? That woman just said, 'There's Gabrielle Roth.'" Gabrielle looked at me and said,

"Yes, and the guy sitting next to her said, 'Who's she?'"

I don't know why, but I have never forgotten this funny scene among many others over the years.

Carol-Renee Pierpont
Santa Fe, NM

Carol-Renee was a long-term resident at Esalen.

This is Gabrielle's inscription in my copy of *Maps to Ecstasy:*

Translation:

Dearest

I only wrote this book because I can't scramble eggs. Enjoy...

Love

Gabrielle

Caroline Kohles
New York, NY

Caroline is a Nia Trainer and 5Rhythms teacher. She met Gabrielle on the dance floor in 1996, appeared in G's videos and helped her with the 5RRO project.

We were a small group, maybe only four of us—which was unusual—rehearsing at some dance studio downtown New York City. It wasn't where we usually had classes. Gabrielle was creating a piece and wanted us to improvise, which I love to do, but nothing was coming to me, and I mean *nothing*. Finally, I just stopped moving my body—which was unusual for me. She didn't skip a beat. She sauntered over towards the barre in her swirling circular fashion and whispered to me,

"Some days are diamonds, some days are stones."

I realized I was free to sparkle or just be still. It was all part of the dance. It completely changed my approach to improvisation. I no longer had to arrive—I could just be.

~ ~ ~

I invited Gabrielle to join me for a lecture/demo at the 92nd Street Y, given by dancer and choreographer David Parsons. He asked for a volunteer from the audience to demonstrate improvisation. Gabrielle said to me,

"Go up there."

She was my director. I responded immediately. I stood up and started my 5Rhythms dance improvisation on the spot. I flowed from my seat in the audience and swirled up the aisle, up the stairs and across the stage. Once on the other side I began to move with the other dancers in the company and at one point I was lifted high up into the air and then gently put down. I danced back to my seat the way I came—completely empty and beaming. It was amazing, a seamless moment in time that we shared that would not have happened without her.

~ ~ ~

Once when I was dancing Chaos she walked by and whispered, "You know, there's nothing you need to get rid of."

~ ~ ~

I once asked Gabrielle if I could teach a NIA anatomy session during the 5Rhythms Teacher Training. She was intrigued when I said, "Learning about the design and function of the human body might help prevent injury." She gave me 30 minutes. After the session she thanked me, but said,

"There is so little time. I *use* the body but I'm actually not that interested in the human body. I'm fascinated with the soul. The body is how I get to the soul. I want to spend my time on that."

~ ~ ~

My husband William and I were thrilled to have Gabrielle officiate at our wedding, where she offered this:

A Blessing for Caroline and William

May you cherish one another.

May you rest in the silent space with no need to fill it.

May you never get so lost that your sense of humor can't find you.

May you be as gracious with each other as you would be to an
 honored guest in your home.

May your love for each other always be greater than your need to
 be right.

May you not be scared of each other's shadow or threatened by
 each other's light.

May your relationship be fascinating, funky, fertile, feisty, and forever.

May you dance in the divine dream of LOVE and never wake up.

—Gabrielle Roth Sept 4, 2000

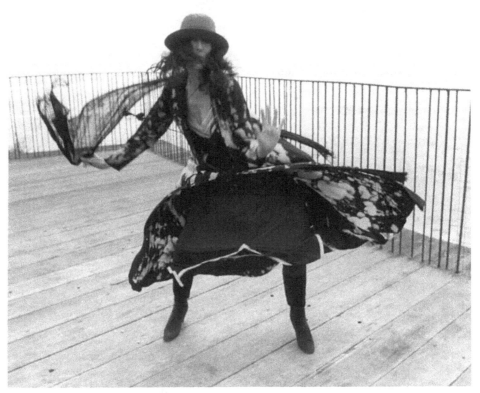

photo by Robert Ansell

Chris Connors
London, UK

Chris is a Creative Director, 5Rhythms teacher, and supported Gabrielle to expand into the visual world via her website, films…and of course, her outfits!

I went to the "Mistress" party during "God, Sex & the Body" in New York City, dressed in a black shirt, black jodhpur pants, some jewels and three black scarves. One scarf became a turban, another a shawl and the other a wrap dress. Not to mention some of the finest Nars Black eye make-up. G made a beeline for my black Annie (Anne Demeulemeester) patent pointy shoes…turns out we had an obsession for the same designers. It was the beginning of a fabulous fashion lyrical friendship. And a real soul friendship. She liked people who turned out well and turned inside even more.

~ ~ ~

G was all about the detail. We would plan to meet at Barneys NYC to look for some Annie as we both called her. Both fashion obsessives with a yearning for shades and shimmers of black, Annie was our most revered designer. A Belgian high-fashion Priestess. G would often bow down to her mastery and craft as a champion of the androgynous masculine/feminine world. That day we both studied one hat and one meticulous handmade jacket from 1pm to 2:21pm. Every stitch, every detail, every way to try it on. Micro-Staccato. Obsessed and exhausted (!) she turned to me, saying,

"I need a glass of deep red to get through this,"

so we headed to Fred's for one of the finest merlots. Of course, we couldn't let those pieces go, and went back in: She got the jacket, I got the hat.

~ ~ ~

It was late 2001 in the aftermath of September 11th, with the world of strict security, restrictions and red/amber codes entering our frozen psyches. A world of fear and control to ensue. I remember talking to G over our favourite food at Omen in Soho about this and my life growing up in a war in Belfast. Bomb scares. High security and a life of repression and restrictions, and how the 5Rhythms transformed everything. She took one sip from her bowl of miso and looked up at me, saying,

"Oh honey, we are all going to be catching up with you soon."

143

<center>~ ~ ~</center>

After one of the deepest darkest and dramatic pieces of Ritual Theatre to emerge from Mirrors in Hamburg, a triptych of Nazi armies, Jewish resistance and numbed-out bystanders, we all laid out afterwards, exhausted, weeping, empty—doing the work for the constellation of our ancestral stories. Two hours of pure sweat. As we all began to lift our soaking heads, G turned to us all and said in her driest tone,

"Well, as the rather fine English would say, let's all go have a nice cup of tea." She looked over to me with a wry smile. So elegant. So hilarious.

<center>~ ~ ~</center>

Filming for her documentary towards the end of her life, I watched her give everything to fulfill her legacy, and I could feel her frustration that her work was not finished and life would take her soon. She was a true perfectionist.

<center>~ ~ ~</center>

I was in NYC for her dying days; it was one of the most beautiful times, just before Hurricane Sandy came. Myself, Tim Booth and Emma Leech, huddled together in JivaMukti yoga centre as she Flew. It was flowing staccato chaos lyrical and stillness in one breath.

<center>

Did you really think this practice

was about dancing?

—Gabrielle

</center>

I will never forget...

The silver desert in your eyes!

Your disappearing act - talent!

Your gentle voice

Your beautiful smile

vulnerable - moments

laugh

drinking Cabernet, eating artichokes
+ Shopping

Christine Havens
Bainbridge Island, WA

Christine was in the first year-long Teacher Training in the mid-90s, taught 5Rhythms for over 20 years, and now teaches for Open Floor International.

I was dancing with Gabrielle at "Cycles" in Hawaii. We had just completed the day on "Mother." My own mother was wonderful and was always so busy doing everything (canning, sewing, cooking, cleaning, teaching pre-school and tending to four daughters) that sometimes I just wished for more time alone with her. I guess that showed on my face and body when I did my theater piece on "Mother."

After the workshop ended for the day, we were all standing in a circle and were asking what everyone wanted to do next. Lots of opinions were called out, and Jonny wanted to go eat Thai, I think. Then Gabrielle turned to me and asked,

"What do *you* want to do?"

I said I thought I'd just walk around the corner and eat in a simple place because I was tired and did not want to drive right then. Gabrielle said to me,

"I want to do what you want to do. I will come with you."

I don't believe anyone had ever said to me: "I want to do what you want to do." It was a revelation to me. So Gabrielle and I went to the little cafe. We sat down, but upon looking at a menu, I realized I did not find anything I wanted. Gabrielle agreed with my assessment. So I asked her if we could just join the others at the Thai restaurant. So off we drove to join the others. But Gabrielle's love had seen my need and reached out to me and that changed something inside me. It is a moment of kindness seared in my memory.

Christopher Boylan
North Yorkshire, UK

Gabrielle and Christopher met at a Mirrors workshop in 2003. It was a beautiful day.

I trained as a 5R teacher with Gabrielle and later with Jonathan to teach "Heartbeat." Her faith in the healing power of the practice was immutable. On my Teacher Training somebody asked how to find a good therapist. I felt uncomfortable. I had been dancing with my own wounds for nearly a decade and, for me at least, therapy would have really gotten in the way. Gabrielle stood up, quietly, calmly, and said,

"I have never referred anyone to a therapist."

Clay Henley
Chicago, IL

Clay has been dancing since 1989 when "Gabrielle helped save my life," and he is now the oldest 5Rhythms teacher in the world at age 80.

In the mid 1990s, at a month-long intensive in northern California, the warm-up was completed and one of the attendees commented that he HATED the warm-up music. Gabrielle looked at him, paused, and said,

"I would love to see your 'I HATE THIS KIND OF WARM-UP MUSIC' dance."
He did, and it was one of the better anger, staccato, edgy, defined dances that I have ever seen. What I learned from that was to just forget what the ego is judging, do the dance that you are feeling and move on.

~ ~ ~

My first contact with Gabrielle (late 1980s), ended up with her telling me,
"YOU CANNOT DO THIS WRONG."

That was so far from my life experience and model of judging and being judged, I was stunned. What I learned from that one was that when I am authentic and not acting out of my many ego characters, I cannot do it wrong: it is me, it is real, and if others wish to judge, let them.

~ ~ ~

In a workshop in 2011 or so, it was not going well and Gabrielle halted the group dancing and asked what was going on. The conclusion was that we were all in our heads and not embodied at all. She asked the group,

"What is the simple solution to correct this?"
After no one came up with "the" answer, Gabrielle said,

"Just dance faster than your mind can think."

~ ~ ~

In the summer of 2007, at a week-long "Silver Desert" workshop in Northern California (Westerbeke Ranch), after one of the morning sessions, Gabrielle said to the group,

"This afternoon, go swim ten laps in the pool."

Wanting to be a perfect student, I went to accomplish that and report back, to receive a "good boy" pat on the head. I noticed that there were very few people swimming or even thinking of jumping into the pool. (Actually, I only saw one other, a senior 5R teacher, doing the laps that afternoon). Both she and I thought it odd that there were so few others doing what THE AUTHORITY had requested/demanded/suggested/ordered.

A lot of issues came up for me around authority: business, military, senior/subordinate relationships, etc. Later, when the senior teacher and I said that the swim had been accomplished, Gabrielle paused for quite a while, and asked the group who else had completed the laps. Very few responded. Then in a very coy and seductive voice, glancing over at me, she said:

"Sometimes you have to question authority, make a decision, do your thing, and let it go."

My learning (at age 65 with 20+ years of 5R experience!) was that I had not yet mastered the ability to question authority when it seemed valid. Still working on it!!!! And may never master it.

~ ~ ~

At a session in the late '90s, Gabrielle was talking about the spiritual aspects of her life, and was having a little trouble putting it into words. At one point she simply said,

"Sometimes the highest spiritual aspect of my life is deciding to gather up the spider I found in my house and putting it outdoors instead of squashing it."

~ ~ ~

About 15 years ago Gabrielle confided in me that there was actually a 6th rhythm, and it was called… "Shopping!"

Your soul is a seeker, lover, and artist,

shapeshifting through archetypal fields of energy,

between your darkness and light,

your body and spirit, your heaven and hell,

until you land in the sweet moment of surrender

when you, as dancer, disappear in the dance.

—Gabrielle

Christina Frith
Bermuda

Christina is a singer of sacred music, and was a dancer in Gabrielle's first video, "The Wave," and sang on the "Waves" CD. She began dancing with Gabrielle in 1985 and has never stopped.

I was 19 when I met you—the magic age of awakening. Beautiful Raven-Mother, how terrified I was of you. You were everything I wanted to be and so far from the mother I knew. On that dance floor my heart broke open, I understood things only a full woman could. New York City traffic zoomed by without a clue. Raven-Mother, dancing circles 'round me, and I, with my hands, trying to begin to move—

"Fall in love, in love with your hands," you called.

Then later, sitting, fearful, against the wall, wondering what to do, you yelled,

"Hey! Christina! You should be doing this! I'm talking to the part of you that paid money to be here!"

Clare Scott McCarthy
London, UK

Clare is a midwife who has danced through life since she met Gabrielle in 1988. She trained as a 5Rhythms teacher, appeared in Gabrielle's NYC theater projects and video, and G's maps now echo in her work as a birth educator and advocate for women.

A friend asked me to go to the St. James Church in Piccadilly to hear a talk about shamanism. I was teaching in a tough, inner-city primary school and felt exhausted, but I remember clearly knowing that I was going to say yes and go anyway.

I thought I was going to some kind of seminar with an anthropologist. Slightly late, as usual, I edged onto a bench in the back. I caught the end of an American woman's voice talking about "movement as a catalyst for healing," and then the next thing I knew we were all standing up and moving our heads—then our shoulders, spines, hips, shaking and rolling. I couldn't see the leader clearly, as I was hiding in the back, but I was so relieved to be asked to move, instead of always being asked *not* to move.

Suddenly the whole place was alive with rhythm and bodies moving up, down, around, and over those pews! Did somebody drum? I can't remember, but I do know that with a few simple words, this slender no-messin'-around shaman-shaker had us all moving, swaying, swinging, dancing, and gyrating all around that cold, old church, like bones were shaking from the dead.

It wasn't very British. Hallelujah!

I never even knew her name, but she made me laugh and got me moving; I went home and fell into bed. That was my first time with Gabrielle.

The second time, a few years later, I was studying dance full-time at Trinity Laban, London; it felt to me sort of like a convent school, full of girls trying to "do their best" and impress the rather stately, older staff. The boys seemed a bit more laid back. I needed a break from this "good-student" dance culture. My friend and savior, Zoe, asked me to go with her to a dance/movement weekend workshop in Hampstead. She promised me it would be different than our Laban days, where I was always late for classes because I was usually quietly crying, locked in a grey, changing-room cubicle, somewhere far away from the next class. I suppose the exhaustion and movement was stirring something inside me. I was ready for change and compassion.

I arrived wearing old black dance leggings and a raggedy T-shirt and was surprised by the array of colourful outfits and unfettered confidence I witnessed before me on the dance floor. I felt so shy and young.

I listened to every word the teacher spoke, and it all made sense to me: relaxing the struggle to follow other people's timing and steps, and having the feeling of shaking up old buried emotions as I danced. I was relieved to find I wasn't alone, that it actually might be okay to feel the sadness falling from my pores each day after having thrown my body around dance studios, hour after hour, for so long.

As we danced across the floor with the teacher's voice guiding us, I suddenly realised that this was that same fucking woman from the church! At the end I went up to her and said, "Thanks, I loved it!" She said,

"And I loved watching you dance."

I remember thinking that I didn't care if she said that to every single person in that room, which maybe she did; it meant a lot to me to feel seen by her. She also said,

151

"I think I am going to know you for a long time," or, "You seem familiar, I think we will see each other again," or something along those lines, which just registered at the time as "weird." (I only remembered it years later, when reading through a notebook I found.)

It feels as if on some intangible level, writing these memories will bring her back: I always feel restless the day after writing, as if I am waiting for an email from her or a postcard. She used to send me beautiful black and white postcards. I have them all tied up with a leather shoelace in an old cigar box. I sometimes check my emails to see if she might be hiding there—a one-liner, a glimpse of her handwriting, a quick "I miss you" note. It takes time to let go of the hope. I usually need some vodka to let go and relax back into routine life. Here I go:

Your Body

At the first workshop I ever went to, in Belsize Park somewhere, a huge room…the way she said (then and always),

"…your body." It blew my mind!

"Let go of your head, move your elbow, find the stories in your hips…"

So simple and so profound, for me anyway. No one ever said "your body" to me, not in the way she said it, which invited and granted self-ownership of one's own body! Oh god, it was such a fucking relief, a miracle, a gift, and a gateway to freedom and empowerment!

"Let your body move the way it wants to…"

Your Head

During the making of one of those early "Wave" videos, directed by a scary woman who had done something for Michelle Shocked, I think, I arrived jetlagged, shy, and surprised to be there, trying to be present and dance, while thinking, "What the fuck am I doing here?'

Gabrielle took a sideways glance at me and shouted,

"CLARE! LET GO OF YOUR FUCKING HEAD!"

Not sure if it worked then or not, but a few years later it truly and utterly saved me: I was in labour with my first baby, in the birthing pool at home; everything had slowed down and the midwife told me to close my eyes and focus. I closed my eyes and instantly Gabrielle's voice filled my mind:

"LET GO OF YOUR FUCKING HEAD!"

I did; I let my head and mind go. I closed my eyes, released my neck, and rolled my head around my shoulders and began to breathe deep. I swear to god, one and a half hours later that baby was in my arms!

Spirit Animal

I once told her that my spirit animal was a rabbit. She looked at me for a moment while getting dressed to teach and said,

"A small, fluffy bunny?"

I nodded shyly and she replied,

"Really? I don't think so…"

I let myself really dance that day. Gordy and Robert were drumming and I found a deeper, fiercer, stronger timeless spirit guide inside my beating mind and heart.

I still like rabbits and I do have four kids.

Teacher Training Project

I was planning to work on a project with special needs kids, culminating in a performance or something to do with teaching and service. I was in G's bedroom one morning, as she was getting ready. She looked at me from under her dark hair, with a not-convinced expression, and asked,

"Why would a primary school teacher, working in an inner-city school, with a diverse and challenging bunch of kids, choose that project?"

I felt relief and excitement as she looked at me in that way she had, kind of off-centre, and said,

"Focus on yourself and performing."

I didn't really understand then that she was giving me a free pass to my own creativity, an escape from the helping/serving thing I was locked into. She said it more like,

"Honey, do you WANT to do that thing you said with the kids? I don't think so. Why don't you perform? And forget the bunny thing too, you aren't a bunny rabbit."

A Memory

Near the end of a Teacher Training session, we were all sitting outside, watching performance pieces. It was getting dark, summertime. I had just finished my offering and was sitting on the grass in our small audience of students. I was totally alert, alive, awake, and also completely dazed. Suddenly, slowly and silently, from behind me, to my utter surprise, Gabrielle's warm body and long arms wrapped themselves around me, black soft velvet raven wings folded around my body, and a soft breath on the back of my neck:

"I love you."

For a second I wasn't sure who it was, and then the gradual realisation of the moment branded itself on my heart. No fuss, no show, silent and still, there and then gone. A forever memory for light and dark times.

Hair Moment

At the studio on that same first video shoot, I was in the changing rooms and came out of the loo to find Gabrielle standing there. Her hair had been kind of kinked/curled/something different, and she was peering into the mirror and saying to me,

"OH GOD! Do I look awful?"

or something similar, can't remember exactly. I was so terrified myself I probably wasn't very reassuring, but it definitely got me out of my own panic, both of us trying to fluff up/smooth/do *something* with our hair in a desperate moment of confidence-loss in a dark cloakroom mirror. A real human moment—those are the best!

Shopping

In London. Gabrielle paying for two Ghost black shirts, as she couldn't decide which one, saying,

"Robert will kill me!"

Really? He must be used to it, I thought, but it was sweet!

Requests not to be refused!

A late-night phone call:

"Honey, can Jonny and I leave our bags at your house while we go to …"
France, maybe? I can't remember the details, except in the middle of my mundane mum day, on a sunny afternoon, with my two little boys fighting and hanging around my ankles, the doorbell rang and there stood G and J with huge bags! Gabrielle in black, smelling of whatever that scent was, wrapping her arms around me and then dumping her bags in my hall and gone in a flash. A sweet skinny black apparition on my doorstep from another world, brightening my day.

"You know being a mom is Holy work, truly in service," she said, as I started to clear away the toys and look in the fridge again, for supper ideas.

That Bran Muffin Recipe!

Oh my god, what was that? I still have it. She loved it or liked being able to eat them while traveling. She used to ask me and Zoe to make them for her in advance of her arriving, and then we had to transport all those little muffins in a box to her at a workshop. They tasted okay, but I was never a baker and I remember that "oh my god she wants those goddamn muffins again" feeling!

Life Philosophy

My boyfriend had cancer or HIV, I wasn't sure which. People around me were saying that stuff about how he had chosen this on a deep level, as if it was something he had done or had control over, and as he didn't, I found it a totally insensitive, stupid, meaningless way of looking at this sad situation. I talked to G about it, who said,

"Look...shit happens!"

She also said something like,

"Honey, don't listen to those goddamn motherfuckers."

It helped. He died.

Fairy Godmother Acts

I had found a housemate dead in his bed; he had shot himself, a doctor, 26 years old, his father was Palestinian, he kept that a secret. I had to meet and talk to his parents. Robert sent me a wooden cat's head for protection that I still have hanging on my front door, and Gabrielle sent me a handsome Manhattan 5Rhythms dancer who was visiting London, to take me out for dinner and to the theatre. He unwittingly chose a great play, with John Malkovich in it, about suicide.

Partners

I was always doubting my choices, my life, worrying that my boyfriend (now father of my four kids and still together 25 years later) was not a 5Rhythms or any kind of dancer. He didn't do yoga or play drums. My crises of confidence in him and myself were always soothed by G saying,

"H is a sweet guy, it's what counts. It's perfect that you have different interests. Make sure he isn't at home too much—that's a downer. Doctors are great partners as they are out at night too; we need space!"

Not her exact words, but perfect meaning!

Hugo, my partner, remembers—he says he will never forget—that when I discovered I was pregnant with our first kid, unplanned, that we went to the cinema with Gabrielle to see *The Piano*. Hugo was in a frozen state of shock and terror about the pregnancy, and Gabrielle told him (25 years ago!),

"It's all gonna be alright! The kid will be okay, you two will be okay, the kid is lucky, you guys are lucky."

All mundane stuff, but anyway Hugo still wants to have "It's gonna be alright" tattooed on his body.

Birth Email

A line in an email from Gabrielle after the birth of my fourth kid and first and only daughter has stayed with me. The world of 5Rhythms didn't always fit easily with mothering young kids, and four meant I was anchored down.

"i am very impressed," she wrote. "four kids! wow - how rich. who would guess that so much love could flow through a skinny white girl. i miss you."

For me four kids were a lot. My chances of workshops in NYC or anywhere were slipping away for the next few years. I did make it out of the house again, to catch Gabrielle teaching in London a year or so before she died. We had tea in a different Holborn hotel; the tea was better, she was tired and thin. And she thought it was her thyroid.

London Squat

Gordy and Gabrielle made a surprise visit to me and Zoe after a London workshop. I was living in a squat; funky and fun, but crumbling. Gabrielle was wearing a black jumpsuit and a leather jacket. She asked where the loo was and I led her through a room with a broken ceiling into a tiny cramped freezing room with the loo in it with a broken toilet seat. She looked completely calm and proceeded to take off her entire outfit. She reappeared a few moments later, elegant and smiling. I was shy and had only just met her. She was very relaxed, which helped! I remember it vividly! Surreal moment.

~ ~ ~

Many Little Moments

Sweat Lodge at Grimstone. I was 25 years old, felt young, urban and not part of the sweat lodge brigade. I had only heard of sweat lodges while studying Social Anthropology. I felt scared and surrounded

by older guys. I did *not* want to sit naked in an old tent with hot stones. Gabrielle must have clocked my silent expression of panic and walked over to me, down the dark path to the dark tent, and once inside, I realised she was sitting just behind me…I was not convinced, but I felt safe.

~ ~ ~

After a workshop in London she was going to the ballet with Lorca; she grabbed me to ask me whether she should or shouldn't wear a thin, black leather tie with her shirt,

"For a ballet."

I said, "Yes, wear it." Not sure if she wore it, but her sweet indecision and brief "Please help" moment seemed so at odds after her full day of confident, focused teaching. I loved the way she moved so easily between roles, stepping out of her teaching power back into her own human, sometimes less self-assured and less confident boots.

~ ~ ~

At a workshop in the Mission District, San Francisco, Jai Uttal was playing. I danced. It was hot. I had been living in Manhattan with Gordy and Zoe, who had just had a baby; Clive and Gay had just had a baby; Eric and Skye were about to have a baby; I had split up with my boyfriend, H, for a boyfriend who was dying, and H had just started going out with one of my friends. I was confused, thin and emotional, and life felt weird. As we all left the venue at the end of the day, Gabrielle found me and just said,

"Are you okay?"

I think I could hardly speak but she just whispered,

"Call me if you need to," and was gone. Her few words made it into my sad, whirling mind and calmed me.

~ ~ ~

At the YMCA in London, Gabrielle standing at the edge of a crowded room in the early days, lines of people dancing three at a time across the room. In my mind she was like Ninette de Valois, Marie Rambert: old school and almost as if she had a cane—tall, slim, willowy, fierce in her knowledge, strict with her instruction, gentle with her advice, no excuses for waving disembodied, floating arms or lack of focus; silent

158

except for drumbeat, breathing and our moving feet. I wanted to stay in that room forever, dancing across the floor watched by her and watching her watch the whole room. A perfect moment in time, etched in my mind.

~ ~ ~

In a restaurant in Camden, winding Jonathan up with her indecision over ordering dinner:

"Salmon or monkfish or not fish or maybe chicken or soup? Do they have mashed potatoes?"

Jonathan with his head in his hands. She wanted to change her order, Jonathan cajoling, laughing. She absolutely did not know what to order. Life with an indecisive shaman!

~ ~ ~

Gabrielle and pizza at the recording studio with Greg and Zoe, at midnight, her listening and asking us to dance: Robert drumming, Gordy drumming and shaking, Sanga drumming. Red-eyed with tiredness, pizza togetherness, crafting the sounds of the "Ritual" CD and other tracks in the cold night studio. Gabrielle's voice:

"Clare, did you eat pizza?"

Like my mum.

~ ~ ~

As I apologised for turning up at her apartment to collect something, she was lying on her bed, recovering from bronchitis after teaching a long workshop. She said,

"If I have to teach this work then at least let me hang out and laugh too—stay, sit down!"

~ ~ ~

She loved the badge I bought for my little daughter, which was pink and said, "It's all about me!" Gabrielle said she wanted to get some to give out at workshops, to remind people it wasn't!

~ ~ ~

"Dancing every day? It's a practice, and great if you can, but who can do that every day? Some days you do and some days you don't."

159

~ ~ ~

Her irreverence for and distaste of over-processing in a relationship:

"Oh God! So dull. Who is going to stick around if there is too much of *that* going on? It kills the moment."

Age

I loved the way she said to me on the phone once,

"It's my birthday. I am turning 70—that is SO FUCKING old!"

It was funny, but in retrospect, gut-wrenchingly sad. She used to say to me,

"Honey, please make me laugh," when she was sick. It used to make me want to cry, not laugh, but sometimes I managed it.

[Claire continues in The Final Journey section, page 311.)

Colleen Saidman
New York & Sag Harbor, NY

Colleen is a long-time yoga teacher, studio owner, and author, and counted on Gabrielle to make her double over in laughter until she had to beg her to stop.

She walks in the room and even the walls smile. Gabrielle immediately makes you feel like you are the most important person in the world, even if there are 299 loose-limbed dancers lost in an ecstatic trance. She captivates and disarms everyone she comes into contact with. When I met her I proclaimed, "I don't know how to dance," to which she replied:

"Aww fuck that, neither do I! Can you move your body? Then you can dance."

She has the perfect combination of badass and twinkle. Her eyes twinkle and her black, knee-high, military lace-up Ann Demeulemeester boots signify her "badass."

Poet and activist Maya Angelou said:

"PEOPLE WILL FORGET WHAT YOU SAID, PEOPLE WILL FORGET WHAT YOU DID, BUT PEOPLE WILL NEVER FORGET HOW YOU MADE THEM FEEL"

Gabrielle made me feel love. Thinking of her fills me with sweet nectar. The memories may fade, but the feeling will always remain near and dear to my heart. We were all blessed to spend time with Gabrielle while walking around in these bodies.

Daniela Peltekova
Los Angeles, CA

Daniela is a poet and business writer who got swept up, rearranged and heart-adjusted by Gabrielle in the early 2000s and has been teaching 5R since 2008.

Do not hide from the dance.

The rhythm will strip you bare, find you anywhere,

String pearls of sweat around your neck,

Entice you free from lazy shells of platitude,

Pull you down from cemented pedestals of saintly-hood,

Run you crazy up and down summer hills of angry ecstasy.

The beat will twist and turn you in the centrifuge of all emotions,

Plunge you in the hidden alcoves of your soul -

Sweet altars you knew not existed, but prayed to find.

Small and shaky as they are, struggling to see the sun,

The beat will cradle them in repetition,

Until they shoot up tall and blast your life

Into a Thousand Beautiful Butterflies.

~ ~ ~

When I first met Gabrielle in person, at the entrance of a dance hall in Kologne, she asked me how I was. I answered: "Sad." She retorted:

"Oh, you are sad TODAY!"

which presumed that tomorrow I might not be. That slight shift in focus was my bingo, full-on, embodied realization of "*panta rei*"—everything flows, everything changes. Gabrielle had the knack of piercing right through you, spotting the deepest "knot" of the moment and untangling it with just the right word or comment.

This happened in 2005. I had been dancing for two intense years and finally had the chance to meet

Gabrielle in person and gladly accept her direct tutelage. As many would testify, she was an intense presence, usually dressed in black, stylish clothes, flowing freely around her fragile frame as if hanging on a thin, wire hanger. Arms open in flight; quick, darting metamorphoses in thought, imagination and dance—just like a raven, her animal totem. Her eyes seeing straight through any surface bullshit, often conveying messages to whomever her attention was directed to with very few words.

The next thing I remember her saying to me was:

"Girl, get over yourself, and just do it."

That line pierced right through my pattern of years of hiding. She continued to tell me that it looked like I was my own biggest hurdle, enemy even, or something along those lines. Oh Gabrielle, I so agree.

Her body gave off the impression of almost transparent frailty, but the energy and presence that she summoned generated an intense, vibrant vortex and inevitably commanded attention, far and wide. She had mastered the art of compelling, unapologetic, powerful presence and self-expression. And we all wanted a part of it.

When I saw her in New York City, right before starting my 5Rhythms training, she turned to my then husband, who had accompanied me to the venue and who looked so much like her—tall, thin, airy, artsy, dark, wavy hair, Jewish nose—and gently laughed:

"Ha, you brought my son, will he dance with us?"

He never did. Two years later we got divorced.

There were many other moments: when I tried to convince her that her 5Rhythms work needed a website (that was in the early days) and a business structure, and she nodded at me, amused; when I went to her house and *did* have a brainstorm session with her around what the website would look like or say; when I was concerned that she looked exhausted and wanted to give her a shoulder rub and, to my amazement, she actually agreed. Many moments, albeit tiny, when I felt intimately close to her. I do treasure them forever, but I also know that her presence was universal and she had the ability to open that special door and invite that unique intimacy with every one of her students—and we were many thousands around the globe.

I'll leave this page with one last vivid memory of her cutting through my jumbled, long, excited explanation about something, some opening or realization that had happened for me in the dance. She said to me:

"You think too much. If you can't express it with two words, even though not entirely accurate, it means that the mind has taken over and the embodied, real, direct experience is no longer direct. You are trying to think it up, devise it, overcomplicate it. Stay with the feeling."

To this day, every day, I'm still integrating that lesson.

Daniela Plattner
New York, NY

Daniela quit ballet and started dancing with Gabrielle at the ripe age of 8. She's now a teacher and brings 5Rhythms to move leaders at companies around the world.

Gabrielle freely sprinkled the f-word into her psycho-spiritual teachings. Her liberal use of curse words elicited humor and made the ineffable more graspable, especially for a second-grader.

During elementary school (when "bad" words were considered a punishable act), Gabrielle's shit-talking was particularly enchanting. Adults weren't "supposed" to drop f-bombs in the presence of kids. She tried to monitor herself in front of me but it rarely worked. After letting one slip, she'd catch herself, put a hand over her mouth and say,

"Shit! I cursed. Fuck!" or just, "Oops! Sorry!"

We'd all laugh.

Then Gabrielle had a stroke of genius. She gave me full permission to use a dirty word IF I learned a new vocabulary word and then combined that new vocabulary word with a curse word to form one coherent sentence. Coolest game ever.

I remember mischievously plotting and scheming on a plane ride home to New York City, scouting out sentences that wove together swear words with smart-sounding vocabulary. I asked my mom and strangers for big words and their definitions. I was elated and proud to learn new concepts and form curse-word-rich sentence constructions.

I ran down the aisle of the plane, eager to share with Gabrielle:

"This is indefatigably fucked up!"

We giggled. She approved. I won the made-up game and strutted back to my seat to continue the quest for more.

This was an early lesson for me that reflects an aspect of Gabrielle's work and life philosophy. She gave me full permission to dive into a "taboo" arena (curse words) and provided a simple structure/exercise to cultivate creativity (combine words in novel ways) that expanded my horizons (new words and thus worlds) and ultimately left me feeling more confident and capable. She brought joy and creativity to a previously "no-no" topic.

Twenty-one years later, as a certified 5Rhythms teacher, I feel certified to curse in the context of the Great Mystery. Gabrielle taught me to dance between grit and grace, horror and humor, and to be able to hold all of it, without shame. For that, and for so much more, I could not be more grateful. I fucking love and miss you monumentally, Gabba! God bless the profane and the profound. ♥

P.S. After I got back from my first Burning Man at 19, I called G and said,

"I was so self-conscious on the dance floor because my mom was around."
And she said,

"You weren't self-conscious, you were mom-conscious!"

<div align="right">

Dat Nguyen
Los Angeles, CA
</div>

Dat designed the 5Rhythms.com website with Gabrielle after meeting her in 2011.

I met Gabrielle near the end of 2011. I had been dancing for a year or so but wasn't really involved in the practice deeply—5Rhythms was just a fun place to dance at that point. It was a Sunday morning class, I

recall, and Gabrielle was teaching. She had us explore Chaos and it resonated with me, because during that time my father's Alzheimer's was getting stronger. After class, I went up and introduced myself and said hi. She asked me what I did and I told her I was a designer and she asked for my business card.

I didn't hear from Gabrielle after that Sunday. A few months later, I went to a showing of *Crazy Wisdom,* a movie about Chogyam Trungpa Rinpoche, at the Rubin Museum. Gabrielle was the guest speaker. After the film I went up to her and she asked me if I got her voicemail. I hadn't. We scheduled a time to meet.

A few weeks later, Gabrielle, Arthur, and Nilaya came to my office in Soho. We talked for a few hours and at the end of our meeting, she asked me for a proposal and threatened to steal my scarf —(it was a nice scarf; I didn't know her well enough at the time to understand that she fancied nice things.) I started working with Gabrielle in early 2012.

It was an inspiring project for me, very different from the corporate clients I was used to, and it was in the direction where I wanted to move professionally and personally. There was a learning curve to understanding the 5Rhythms practice, as I was still pretty new to it, so understanding, capturing, and conveying the spirit of the work was not comparable to understanding the mission of an ordinary business.

I created rounds and rounds of design trying to capture her vision. At one point, she was not happy with the work and voiced it, which left me feeling very frustrated and discouraged, feeling as if I was running around in circles. I asked her,

"Why do you want to work with me, why not someone that has a deeper knowledge of 5Rhythms?"
She replied,

"There's a reason I didn't choose someone like that. I want to reach out to a larger audience, and so I need someone who's new to the practice. You bring a beginner's mind."

I was also typically well-dressed and fashionable those days—I think she gave me points for that! :)

Once, when I had a breakthrough during the design strategy process and said to her, "I understand what you're selling, you're selling 'freedom.'" She looked at me directly in the eyes and said,

"Yes Dat, and I can promise you freedom."

Little did I know!

The last time I saw Gabrielle, she was very weak from cancer treatments. We were almost complete with the design of the website. She told me how important the work I was doing was, that it was the tool that

would help 5Rhythms continue to grow, a portal for the tribe. My very first 5Rhythms workshop was "Slow Dancing with Chaos" in New York. The very next day, Gabrielle passed.

Despite knowing her personally for only about a year, I felt a great loss. I recall her genius, love, passion, humor, presence—I guess that's why she was who she was and great souls have a way of touching you like that. Having the opportunity of lengthy conversations with Gabrielle about the 5Rhythms, I realized that there were students around the world who would have died for that opportunity and I am grateful to have received an intimate, unique teaching/experience of the 5Rhythms (and life in general) through working with her directly. She told me that people come into your life for a reason. I know she came into mine for many and I feel grateful and blessed for them all.

With love,

Dat

PS: I did have a recent vision of Gabrielle. During a shamanic ceremony, I was struggling to let go of fears and trust my own path. I started calling up old teachers for guidance and when she showed up, I asked something trite like, "What makes me happy?" She looked at me and said,

"You called me back from the dead to ask me that?"

Then we had a big hug.

David Juriansz
Woodend, Victoria, AU

David is a graduate of Gabrielle's final Teacher Training, and is the co-Director of Moving Essence, a centre for the 5Rhythms in Australia.

When I came into the 2010 Teacher Training module, Gabrielle was already unwell. She had been for some time. We never knew when she would be coming. But we were so grateful when she did.

No doubt her illness was serious, but it didn't affect her transmission. She was potent, transparent and compelling. I will never forget her discourses when she was leading the group. Significantly I was taken by her humour. My wife Meredith had trained with her a decade earlier and I had been in "the tribe" since that time. So MANY people had said the equivalent of,

"Just wait until you meet Gabrielle!"

But no one had warned me how funny she was. I was in stitches often. I loved it. I loved her.

As I listened with intent, I was drawn to the occasions when Gabrielle would sing. Maybe it was one or two lyrics and she was not bothering to nail the melody—simply to embellish a story. I think it was because I was a singer-songwriter, I really loved those moments, and I would have loved to tell her—to compliment her. Every student wants to "be seen" by the teacher. It's natural. But for most of my fellow colleagues, two things were at play:

Firstly, most of us were shit scared of her powerful presence, so even approaching her felt scary. Secondly, as we all knew Gabrielle was unwell, we were already under instructions to give her some space. Most of us were grateful just to have her in the room with us as much as we did.

One night I arranged to have dinner with Kathy and Lori and was surprised when I arrived to discover that Gabrielle was coming too. I had that quiver of excitement. Informal, relaxed, "out-of-shop time." How lucky was I?

It was a great night. We talked a lot about the appalling state of the nation and how the financial sector had held the country for ransom (post-Wall St. crash). We discussed favourite movies. A little wine lubricated the conversation and by night's end we drifted into favourite topics around creativity and the work we are all drawn to.

The moment felt right and I took my chance:

"Gabrielle?—I have a special request…I'd like you to sing more."

Gabrielle seemed taken aback and surprised:

"Oh really? You like it when I sing?" She seemed curious to understand my request.

"Yeah, I love it when you sing—you have a nice voice, it's really natural and helps convey the story." She took that in carefully and nodded.

"Okay, I will."

The night continued on.

The next afternoon, back in the training session, Gabrielle was in full flight. We were all glued to her every word and every movement as before. At one point she was talking about Ego and how we are trapped— all of us caught like robots in our mechanistic operation. She paused and her eyes glanced upward. It was almost as if our thoughts collided across the room.

In that moment, I connected with that part of her that I had recognised earlier— downloading, connecting to a song.

Would she, could she? And…if so, what?

In an instant she opened her stance, assumed her Pink Floyd rock guitarist posture, and passionately sang:

"So Wel-coooo-oome…..to the Ma-chineeee."

I think most of the room was shocked. She looked to the back of the room, saw my grinning face and smiled, then turned and addressed the group:

"I've been told I need to sing more," she said sweetly.

And continued on…

Davida Taurek
Sebastopol, CA

Davida is a psychotherapist, began her dancing journey in 1989 with Gabrielle, who told her in 1994 to teach the 5Rhythms, which she has been doing ever since.

From the first time I met Gabrielle in 1989, she has been my teacher, mentor, mother, friend, and rebellious sister in the dance. With a sparkle in her eye and a mischievous smile on her face, she invited me to New York to dance and join her theater company. I moved within two weeks and stayed living in New York for the next ten years. There were countless dinners, afternoon teas (Earl Grey with half & half and honey of

course), and late-night drinks with laughing spells woven throughout. It is hard to narrow down one story to encompass my relationship with Gabrielle, but one that stands out most is when she reached in and opened my heart to the nature and value of family.

As I started teaching the 5Rhythms, Gabrielle would often come to my classes and totally surrender herself as my student. She was indeed a shapeshifter. After class one night, we were out to dinner and she could tell something was amiss with me. Earlier that day I found out that my father was told he had a year or so to live. I really didn't know what to do, but it did not occur to me to move back to California to be with him. I loved my life in New York. I had my tribe, my friends, my work, and the dance. As we sipped on our wine, Gabrielle slowly reached out and took my hand. Her long fingers surrounded mine. She gently squeezed, looked deeply into my eyes and simply said,

"You have to go be with him Davida. You will regret it the rest of your life if you don't."

It was that moment my life took a very different turn than I had planned. As much as I missed my tribe in New York, the time I spent with my father was precious. Of course, before I left we had a glorious going away party at Leon's 6th-floor walk-up downtown apartment. You can read the rest of that story in the *Sweat Your Prayers* Epilogue by Gabrielle, where she eloquently describes the "Ghost Dress" she gave me and tells of our dancing New York tribe that extended out to all parts of the globe.

~ ~ ~

Gabrielle and Robert were such a large part of my life, and still are. My heart is forever touched, my life forever affected. And there were certainly more times than not when Robert's sexiness and awesomeness of being a husband was the centerpiece. :-)

I remember when I was helping clean out Gabrielle's closet, not an easy task! But most definitely a privileged one, because who did not want to step into that closet?! Gabrielle expected you back home, Robert, but you didn't arrive on time, so very unlike you. Fifteen minutes later, she was getting concerned. A half hour later, she was almost in a panic. Tears were in her eyes, and at that moment I knew how much you were not only a part of her life, you were a part of *her*.

I stood in awe of how deeply connected you were, and still are. It was a very humbling moment for me to feel the depth of connection you had. I attempted my best to soothe Gabrielle's worried soul, assuring

her you would be home soon. When the front door finally opened, we both exhaled and realized we had not taken a breath since she noticed you were not home.

I was always so happy to see you Robert, but never more so than on that day in New York City.

Deborah Bacon Dilts
Santa Cruz, CA

Deborah has been dancing the 5Rhythms since 1991 and teaching since 1998, and is grateful to have had the opportunity to open that amazing door for many people around the world who might not have found the 5R otherwise.

In 2005 at "Heartbeat" training in New York, we did an exercise where we would take someone's hand, walk together, tune into each other, and share a word or two about what we felt. I found myself walking with Gabrielle. We walked a few steps and she whispered to me:

"So very vulnerable."

And a few steps later,

"And so scared of it."

Bingo.

The fastest, cleanest, most joyful way to

break out of your own box is by dancing.

I'm not talking about doing the stand-and-sway.

I'm talking about dancing so deep, so hard,

so full of the beat that you are nothing but

the dance and the beat and the sweat and the heat.

—Gabrielle

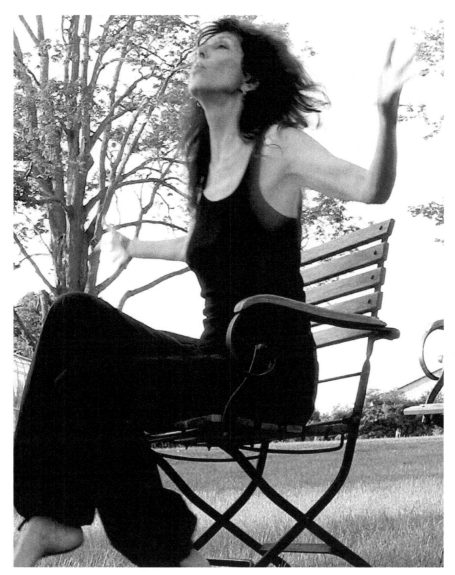

photo by Julie Skaratt

Deborah Jay-Lewin
Findhorn, Scotland

Deborah first danced with Gabrielle in 1989 and was bullet trained into an unequivocal fascination of energy in motion. Every time she teaches she still wears Gabrielle's quartz bracelet that Robert sent her.

The year was 2000, the place was Sausalito: the first five-week "On The Road" immersion with Gabrielle. A large group of us stood in a circle in this huge gymnasium, and if I recollect correctly, the fabulous Morgan Doctor was seducing us onto the dance floor and into a space of deep surrender. Out of the corner of my eye I saw Gabrielle move in on one of the dancers who was…stuck? lost?—something. My whole being was called to attention as Gabrielle did her magic, and catalyzed and midwifed this dancer into an unknown zone. Something in me said, "That. That. That is what I am called to."

Gaunts House, Dorset, UK. It was the 1999 "Mirrors" and I was doing the "Repetitions" exercise, my first time up in front of the group, totally clueless. From her chair, Gabrielle spoke to me:

"You're wearing black nail varnish on your toes."

"It's dark blue," I said to her.

"You're wearing black nail varnish on your toes."

"It's dark blue."

"You're wearing black nail varnish on your toes."

"It's dark blue."

"You're being pedantic."

"What does pedantic mean?"

It took me some months before I realized that Gabrielle had been trying to teach me. How many times did she try to teach me something, obliquely?

I frequently felt utterly clueless in Gabrielle's presence. My soul? Ever hungry for more.

Dilys Morgan Scott
Torque, United Kingdom

Dilys was a Circle Dancer and traditional English folk (Morris) dancer who was star-struck by Gabrielle in the first UK Teacher Training in 1989, and has been teaching the 5Rhythms and creativity ever since.

I never really got to know Gabrielle, but I certainly got to know and love myself better from knowing and loving her.

In the first training, at Grimstone Manor, in 1989, G talked of "the dark night of the soul" and I immediately started crying. I recognized that here was a place for me. During that training, one day G arrived in the room wearing peach-coloured clothes. I had only previously seen her wearing black. I had the audacity to say to her, "I don't think I can learn from you in peach!" She laughed and later, much later, she remembered me saying this and, with a smile, announced it to a workshop audience of many—I remember blushing!

An occasion when we were working with the "Heartbeat" maps, there was a piece of theatre where G had listed the many aspects of each emotion. She came round to each small group of seven or eight people and gave each of us a single aspect of an emotion. I think we were the Sadness group. She looked at me, looked at her list, and gave me "Sentimental." (Something I did not identify with!) Someone near to me was given "Hysteria."

Eventually we had to present a piece of theatre embodying these qualities. The woman embodying hysteria went into a loud and crazy state, standing just next to me. I reacted and went into a child-like part of myself, and hid behind another person's legs, and started sobbing—for real. That sentimental part of myself was revealed and has become familiar to me ever since.

In another part of that training, G asked each of us to ask her what we wanted from her. We had to find a time when she was available, and I did. I asked if she would be my teacher. She looked me in the eyes and said,

"Would you be mine?"

I was taken aback and deeply touched by this. She taught me well. During this same workshop she said,

"If you want to give me a gift, I would like it to be either very expensive or made by your own

175

hands."

I rather liked this and made her a tiny, black feather pin. I wish it had been better made, in retrospect!

On another occasion at Grimstone Manor, G wandered into the dance space, where there was only one other person and myself, already dancing. G started dancing and subtly (or perhaps not so subtly) the other woman and I both started vying for her attention.

"You Brits are always so polite!" she said, often.
Along with something like,

"You Brits are something else. Where America is a nation of neurotics, you Brits are a nation of eccentrics. Some of you even wear sarongs when you dance!"

I remember that last comment because I had taken to wearing sarongs when I danced—and still do! (This was around 1990, when sarongs were unusual.) I remember thinking that I was just dancing for myself—being myself—but I had an eye on G all the time. So did the other dancer! G had of course known this and used this story in her teaching (without naming us), but I recognized myself in her story and that event has fed into my teaching many times.

G, with a smile on her face, also publicly accused me of flirting with her husband, Robert—and I knew it to be true. He had identified me as a drummer, and she had added,

"Mother Drum."
I was touched, revealed and seen in that moment. G said that in the Tarot Deck she was "THE STAR," and in the same session she identified me as "THE EMPRESS." All this has stayed with me.

For another part of the Teacher Training, we all went down to Cornwall for a wedding and a visit to the *fogou*—an Iron-Age cave. We were in celebratory clothing, but it had gotten dark, and hence grown cold, and Gabrielle was wearing something flimsy. She was shivering and I had with me a black pashmina, which I needed, but wanted to share with her. So I stood behind her and wrapped my arms and the shawl around us both. I felt the slimness of her body and shared my warmth —and have kept that memory of her body with me.

I'm probably the dumbest person of all the people

who have ever found themselves in my position—

I really am. I don't know! I just don't know!

I show up, I dance!

—Gabrielle

Donna Karan
New York, NY

Donna is one of the most iconic names in American fashion. Founder of DKNY and URBAN ZEN, she is a pioneer and visionary designer who collaborates with artisans from all over the world in the spirit of community, wellness and social impact. And she was also one of Gabrielle's closest friends.

The loves of my life were my father Gabriel ("Gabby"), my daughter Gabrielle (also "Gabby") and of course, Gabrielle herself, my best friend who is always by my side. God only knows what she is doing with my husband Stephan up there, but I imagine her riding on the back of his motorcycle, waiting for all of us to join them.

And to have her name a song after my granddaughter, Stefania! As my husband once said, "We're all dots and we're all connected."

[Note from Robert: About 15 years ago, Gabrielle was with Donna in the Turks & Caicos. I was in New York working on an album and sent Gabrielle a rough mix of a track I was working on. She was listening to it on her Walkman by the pool when Donna's 3-year-old granddaughter Stefania came along. Gabrielle put the

headphones on her and right away she began to do a beautiful dance around the pool. Gabrielle called me that evening to say: "We've got a title for that track: 'STEFANIA'S SONG'." It appears on the album STILL CHILLIN'.]

Gabrielle and I were bad girls; we explored. From the moment I met her in California dressed head-to-toe in black on a gorgeous sunny day, I knew I had met my soul sister forever. We either wore no clothes or all black. We were the black closet queens. Black clothes or nude was our way of dressing. My best friend, my best inspiration: A girl named Gabrielle.

Donna & Gabrielle

Elizabeth Barnum
Tenants Harbor, ME

Elizabeth is an ordained minister who became a student of Gabrielle's in 2000 and a 5Rhythms teacher in 2005.

When I started dancing the 5Rhythms, I was in my early twenties, from a suburb in New England, and had just started a graduate degree at the Divinity School at Harvard University. Over tea in New York City with Gabrielle, shortly before finishing the degree, she quipped,

"You go finish up at that school and then go do kick-ass work!"

When I emailed her about the weight of writing one particular paper, she typed back,

"I like weighty things, particularly when I can get them to move. Search for the movement my love."

Her messages were always quick-witted, direct, and full of encouragement:

"You are a peach. Patience is cool and presence is hot, so you are covered!"

At a 5Rhythms Teacher Training module when we were watching our audition tapes and providing feedback, she turned towards me and said,

"You need to learn how to go up on the downbeat. Dance to more reggae."

She was always trying to get me to lighten up.

Gabrielle & Elizabeth

Emma Leech
East Sussex Hastings, UK

Emma met Gabrielle in 1991 and it "felt like the chorus line of The Beatles' 'Hey Jude'; been rock 'n roll ever since!"

Gabrielle and I met for the first time in 1991. I had never heard of the 5Rhythms—I was a Southeast London girl, a rock'n'roll chick, my life was in a place of turmoil, drugs, overdose of my First Love, heroin addiction, groundless direction and self-sabotage, alongside my passion for theatre and the visual arts. Fate turned when I met a woman who owned a shop that I would go to regularly, drawn in by its magic and the charisma of the owner. She introduced me to Gabrielle Roth's work and it just so happened that Gabrielle was coming to London to teach a three-hour session that autumn. The owner of the shop and I went together (we are now 20 years into a beautiful friendship).

When I saw Gabrielle up on the stage, I was shocked to see a sassy, rock chick/Patty Smith/Chrissy Hynde kind of vibe, all in black, a leather jacket and wild moves! I didn't know what to expect but it wasn't this! For the first time in my life I danced like I didn't care, wild and free, raw and real. The 5Rhythms flipped my world around, opening my life up to possibility and hope once more.

Gabrielle suddenly swooped down to me and looked deep into my soul, her dark infinite eyes seeing beyond my predictability.

"What is your name honey?"

This was the earth-shattering moment; time seemed to stand still, something happened that couldn't be reversed. A spell! She could "SEE' me alright! And once those Raven eyes have clocked you…you know it! And you know her amazing sense of "real" with the Mystery, her intelligence that expanded beyond time and yet was so present.

From that moment, for the next 22 years, we had something, a respect grew between us, a "street wise" connection, a quiet, no fuss, simple relationship. I was shy of her, in awe of her, in love with her. But what still throws me to this day is her commitment to my dancing path, and her love that held me through my darkest hours. She had a fierce love, a no-bullshit love, expansive and courageous. I feel her life's work has always been my rock; as life throws its challenges, I know that I always have the dance to hold me and her teachings in my bones that I will always be alright, and it is a privilege to give this back to humanity in all its

fucked up-ness and beauty.

I had the good fortune of spending 20 years in a dynamic relationship with her—it was in the background, I never wanted to bother her, I tried to stay at the back of the room out of sight (not so easy with bright red hair) and every time she would pull me out of the crowd.

Off the dance floor I was working with disadvantaged communities, teens locked up in prison, vulnerable children, addicts in recovery. This work became the foundation of our relationship. Gabrielle was one of my biggest supports and mentors—at that time I was one of the few teachers taking her practice to the "streets." I was always struggling financially, and yet I was so committed to the 5Rhythms and knew I needed to keep up the practice and use every opportunity I had to learn from her teachings. I would do all I could to be there; this she knew, she had been there herself as a young woman, it's where she began. Community work is never well paid, often no pay at all. She would offer me BIG discounts to attend her workshops, a bursary to complete the Teacher Training, and she wrote to me regularly: postcards would magically appear through my letter box from time to time, a complete delight!

But it was my reach-out work that held our hearts together. She told me that,

"This is where I've always wanted my work to go, and you are a pioneer."

She tried very hard to get me to work in the USA. For months we had a very real dream that was about to become a reality when she had connections and an opportunity opened up with a children's charity. Alas, the last hurdle was dealing with bureaucracy and getting a visa, and the project didn't happen. But out of that journey "5Rhythms Reach Out" (5RRO) was born.

We were emailing each other up until two weeks before she died. I was working in an addiction clinic, struggling with the clients' resistance, and Gabrielle was giving me her wisdom, offering possible ways through their trauma. Her commitment and dedication and creative genius never ever faded. I feel so blessed to have met her in this life. Twenty years is gone in the blink of an eye, yet has the depth of a thousand lifetimes.

Below: My first ever postcard from Gabrielle in 1993! It fell out of some paperwork recently, just about the time Eliezer was asking for memories!

Translation:

Dearest Emma –

Happy holidays to you from me and Jonny. We were touched by your letter—I imagine you dancing flaming air flying in the winds—characters gasping for breath—soul soaring & of course coffee—or whatever next time. Jon's address is [...] Take care Emma—you are a delightful lady—Love Gabrielle

Along the right side, in reference to my address being "Palace" Road:

Does this mean you're a queen?

Typical Gabrielle humour and sweetness. (Sent in 1993 from NYC.)

And I also received this wonderful letter from her in 1995:

Translation:

Dearest Emma,

I'm so pleased you made peace with your dad. When I want a soft sweet smile I close my eyes and imagine you dancing a specific dance I witnessed last time we were together. I hold your beauty like a fragile bird and rock your soul in my reeboks. Keep that Jah provides spirit pumping. Jonny sends his mighty love.

Blessings & Bless, Gabrielle

Emma Rose Westphal
Seattle, WA

Emma Rose is an acupuncturist, a 5Rhythms teacher, and a dog whisperer who first heard Gabrielle's call 21 years ago at the wee age of 18 when Maps To Ecstasy *jumped (literally) into her arms.*

I cannot ever delete my Hotmail account because this email lives there. Sometimes I print it out and put it on my wall. Best note G ever wrote me. So *her*. Words alive. I can hear her whispering to me "dearest hot sweet mama, dearest hot sweet mama, dearest hot sweet mama, i adore you, i adore you, i adore you."

dearest hot sweet mama,
i was deeply touched by your email.
i adore you and love being part of your
posse.
love,
g

At a workshop in New York City we were ending our weekend with Ritual Theater. Gabrielle was choosing particular people and giving them actual lines. They were to look them over and prepare to BE the words and MOVE the words in the final piece. That morning I had had a rare breakdown, sharing with G about my past family trauma, specifically my alcoholic mom. It was way more personal, of-this-planet and heady/hearty than I usually was with her. I kind of expected her to walk away. She didn't. She gave me a hug. And, at lunchtime, she came up to me and gave me a line. ME!! AH!!

"I have been dancing with death since the day I was born and there is nothing I could ever do about it."

When she called me up to deliver my line in the piece, I, in true Shadow-Lyrical style, pranced up front and said my line like a jester. Gabrielle narrowed her eyes at me and said,

"Emma Rose, feel your mother. Now say the line again."

Oh. Oh man. Oh ouch. In that moment I got it. I got my mom. I got my relationship to my mom. And I got the gift G was trying to give me.

~ ~ ~

AND…Best boy advice G ever gave me, bless her heart, after an exceptionally long, rambling email I sent her, of (in hindsight) rather ridiculous agony. She wrote,

"When in doubt, do nothing."

I think that's literally all she wrote in response! Sat me right on my ass. It's hard to get lost on a head trip when you keep getting told to chill out and sit down.

I will never forget…

how fiercely gabrielle fought for me – even though it was practically the first time we met.

Eve Ensler
Kingston, NY

Eve Ensler is a Tony Award-winning playwright and activist, most known for The Vagina Monologues, *who found in Gabrielle a true like-minded artist-spirit and friend.*

Gabrielle. I miss her every day. I miss her energy. I miss her fire. I miss her imagination. I miss her body. I miss how much she understood the body. I miss her faith in the body. I miss how much she understood that dance is the way we come into the body. I miss moving my body with her.

We had cancer at the same time. We talked regularly and shared our pains and medications and transformations. Her body was being ravaged but her vision, her heart became more and more open and acute.

She once came to be with us at the Superdome as we transformed the space after Katrina from a brutal stadium of hurt and abandonment and misery into a sacred healing ground. She invited thousands of wounded ones to step into their bodies and vital energy.

As they moved and moved you could feel love return, you could feel the holy that comes when we are in liquid radiant community. You could feel the world inside us and outside of us being remade.

She did that everywhere.

I will never forget…

the wild incarnation
of divine female
energy in all its
diverse totality.
Your love in it.
Cora

Fanny Behrens
Totnes, UK

Fanny trained with Gabrielle in 1994 and now is co-founder of Movement of Being.

It was my 31st birthday.

The session ended and people gradually left the room until I was alone, dancing. Dancing with every ounce of energy I had, dancing with remorse for every incredible being I had missed in my own self-obsession, dancing for my own neglected heart, dancing my shame, and wondering how I could face anyone again.

Suddenly Gabrielle was there, kneeling at my feet. She flashed me the most beautiful smile, full of love, placed a small black box on the floor, tied with a black ribbon and whispered,

"Happy Birthday"

and then was gone. In the box were three silver brooches, each of the moon in a different phase of her cycle.

Francis Michael Eliot
Hebden Bridge, UK

Francis first met Gabrielle at her "God Sex & the Body" workshop in England in 2001; they danced deep, fell in love, and she became his teacher and friend from that day onwards.

Gabrielle opened up my heart like no one ever had. I felt such an urge that my mother must meet her—even though I'd almost never felt any generosity towards my mother in my entire life. Such was Gabrielle's influence. The opportunity came when G. was speaking at Alternatives in St. James' Church, Piccadilly, London. I remember so clearly the moment when they met. I introduced them and then stepped back to witness this extraordinary scene. G. tenderly told my mum that she had done so well producing a

lovely man like me—and my mother replied, saying that I'd done it all myself. I'll never forget those words—those words she spoke to Gabrielle touched me deeper than any words I've ever heard anyone say. I think it was the first time I actually felt a deep gratitude to my mother. Such was Gabrielle's influence.

~ ~ ~

Witnessing Gabrielle's hilarious relationship with her audible stopwatch during the "Repetition" exercises at the "Mirrors" workshops was beyond endearing. She would have the timer set on about two minutes, but during each pair's exercise, when the timer would beep she would invariably scramble her long fingers frantically around the buttons, hair straggling around her face, trying to stop the beeping while always asking the pair to continue. This would happen again and again, much to everyone's hilarious delight. It was like a persistent fly that she couldn't quite swat. Heaven knows why she didn't just ditch the timer!

~ ~ ~

I think it was during the extraordinary "God, Sex & the Body" workshop in Dublin when a dear woman spoke up in the circle about the deep self-esteem struggles she was having in the group. She asked Gabrielle what on earth she should do about the fact that every time she looked up she seemed to be surrounded by beautiful skinny women who she felt were all so much more beautiful than her. After a long silence Gabrielle looked at her and lovingly replied:

"Bring them some food."

~ ~ ~

Gabrielle had a whisper that resonated through my cells, beyond time and space. In one workshop she had us all weave in and out of each other in what she called the Porpoise Dance, and as we glided past one another, she had us gently whisper a compliment into the ear of whomever we passed in the dance. Gabrielle glided towards me and I sensed I was in for a treat: her mouth cut through the air, passed my ear, and I still hear her words:

"*King of the dance...*"

So perfectly Gabrielle, still melting my heart.

189

Gary Morgenroth
New York, NY

Gary is an architect who designed Gabrielle and Roberts' loft renovation on 13th Street and loved every minute of it.

My fondest memory of Gabrielle was when she taught me how to hug. After a design meeting, when we were working on a renovation of her and Robert's loft, we said goodbye with a kiss on the cheek and what she called my "midwestern hug":

"You call that a hug?!"

She proceeded to pull me tight against her body, so that we could feel contact from our pelvises to the top of our heads.

"Now *that's* a hug!"

To this day I think of her whenever I am hugging someone goodbye.

So a big Gabrielle hug and many kisses to you, my dear!!

Greg Miller
New York, NY

Greg began dancing with Gabrielle in 2002 and founded NYC's Dance Parade in 2007.

I've learned all kinds of things from Gabrielle and have had a lot of fun along the way. I was once in a class at the Steven Weiss Gallery, the space offered to us by noted designer Donna Karan, one of Gabrielle's close friends. The gorgeous room was the largest I had ever practiced the 5Rhythms in, with 30' ceilings.

Gabrielle led us through the Rhythms in typical fashion. Suddenly, she stopped the music and had everyone divide into two groups, one on each side of the room. She tasked us with choosing someone across the room that we might be interested in, and had us "track the person" while we danced, as though we were spies, such that the other person couldn't tell we were watching them.

190

As we all started moving amongst ourselves, in and around one another, Gabrielle suddenly yelled out:

"Now STOP! You see how fucking hard that is? Don't do it!"

The music went on and ever since that moment, I never again measured my dance by whom I danced with; I became more present, didn't worry about how I looked, and dropped the folly of wanting others to like me. She helped us feel whole, inspired us to transform pain into art and then art into action. The dance became an analogy of life:

"You don't think this is at all about dancing, do you?" she cackled, like a sorceress casting a spell of freedom on to us.

"It takes discipline to be a free spirit."

Hal Zina Bennett
Upper Lake, California

Hal was Gabrielle's friend, editor and writing coach...or creative pest, depending on the day.

I don't know exactly how to describe the role I played as Gabrielle's editor, writing coach, sounding board, friend, student, perhaps fellow story-teller—maybe even teacher. Boundaries often blurred.

I saw that writing wasn't an ego thing for Gabrielle. It emerged from her wisdom, and her experience of being in her body. I didn't quite know what that meant until I'd signed on as her "editor," when she caught me by surprise by declaring,

"The best writing doesn't come out of words."

As a writer, that certainly gave me pause; like a Zen riddle.

But clearly, writing a book just wasn't her thing; it was such a seemingly static process, and made her restless and impatient. But as soon as she invited the reader into her psyche to participate in the creative process, everything shifted, and suddenly her writing process became a dance with the invisible reader. When

the book was done, the reader completed the process, breathing life into all those words, transforming mere ink on paper into a living, energetic force. A dance.

In retrospect, I realized that, unbeknownst to me, Gabrielle had been teaching me the metaphysics of making a book. And I thought I was supposed to be the expert?

<div align="right">

Helena Barquilla
Valencia, Spain

</div>

Helena met Gabrielle in 2003 and heard a deep, inner calling to be with G and follow her dancing maps wherever they led; she has been a 5Rhythms teacher since 2008.

Major Love Teaching

When I first started practicing 5Rhythms I went to several of Gabrielle's workshops. I spoke to her briefly a few times, but we never had a long conversation. Every time a workshop was finished, she was always surrounded by a large group of people waiting to talk to her, so I didn't want to go and add even one more person for her.

At one point I was passing by near her, while she was signing autographs, and I heard her calling me and asking:

"How do you write 'heart' in Spanish?"
I told her and the next thing she said was:

"People always come looking for me, but I had to look for *you* to ask you for something…I would like to have dinner with you."

And so we went. Before meeting her I was nervous about meeting this fascinating, powerful being who I felt in every cell of my body and soul as my spiritual teacher. That nervousness stopped the moment she came out of the elevator from her hotel. She engaged with me immediately, like a long-time friend will do, in such a real, open and warm way. I felt the heat of her heart embracing me in sisterhood throughout the

dinner. At one point, talking about my life, I told her that I had just finished a relationship with my partner, and that I felt it was the first time I had truly been in love and I was heartbroken. I said to her, "I found love and then I lost it."

And she answered,

"Once you find love it will never leave you."

That sentence has been like a compass for me ever since. For a couple of years after that, I chose somehow not to be in a relationship. I didn't know rationally what she meant by those words, although I knew that was a major teaching for me.

Until one day I had a profound experience during a White Tantra retreat. During an exercise I felt inside me all the places that were empty of love. I cried deeply like I had never done in my whole life, feeling all that unloved territory inside of me, and with every empty place I had contact with, I felt love pouring from my heart to fill it. I understood that day, consciously, what Gabrielle had meant; I had to find and nourish love inside myself.

Ever since then I ended the search for "the lover" outside myself and started the journey to find it inside. And not long after that huge realization, life and Gabrielle's strings (or as Robert calls them, "G-strings") brought me to meet an amazing soul and we are sharing love and growing from then until now. Still, every day of my life I'm learning new insights from that one teaching.

Major 5Rhythms teaching

In 2007 I trained as a 5Rhythms teacher. One day during the last module, I felt like I did not know *anything* about what I had been taught in the last year. I felt like a fraud, and that I needed to be honest about it. Anxiously, I went to Kathy Altman and shared this with her. She told me to go and talk to Gabrielle about it. So I did. I said: "Gabrielle, I feel like I don't know anything about what I've been taught in the training," and she answered,

"Oh, that's the perfect place to teach!"

Ever since, that has been my internal mantra when I share the Rhythms. I'm still learning to surrender to the unknowing rhythmic mystery.

Lori

I will never forget...

when Gabrielle went up to Cecil Hall on the dance floor, danced with this very stuck, shy, still minister's son, and finally pulled up her shirt to get

him to loosen up. It worked....

photo by Robert Ansell

Jamie Catto
Oxford, UK

Jamie is the creator of the film 1 Giant Leap *and author of* Insanely Gifted, *and was Gabrielle's friend, collaborator, champion, and co-conspirator.*

My friendship and artist-ship with Gabrielle began in the '90s, when I was 25 and she was always trying to get me onto the dance floor, which I skillfully dodged by inexpertly drumming for her with Sanga of the Valley in her workshops. I loved how no-bullshit she was, and reverently irreverent, like when she said during one of our many feisty chats about being a human,

"Jesus was a radical revolutionary and he would not have put up with one iota of this stuff. I can just imagine Jesus seeing the American Christian TV channel and barfing."

She had always been so eloquent and unapologetically articulate, so when we made the *1 Giant Leap* films, she immediately became our Queen and lit up the movie with her wisdom and her badass hilarity.

But the moment that really struck me and stayed with me from our friendship was when I had been assaulted in New York City, somewhere near Union Square, on the night Obama was elected. I ended up in surgery the same night and woke up the next morning in Beth Israel Hospital with Gabrielle sitting at my bedside, stroking my hair…so, so tenderly, and it was the most feminine, gentle, motherly, soft moment I ever shared with her. We were silent like that for ages and she just gave me her loving care, and when I think of her that's the first thing I feel: her deep *yin* within all that electrifying *yang* expression.

I almost never go to New York anymore, as she was so central to any visit I made that now it always seems like there's really no point in going any more.

~ ~ ~

Whenever anyone shared with Gabrielle their present or past tragedies or crises, she would always answer enthusiastically,

"Wonderful! I expect great art from you."

Such a profoundly cool woman.

photo by Keith Levit

Jane Selzer
Brooklyn, NY

Jane is a 5Rhythms teacher who also taught Yoga in the Teacher Trainings and privately to Gabrielle.

One of the greatest hindrances to dancing freely is self-consciousness. Gabrielle would frequently explain to us that self-consciousness takes two opposing forms: hoping that nobody is watching you, or hoping that *everyone* is watching you. In the large 5Rhythms classes, that translated into either hiding or performing, both of which she said were boring and predictable. The solution, she explained, was to

"Give your practice the attention that you were trying to get from others. Be fascinated by your own dance, whatever that is."

If you really wanted to be seen, you had to give up wanting it. Gabrielle would often talk about how magnetic it was when someone really let go and surrendered into their dance. If someone was truly "letting themselves *be danced,*" she would see light there, and the attention of anyone watching would naturally be drawn to that person.

Almost everything she taught fell into the category of "getting over yourself" so you could experience your true cosmic nature. She'd create an exercise, like attempting to dance freely in a group, and then patiently watch while we struggled. Her timing was impeccable and accurate; when our ego patterns started to dominate the group experience, she'd expose them. Then she'd show us the simple steps to be free. Over and over, this is what we did.

Jason Rowe
London, UK

Jason first met Gabrielle in 2004 and came to believe in the 5Rhythms as a complete healing mandala for today's world.

Work

Gabrielle often mentioned that, as 5R teachers, we needed to adjust the language we used to connect with those we were with.

"It's a lot of fun to keep having to change the language to reach the person to whom you are speaking!"

As I trained to become a 5R teacher, Gabrielle was always in the corner, giving out support, love, and doses of inspiration. Towards the end of her life she became more and more interested in reach-out work and how the practice could be introduced into hospitals, schools, retirement homes and prisons. The 5Rhythms Reach Out (5RRO) became a focus for her. I remember a very tender exchange when she mentioned,

"One of the side effects of the medical treatment I'm receiving is my fingers are becoming very tender."

And yet she continued to write prolifically.

An email exchange:

I wrote her a rather long email after feeling the pain of being rejected from the first Teacher Training I had applied for. I was angry, upset and distraught, and wanted reassurance that she believed I was on the right path. I wrote to her with my heart wide open and will always treasure her response:

Gabrielle Roth gabraven@panix.com
Mon 07/05/2007 22:10
To: jason rowe jason.rowe@hotmail.com

dearest jason,

what a beautiful heartfelt communication.

i wish i could give you a hug.

i will speak to kathy and review your situation.

i may not be able to change anything but i hear you and i feel you and i know you are on the right path.

fortunately, so many people are close, i decided to go right ahead and do another training on the heels of this one. so your turn is coming, if not now, then very soon.

please do not lose faith.

love,

Gabrielle

Jenny Knecht
Nordmaling, Switzerland

Jenny met Gabrielle and the 5Rhythms in 1989, fell in love, became a teacher in 2007, and the dance remains a guiding force in all her endeavors as a student and teacher at the University of Life!

I feel very blessed to have met Gabrielle in person. She was without a doubt an extraordinary human being with a very important message to the world.

Somehow Gabrielle always seemed to know what I—or whoever she met—needed in that very moment. Her words were like medicine: A call to awaken. I would like to share a few "snapshots," moments forever engrained in my being.

Snapshot #1:

Getting a reply to an email within a half hour after sending it. This may not seem like a big deal, but for me it was, considering that the last time I had written to Gabrielle was almost a decade earlier. As if we had met yesterday, Gabrielle of course knew exactly what I needed and showered me with her love, encouraging me to follow my heart. I found my way back to the dance and was very excited to be a student of Gabrielle's again.

Snapshot #2:

Having had, to me, a very important realization during the dance, I rushed up to Gabrielle during a break to tell her about it. Gabrielle looked quite fiercely at me and said:

"Jenny, you don't see me; I don't need you, I need my tea."

Needless to say, from that moment on I became very aware of how I approach other human beings—lesson learnt!

Snapshot #3:

During a workshop Gabrielle saw that I was really stuck while doing the "Repetitions" exercise. She gently looked at me and said with the sweetest voice:

"Jenny, you have to have an eye in your ear."

Gabrielle knew exactly what words to use to convey to me what the art of listening is all about.

Snapshot #4:

Convulsions of pain and tears ripping through my body. I am on the dance floor amongst 80 others during a two-week intensive. Self-hatred, disgust, grief, and the feeling of being totally abandoned fill me to the brim when I suddenly feel another body coming closer to mine and I hear Gabrielle's gentle voice whisper into my ear:

"Jenny, do you think your soul hates you?"

Gabrielle knew; her timing was divine. Time stopped, I felt recognized, understood, and seen to the very depths of my being like never before. That moment changed the course of my life and since then I have never suffered from depression again.

Snapshot #5:

Other times the encounters were on another level. Gabrielle did not like students to take notes when she was talking, and several times asked me, the notorious note-taker, to stop.

Break-time several years later, Gabrielle says to me,

"Jenny, you know I don't like it when people take notes, and still you continue."

I answer, "I know you don't like it, but it is my way of being really present and receptive."

Gabrielle: "Well, it is not all about you."

Jenny: "Well, it's not all about you either Gabrielle."

With a quite surprised face, a sparkle in her eyes and a smile, Gabrielle looked at me, tossed her hair back and walked away. Again I just felt so loved and allowed to be.

In these funky, frenetic times,

we need our feet on the ground,

our instincts intact

and our intuition in full force.

Being true to the signs and signals

that come from within

is our survival art.

—Gabrielle

Jeremy Whitt
New York, NY

Jeremy is an entrepreneur and venture capitalist who shared virtually nothing in common with Gabrielle apart from their insatiable enjoyment of each other's company whilst unlocking profound depths of mental-fornication.

What I miss most are my almost accidental, often ad hoc and entirely agenda-free meet-ups with Gabrielle at our favorite haunt, the Gotham Bar and Grill on 12th and University. Starting with a drink around 8pm, we closed down the restaurant on many occasions, adequately tipping the wait staff that diligently and most politely huddled in a corner just out of view so as not to rush their favorite patron, Gabrielle.

During one such rendezvous, and in just one exchange amongst hours of banter, Gabrielle was bemoaning the tidal wave of requests for her time from so many different sources. Her assistant had called her earlier in the week reminding her that she had committed to speaking at a dance school and needed to know what the title of her workshop would be. Having completely forgotten volunteering to do the workshop, she hadn't given it another thought since. Her assistant persisted, informing her that they needed her workshop title so they could send out marketing information. So in the spirit of that which is only Gabrielle, she quickly replied,

"Call it 'Confessions of a Spiritual Anarchist'," and went on with her day.

Earlier on that same day, her assistant had again called, because due to the powerful combination of Gabrielle's celebrity mixed with such a provocatively creative workshop title, the program director had been calling her frantically, wanting to ensure that Gabrielle was confirmed to attend as the entire auditorium was sold out with consideration for overflow and standing room participation.

Once again, the genius of Gabrielle was always and only, in the moment.

Jewel Mathieson
Sonoma, CA

Jewel was Gabrielle's featured poet in her books and workshops, an artistic collaboration of thirty years. Sadly, she passed away on Wednesday, August 5th, 2020.

Gabrielle on Jewel:

"I remember the moment
Jewel burst into my vision.
Liquid motion, raw passion,
revolutionary leaps of consciousness held together in faded leotard.

The bones of her story hung in space
like skinny revelations whispered in quivering muscles.
I witnessed her transformation from a girl to a woman,
from a lover to mother,
from student to teacher,
from an abused child to a wounded healer
and all the while I could not separate her feet from her mouth,
her pain from her beauty,
her freckles from her wisdom.

In her surrender, I have seen God with my own ears."

Jewel:

One of my most intimate moments with Gabrielle was during a "Heartbeat" workshop at the Westerbeke Ranch. We had just finished a session of dancing "sadness" and broke for lunch. A quarter of the participants were still teary but I was at my normal numb setting until Gabrielle fed me a peach. The juice dripped down my face and I burst into tears. Gabrielle wiped my tears and the peach juice with her napkin and just held me while I cried. I went into the garden and wrote this poem:

The Jewel of Denial

Gabrielle says, "You must identify your wound
it may be the body, it may be the heart, it may be..."
It may be...
I look at the reels of gauze falling at my feet
It looks like snow
I'm cold
It's my nature
She is feeding me a peach
It must be a message
She is feeding me my fear, my anger, my sadness
She places my heart on the tips of my fingers
I arrived with severed hands
My heart had been struck dumb at six
I don't know what to say to this familiar posture
 like waiting for a communion wafer
My lips tremble at the contact
She does not say, "Body of Christ"
I do not say, "Amen"
I understand
It is my body
A woman
She says, "It is sweet"
I weep and weep
Love descends as the black-winged raven
 priestess practicing the art of alchemy
Cradles us back into the heart of matter
Dancing souls back into starlight
Baptism of self in the creative well
Sweat is the holy water in this alchemy of art
She bleeds the moment into being
She takes a collection plate, gathering our tears
And the offerings are made

Jewel Mathieson

I will never forget...

Your poetic praise . . .

"sweet sister of the moon..."

"Medicine Mama, mouth of prayer
and wings of feet"

"Mz. rockin' poet
I'm your biggest fan"

"forever I will love you"

R.I.P. Dear Jewel

September 1, 1957 - August 5, 2020

Joanne and Gabrielle were best friends since they met in Big Sur in the early 70s: "We shared our lives together at the deepest levels. We still speak often."

She called. (We spoke often). She said she didn't feel well and wanted to go to the desert, and said,

"Will you *please* go with me?"

I said I couldn't. Gil and I had plans that weekend.

"Too bad," I said, "but come down here and join us in Pacific Palisades." (She lived in Mill Valley.)

"No," she said. "I need the desert."

An hour went by. Gil called me from his office and said,

"I have to go to Palm Springs on business and check a property for a client." (He was a business manager/attorney).

Sooooo, I called her in amazement and said,

"You won't believe this, but we are going to the desert. Meet us there."

Oh Gabrielle, how did you do that?

In Palm Springs, the magically created weekend continued to unfold. Everything we did was filled with the sense that some otherworldly scribe had written this script and we were only meant to follow it.

In a shop we were drawn to, golden hoop earrings in the window called to her. She loved them, but couldn't afford them. Suddenly the price was dramatically reduced by the owner. They looked great as we danced out with them, lighting up that remarkable face.

Another shop owner said to her,

"Your energy is very deep. You need to *claim* it more."

Everyone we met had a piece for her that brought a new flash of awareness to those remarkable dark eyes.

We went back to L.A. at the end of that weekend. Gabrielle and Gil went to see a psychic who told her that she was a double alien from another planet, and she needed to *claim* that power.

She said to me,

"I love the way Gil supports you on so many levels. I want to marry a Jewish attorney like Gil."

The next day, the plan was to break ground on what was to be our new home in Malibu, and I said, "Gabrielle, stay with us another night, and come to the ceremony."

The phone rang. It was a call from a friend Gil had met at a Brugh Joy spiritual retreat. A guy named Robert Ansell, who said,

"I'm in town from New Jersey."

Gil replied, "Come with us tomorrow".

I went into the guest bedroom where Gabrielle was resting and I said, "Someone is coming tomorrow to Malibu. Oh my God, Gabrielle, he is a Jewish attorney!"

How did you do that, Gabrielle?

They met the next day. We buried a bottle of wine in the sand and began the auspicious spiritual creation of our home that was to become a transcendent space for lovers and other strangers, and these two magicians fell deeply in love.

Gabrielle and Robert later married and stayed happily in love until the day she left this planet, and long afterward.

Our lives continued to intertwine for many years, with Gabrielle and I and the journeys of our husbands and our two families unfolding in the cauldron of a deep love connection. It brought joy to every single one of us.

Oh Gabrielle, how did you do that?

Jules Cazedessus
New York, NY

A creative, social entrepreneur and founder of Venus Matters, *Jules is profoundly grateful for the 5Rhythms and Gabrielle's inspiration to discover the premise of her life: healing the false split between Spirit and matter.*

It was a bright, sunny afternoon, flowers blooming in Union Square, New York City. Gabrielle had agreed to coach me on a song I had written about rising oceans. I buzzed her apartment and waited for the elevator with a mix of excitement and nervousness.

I had asked G. to come to Mexico to direct a music video of the song but that was impossible; outside of her ridiculously busy schedule, she was already on Round Two of cancer. Outside the elevator, the door to her loft was cracked open so I walked in and took my shoes off, stepping barefoot onto her sisal rug. She was sitting on the over-stuffed white couch, looking so thin but with eyes still sparkling dark and playfully.

After a few moments of dropping in together, she asked me to sing, then quickly stopped me.

"Get into your body. Do a wave."

Yikes, here was my mentor, my friend, the shamanic opener of inner—and outer—worlds, alone with me, asking me to dance…

I cannot imagine what my life would have been like had I not found the 5Rhythms about a decade earlier. On those wild and welcoming dance floors, I had moved through the loss of pregnancies and grandparents. Collected the pieces of my broken heart after relationships had ended. Shaken off the terror of 9/11, even as the punctured holes of the towers still burned. In the midst of that chaotic city, the 5Rhythms helped me return to a fluid presence, within my body and, thankfully, within the full spectrum of emotions. (I was so fed up with a bypassed spirituality that denied both the body *and* the emotions.) I finally found a real spiritual home in the 5Rhythms community of brave, beautiful souls, excavating our unique freedom in the shared beat.

I had never danced with G. alone, though. So I started to move, a little unsteady.

"You're not grounded," she said almost immediately, with a hint of surprise. She saw right through me—that was true outside that room as well. I breathed, deepening my center of gravity, and kept moving.

She asked me to keep vocalizing as I warmed up my body. Concentrating on being present, I stopped worrying about how I looked and kept dancing.

The seed of my song had been planted years earlier in Costa Rica. Looking at the stars one night with my young nephew, I was struck by a tender note of fear in his voice as he wondered aloud if adults would leave kids like him an inhabitable world when he grew up. My heart hurt as I tried to assuage his fear; I wanted to assure him, yes, but I truly didn't know. I *did* know that the best medicine for a broken heart was to write a song, and so EnviroSiren's "Sink or Swim," an SOS on rising seas, was born.

Arriving, step by step, in my body, Gabrielle again asked me to sing the first line.

 "Goodbye New Orleans, goodbye New York. You're going under, it's not a joke."

"Faster," she said, urging my dance to go deeper. She had said it so many times before: the best way to get out of your head is to

"Dance faster than you think."

 So I flirted on the edge of what was possible.

"Now sing," she said, in the midst of Chaos. I struggled for breath...and suddenly my voice sounded different—heart opened, soul set ablaze, words riding on the wave of truth, rising from my core.

Lyrical arrived as tears came to my eyes. Heart, body, mind and soul swept up in a wild and tender union. I sang for my nephew, and for the timid hearts of young ones everywhere. I sang for humanity to wake the fuck up, before it's too late. I sang for the Earth, herself. True longing, like a rare and precious fruit, ripened on my lips.

In Gabrielle's no-bullshit illumed presence, I sang SOS with more honesty and more power than I'd ever sung it before or since.

In those treasured moments, Gabrielle showed me how authentic, how powerful I could be when I was truly embodied—not just halfway in. No holding back, no pushing, just fully present to the gift of being alive and to bringing what I alone could bring—my own unique creations.

I am eternally grateful for the way she blew open the doors for me and for so many others on this earthly plane.

Now to just keep feeling my feet on the ground—along with the magnificent whole—moving into the space between, daring to sing my heart of heart's desires.

Julia Wolfermann,
New York City, Germany, Switzerland

Julia is a shapeshifter in the arts, movement meditation and language worlds, and was introduced to Gabrielle in 2005.

I often had the feeling that Gabrielle was not made of bones and flesh, but rather of crystal glass, wind and ether. When I was lucky to greet her on the dance floor with either a hug or a kiss, I had the impression that a soft-loving wind breeze would gently touch through me, the encounter being beautified by a festive and fiercely sharp, sparkling vision magic. An extraterrestrial move through experience where presence was required. If you started chatting—externally or internally—this reality would disappear in less than one second.

Many, many, many times was I reminded of needing to bow my head to the beat of my feet, hips, knees, elbows, guts, spine, heart and soul.

"Your HEAD!!!!" she would call out.

"What?!" (Me thinking: Weren't we not supposed to talk on the dance floor…???) And again, her voice shouting:

"Your HEAD!!! Let your head go!"

Even if she had to yell at me in the middle of a 300-person workshop, Gabrielle was committed to guiding me out of my head trips into the moment.

When I walked down 8th Avenue, we'd sometimes meet randomly on the street, coming from opposite directions and walking toward each other. Sometimes I had the impression that we'd literally walk through each other.

It was through Gabrielle that I rediscovered the joy of shapeshifting and healing my wounds, by taking the freedom of expressing my innermost, secret devils, allowing my ego and my pride to shatter, to

"Let your soul sit in the front seat," as she would so often say.

Gabrielle did not judge on the dance floor. Neither did she pretend to be right, nor to have the world under control. This made me trust her, allowed me to feel safe, and encouraged me to explore the dried-up deserts of my thirsty soul.

In the middle of a very hardworking, eclectic, hectic New York City artist life, she taught me how to make sense of Chaos, how to dance with the order of disorder, how to surrender and move through rather than to fight it. To make love to the unknown, unpredictable abysses and sky rides of life opened my German mindset to a completely new dimension.

"Sometimes you need to unplug."

But when there was no chance to rest, reflect and listen, Gabrielle showed me how to focus on breath and empty space. Magically, this tight agenda held space for all—writing, gazing, gathering, laughing, crying, sharing, caring and daring.

I do not feel that Gabrielle held me in a mothering way—she held me more like a friendly and funky firm father figure, reminding me of "the discipline to be a free spirit" and the art of alchemy that was already slumbering inside.

What made me appreciate her deeply was that she would turn away as soon as she felt someone was caught up in ego trips; her time was too short to listen to fake news. With the simple sword-cut of a Gabriellian Wonder Woman, using a joking confrontation or other unpredictable, moment-to-moment invention, or else just a simple look that said, "Are you kidding me girlfriend?!" she would abruptly end the energies of false relating and lead people back into soul-to-soul communication.

Sometimes I desired to be closer to her than I already was. But her warm and perhaps more fatherly distance actually gave me so much deep understanding, which I truly needed at that time of my life. Egos have the tendency to want what they don't have, and her medicine right here and now was simply perfect.

"If someone wants your freedom, run!!!"

Gabrielle taught me how to love my own freedom, my own choices, how to nurture myself in ways I had forgotten or perhaps never experienced before, how to reinvent myself and keep going no matter how terrifying and unknown the path seemed...well, *seems*. This journey is not over yet.

There were also times in which I did not want to be seen. In those moments, I was terrified of Gabrielle, because she would almost always scan right through me and my ego trips.

"If you like to think that you were selected for the Teacher Training because you are one of the best people in the world, I have to disappoint you. My selection criteria is different: I always seek out the most

fucked-up ones, to make sure that when you have managed to heal yourselves, you will be able to help others, too."

When we heard about Gabrielle's declining health, she was still teaching us. I was very lucky (or fucked-up enough!) to be among her last Teachers-In-Training—"TITS," as we were so lovingly called. Gabrielle didn't make a secret about her illness. She even went so far as to make jokes about cancer. My mother passed away from cancer and I had long since shared that with her. Once, during the training, she made one of her cancer jokes and we both literally cracked up; it was such a compassionate and somehow kindred moment of mutual understanding, this momentary detachment from painful experience. Suddenly, it became uncomfortably silent in the room. With her, I could even laugh about illness and death.

Gosh, was she fearless.

Once I asked Gabrielle, "Why do I need to be open all the time? I'm afraid to get hurt." She smiled, and said,

"I get heartbroken almost every day. It's inevitable to be hurt by people. But it doesn't stop me from moving through it."

And then she continued:

"One of our jobs is to see and show how beautiful everything can be."

I still feel her guiding presence near me, tenderly, poetically, unimposingly free and refreshingly inviting me to BE.

Thank you from all my body parts for this blessing I was gifted with, meeting YOU, Gabrielle.

With eternal love and gratitude,
Yours truly, Julie
(You were the only person whom I allowed to call me this way.)

Juliana Fodera
Ridgefield, CT

Gabrielle saw Juliana's mystical spirit surpass the limitations of her physical body.

I was born with a rare genetic condition known as Noonan Syndrome, which has led me to have around 27 surgeries in order to help maintain my health and wellbeing. It is truly a miracle that I am still here, and meeting Gabrielle was one of many key teachers I met on my spiritual path.

One of my most profound encounters with her was in the summer of 2006. We had just completed a 10-day workshop. I went up to Gabrielle and expressed how I felt myself opening up. Gabrielle, in her gentle shamanic way, took her knuckle, and brushed my chest in a circle, and replied,

"Oh honey, you are always opening up."

As it happened, in November of that same year, I required open-heart surgery in order to save my life. I don't know if the way she had touched my chest was a foreshadowing or an acknowledgement that I was healing on multiple levels.

The following summer I attended the "Silver Desert" workshop with my parents. As part of the workshop, we were to do a sweat lodge. Having recently healed from the heart surgery, there was some concern that this might be too stressful. After obtaining clearance from my doctors, Gabrielle left the decision to me. I went through with attending the sweat. We finished the first round and I emerged. Gabrielle was pacing outside the entry, similar to a Mama Panther. She immediately enfolded me in her arms and I felt the vibe of her love and concern at that moment. Gabrielle was always able to hold the space of empowerment for me. She knew how capable I was and thus encouraged me to embrace my power as a warrior.

Julie Skarratt
New York, NY

Julie was quite often Gabrielle's personal photographer.

There was a tea break at the workshop. Gabrielle came and found me, and said:

"Let's go next door…you need some retail therapy, Miss Jules…"

I now own a beautiful black cashmere cardigan from Urban Zen in NYC. I wear it and think of raven wings enveloping me.

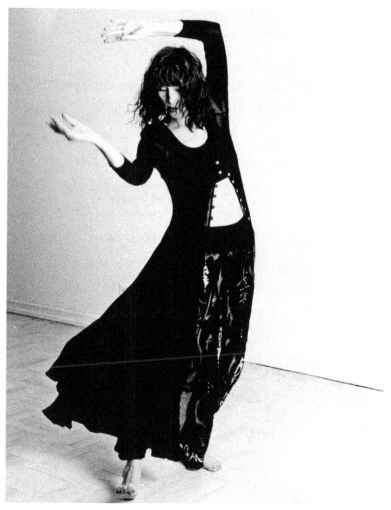

Photo by Julie Skarratt

Juliette Phyllis Kunin
Grass Valley, CA.

Juliette, co-owner of the magical gift store, Garden of Enchantment, *leaped into the 5Rhythms about 20 years ago, devoured the practice in body, heart, and soul, and was moved so deeply that she is now a 5Rhythms teacher.*

A week in "Mirrors" with Gabrielle and Jonathan shattered who I thought I was. Gabrielle, in her laser clear way, pulled me aside and with the back of her hand to her forehead said,

"Juliette, you are so complex."

With sensitivity and softness, she followed up with,

"Sorry, I'm trying to be nicer."

Realizing that being "complex" was one of my core beliefs about myself and not very helpful, my journey to debunk that belief officially began. That teaching stays with me to this day.

I was in the last 5Rhythms Teacher Training with Gabrielle. Overwhelmed and ungrounded for a good portion of the training, we were gathered for our final sit with her. Her stamina was low and she was attempting to lead us in song but struggling to sing. She asked for support from anyone who knew the song and in my self-consciousness and shyness I sat there frozen, knowing the song and seeing that no one else was stepping up. After all this woman had done for me, the least I could do was get out of my own way and help her sing that song. I mustered up the courage to sing with her not realizing that this would be my last opportunity to give something back to her. So glad I did.

Listen, listen, listen to my heart song
I will never forget you, I will never forsake you

Jup fell in love with the rhythms in 1998, not knowing there was a genius behind them. Then she met Gabrielle.

I have a lot of dear memories of Gabrielle, although the first few times we met I was really afraid of her. She was so impressive that I always started to behave like a complete idiot when she was around. Years passed, mirrors got broken and veils got lifted, and slowly I found my relationship with her. She once asked me,

"Are you a Gypsy?"

I felt a big, fat YES coming up, and felt that she had seen my true nature. Then I realized that even my parents' house was called "The Gypsy Spirit." And so from this Gypsy Spirit, I now offer a bunch of workshops that combine traveling and dancing and love and the magic of life.

"God, Sex & the Body" in Hamburg was the most powerful workshop I ever did with Gabrielle; I got to witness her in her full power, taking us to the very edge of our beings.

Her tribal work on World War II in that workshop still gives me goosebumps. I was completely blown away by her ability to lead us through an extremely painful history with such grace and forgiveness. I hope somebody will write about this much more articulately than I can right now.

[Editor's note: See Andreas Tröndle, page 123.]

That workshop was such a playground of dark and light, and her invitation to come to the Saturday night party as your own "Mistress" with the descriptor,

"Come as you are *not*"

allowed me to dig deep into the things I'm not. And so I dressed myself as a blond doll in a green velvet dress with a blond, curly wig and a fur cat. The fun part was that if you touched the cat it started snoring.

In my role as a doll I dared to approach Gabrielle and she invited me to sit on her lap. I asked her if she wanted to stroke my pussy and she did! The cat started snoring and we laughed and then she looked at me and asked me,

"What's your home rhythm?"

I said, "I think it is Chaos," and she looked at me again with her deep, dark eyes and said,

"NO it is not. Your home rhythm is Flowing—research it!"

It was like I was being struck by lightning, as if I was being truly seen for the first time ever, and with that simple line she changed my life and my perception of myself completely.

So now when people ask me if I've ever met Gabrielle, I always say,

"Yes, she stroked my pussy and changed my life."

I will never forget...

your fierce girlish Voice daring me to be heard on the streets of our City... to combine my rhythm with NYCs Body. You seduced me into my life Gabriel!

Kabba Anand
Makawao, HI

Kabba is an acupuncturist who offers deep dives into mystical soundscapes, building community on the beat, thanks to Gabrielle's guidance and encouragement.

Feeling her there, in the room, her penetrating eyes, her strong voice, kindled a rumbling fire in my belly. She became this permission to be fully alive, to be a kind of marriage between insatiable curiosity and radical courage. I let go of how I thought I "should" dance, of all the cool moves that I had practiced, and opened up to the bigger mystery. I awoke in the dance that day.

Gabrielle came over to me at the end, as everyone was filing out. My grinning sweaty breath met her sharp warm eyes.

"It is an honor to dance with you," she said.

Those generous words wrapped their arms around me, welcomed me.

Love,
Kabba

Karyn Tonkinson Gartner
Crystal Lake, IL

Karyn was invited into Gabrielle's vision; G who called her "Nightbloomer: One that blooms out of darkness." They bonded through Patti Smith, Sam Shepard, Steppenwolf Theater, films and books...books...books. True love!

Gabrielle, Patti and Me

It was 1994, and I had just become disillusioned with my participation in Peyote Circles. For someone who came from the drug culture and at that time still dabbled, I was quite shocked by this. But there I was, not vibing with the idea of having to alter myself to reach a state of ecstasy. With that as the backdrop

of my thinking at the time, I happened to go to a bookstore, and there on the shelf was *Maps to Ecstasy: Diary of an Urban Shaman.* The cover had an image of a woman in what seemed like a joyous state of movement and I was curious. I opened the book, flipped a few pages and came across one of the epigraphs before a chapter. It was a quote from my favorite artist who had deeply inspired my life, Patti Smith.

Well now, Patti wasn't everyone's cup of tea at that time, so I was immediately connected to whoever this author was and had to buy the book. The author, of course, was Gabrielle. That evening, I started to read the book and I fell in love. I loved her way of thinking and writing. I could relate to it from so many of my own experiences: Being brought up Catholic, the '60s and drug culture, the rock world, dance, theater, books, modern culture, philosophy and a general yearning to understand myself and the world around me. I read that book in two days.

At the back of the book was a phone number for The Moving Center, her organization at that time. I called to see where she might be speaking or doing a workshop. She was coming to Chicago the very next weekend, which happened to be my birthday. And there you go…

I don't remember much of the workshop itself as I was still living a bit outside of myself and inside myself, not really "just being," and I was also probably a bit overwhelmed by it all. At the end of the workshop, people, as usual, wanted to speak to her and I joined in. The first thing I ever said to her was, "I love you because you love Patti Smith" and she said,

"Well honey, I love you back because you must be grand for loving Patti Smith." She then proceeded to ask me to stay with her and hold her flowers while she talked to others. Thus, began a connection that would be with us forever.

After many years of studying with Gabrielle and knowing more about the 5Rhythms, I was invited to be part of the 5Rhythms Teachers Training. I was not really sure why, as I didn't feel like I fit in at all. Most of the community at that time was Californian and European, and I was a Midwest city girl who had grown up on the streets. And the story in my head was that they were all much more a part of this whole "consciousness world" and way more evolved than me; I was still living in the world of rock 'n roll and theater. I accepted because I really wanted to know and understand more about this philosophy and I loved being around Gabrielle and some of the wonderful people I had come to know.

My birthday happened to fall during that training. As I was sitting and taking notes from sheets on the wall, Gabrielle slid her way in front of me. She sat there looking at me with such a giddy childish quality.

"Honey," she said—(I always hear her that way: "Honey, Honey, Honey" she would say in so many ways to me)—"I have a birthday present for you."

She could hardly contain herself. I took it and said thank you. I think I was so in shock and a bit embarrassed that she gave me something that I just put it to the side.

"Aren't you going to open it?" she asked.

I did and there it was, Patti Smith's newest book.

"Open it, open it."

She was so excited. Inside a dedication:

Happy Birthday, Karyn. May you forever rock on. – Patti Smith.

Oh, my God! Through her connections, she had gotten Patti to sign the book to me. I was so touched I couldn't stop crying. Somehow I must have said something about not knowing why I was there, because I remember her saying to me.

"This work was born out of a rock and roll spirit and it needs one. It needs you." (Okay, can I stop crying as I remember this now? No, I'll let them flow!)

Another time, I was really struggling to find my dance, and I had a conversation with Gabrielle about this. She said something to the effect of,

"In those times, pull out your inner Patti and embody the music as if you wanted to communicate how it moves within you to your audience."

I still do that to this day: I imagine how I want others to understand the movement and emotion of the music, and I get it across through my physical interpretation of it.

Throughout our relationship, we had many Patti moments. One that really touched my heart was once on New Year's Eve I got a call at midnight. I couldn't make out what it was and then I got it: It was a Patti Smith concert. Over the noise I then heard,

"Happy New Year, Honey. Now, we can say we've heard her together."

Gabrielle and Patti are together forever in my heart and psyche. When I think of one, I think of the other. When I think of both, I feel blessed.

Kate Shela
Los Angeles, CA

Kate Shela is Kate Shela.

> *a lady makes a lady*
> *a woman rears a girl*
> *a teacher demands you grow*
> *a shaman makes you go where you don't want to go*
> *a shaman only makes sense later*
> *Gabrielle did all of those for me.*

At 19, working at *Elle Magazine*, I went to a Psychosynthesis Therapy workshop in London. That weekend marked an emergence. Not only was I introduced to the concept of sub-personalities in my internal orchestra, but the leader of the workshop mentioned a woman named Gabrielle Roth. A flash card with her name on it appeared to me and was placed in the storehouse of my internal library.

At 21, I had a nervous breakdown/breakthrough and moved to L.A. to study with a meditation teacher and a motley circle of international lost souls. A woman in my circle told me she had just come back from Esalen where she danced with this incredible woman who I had to meet. Her name was Gabrielle Roth. The flash card hummed.

Two weeks later, I was attending an all-women's camping trip run by the incredible Phyllis Shankman. The first question I ever asked Phyllis was, "Do you know a woman named Gabrielle Roth?" She said, "Of course, we have been friends since the '70s." She promised to give me Gabrielle's telephone number.

A week later the flash card was so noisy and disruptive that I called her. I knew we had some kind of appointment even if she didn't! I rang her home number; she answered the phone. She was quite surprised I had been given her personal number and, as a young 20-something, I told her my dreams of dancing and patiently, kindly, she gave me Kathy and Lori's number in Mill Valley. Days later I was dancing in Hollywood with Rick Sinderman, a 5Rhythms teacher.

A few months later, I was on a plane to my first Gabrielle workshop in New York: "God, Sex & the Body." I remember the feeling as I walked in wearing my Brazil soccer tracksuit: I was immediately part of an incredibly eclectic tribe of about 150. I saw my invisible outline dancing in the room; it had been waiting for me to join it. That night I was born to myself for the first time, the first of many. In a state of euphoria, I was approached by a young, handsome man who asked me if I needed a ride home and I said that was very kind. He said his friends would drive me. He took me over to his friends and introduced me to Gabrielle and Robert, his mom and step-dad. That night in the back of their black Volvo I got driven downtown and welcomed into the tribe with lots of questions and answers. On exiting the car, Robert gave me a Hershey's chocolate kiss, my first of many.

One of the first things Gabrielle ever said to me that hit me like a truck was:

"Stop waiting for your soulmate and be your own soulmate."

That weekend I stood up in front of the whole group and danced the "Bright Mother" archetype. Gabrielle was a black, shiny signpost on the illuminating dark, bright path. She was the first adult I had ever met that combined sexy, fearless shamanic realms with the qualities of a literary fashionista. She was fascinated by mainstream culture, as much as the forgotten elder sitting at the bus stop, and the ancient traditions of the indigenous. She was a yenta who loved love, freedom, a great manicure, and movies. My own young passionista dark brightness got illuminated and I was turned the fuck on and on and on.

Gabrielle reached out beyond her lone wolf self and formed a pack. We traveled as a pack, danced with her everywhere, and tended to our deep wounds and to each other's; caused some wounds and helped heal many. Gabrielle loved us all, each one of us. She saw into us and we grew in the reflection of her cutting, loving, clear seeing. Trimming and shaping away what was not needed, honing ourselves and excelling in her demanding, loving presence.

Somewhere in this timeline, a fine figure of an Englishman who was known to sing love songs at various workshops to the group, declared his love for me. I was not sure. I had been in a selection of passionate and difficult addict-boy dances and was not accustomed to a man wanting to know about my feelings! So I asked G her thoughts. She said:

"Honey, you have to feel it in every chakra."

Even after love was blooming vividly, my deep denial was ever-present. Not sure if I should leave G in New York for Tim in the U.K., she point-blank said:

"I am never going to marry you, Kate. I am happily married and have kids and you should go see if this ecstatic dream is the real thing."

I left my NY tribe and moved to Brighton to be with my love and become a full-time mom to his son, Ben, now my eldest son. She gave me my power back in that moment. She set me free.

Years later, she married Tim and me after helping us create a theatrical "Ritual," not "just a wedding," as she put it. Everyone wore pink and red and she was the only one wearing black, from head to toe! The Black Raven in Dries Van Noten.

Years after that, NYC, January 2012. Her last "Teachers Refresh." The last time I saw her in the flesh. Like her, my mother also had cancer. G kept asking me to demonstrate, pulling me out to share both my physical dance and my vocal story of wisdoms garnered. She asked me to talk about being with my mother in her illness stillness death dance. She whispered many things in my ear over those five days, things I had been waiting 20 years to hear. Some I am still unraveling, but the ones with the most urgency that she gave me, were,

"You are a great catalyst of dance; you have stepped into your power…and you're a sexy thing!"

I had just cut off all of my very long hair in honor of my mother's illness. I was a new woman. I remember Martha, Ruth, Davida and I on the street corner that cold, crisp, crepuscular night. Gabrielle came out in her long, black, puffy coat, a beanie, and big cozy boots, and was about to get in a cab. She told us she was tired, she told us she loved us, and off she went into the night. Au revoir…

I dreamt of her last week; it had been a while. We were in class, she was young and in a fab outfit, as always, and she pulled me out front and asked me to learn some new steps. She kept on and on until I got them. She smiled and said:

"I love you baby."

Tim Booth
Los Angeles, CA

Tim is the lead singer of "JAMES" and was the rock and roll star of Gabrielle's dreams.

.

I feel I could write a book about Gabrielle but here are a handful of stories that hopefully give a taste of her vitality and magic.

I first met her through such an unbelievable thread of coincidences that they stretch credulity. I'll save that story for another day. We instantly recognized each other as kindred spirits in a way that has only happened once since; and that was with my wife. Gabrielle was in her mid 50s and was the most youthful "old" person I had ever met. I remember thinking maybe getting old won't be so bad.

Friendship established, she invited me to a workshop and I figured I should go check her out and see if my new friend was any good. At the end of any workshop with Gabrielle it always felt like you stepped out with a missing part of yourself reclaimed. In the guise of an often riotous, sometimes outrageous "Dance Workshop" hid deep transformational experiences. Within a few months I found myself in her Teacher Training program. I had no intention of becoming a "teacher"; I had a fair bit of resistance to it from previous experiences, but life had other plans. It felt like Gabrielle, as a friend and teacher, had been lying in wait for me.

A few months after the training had passed, I awoke one morning with an unnerving, vivid dream. Gabrielle had come to me in the guise of the "Mother" archetype (we often worked with archetypes). In the dream she was more fleshed out, "Motherly," than my skinny witchy friend.

She came to me and said,

"I am going now." And the words felt final.

If I didn't know how much I loved her before, I did after that dream.

I awoke crying, convinced that she might be dying. So I rang her cell phone from England and left her a bumbling, abrupt answer machine message.

"I've had this dream, nightmare really, and I just want to check you're okay, and I miss you."

Two days later she rang my cell phone:

"Hi," she said, in that throaty playful sexy voice. "How you doing?"

225

She heard out my dream and assured me she was fine. She told me that she was teaching at The Esalen Institute in Big Sur. She was calling from a pay phone as there was no cell reception at Esalen in the mid-'90s.

"I keep seeing you here Tim," she said, chucking in a few more quarters. "You're meant to come here to this place. I don't know why, but you're meant to come here. It will be important for your life."

I knew nothing of The Esalen Institute at that time but assured her that I would come next time she taught there.

A year later I flew in from England to California to work with her there; quite a pilgrimage based on intuition. The Esalen Institute is built on the most powerful land I've ever been on. It feels like you're walking into a dreamscape. Everything slows down and seems to have resonant symbolic meaning.

On the first day, on the lunch break during the workshop, I am in the line for canteen food, standing behind an attractive raven-haired Englishwoman in her mid 20s. She's berating somebody in the queue and I'm pretending not to listen. I like her, she's feisty and has a great laugh and she's calling this guy out on his bullshit. I follow her with my tray of food to where she's sitting and ask if I can eat with her. We start talking and after a minute she is crying. Neither of us can remember why she cried. Twelve years later Gabrielle would marry me and Kate in a tailor-made Burning Man-esque ceremony outside Brighton.

Gabrielle would often call upon me to sing at workshops. At first I'd turn up wanting to be anonymous, feeling shy, but she would out me, and I would secretly enjoy it. Music played an important part at her workshops. For example, Carter Burwell, who would become the Coen Brother's musical muse, was at that Esalen workshop. She asked me to rehearse with two other musicians there, asking us to generate some live music. We rehearsed and each day the musicians turned up eager to play, instruments at hand. But the workshop had a mind of its own and there was never an appropriate moment. Too many tears. Too much laughter.

On the final day, for the closing circle, everyone had packed up and checked out of their rooms, ready to leave. We were just coming together to say goodbye. A hundred people in a circle, including Joan Baez. Gabrielle did this beautiful honoring about how important Joan had been to the peace movement in the '60s, playfully building a loving and respectful picture of her friend.

"In the beginning was Joan Baez," she intoned. "Before Dylan, before God, before the Big Bang..."

It went something like that and then she built to a crescendo in Gabrielle's inimitable poetic style that reminded me of Patti Smith: Patti Smith with a pinch of Robin Williams.

"And so now my gift to you Joan, to thank you for the role you have played in our lives and culture— is that Tim will sing a song for you." She turned to me with that winning smile, knowing that I was totally unprepared and the instruments packed away.

You never questioned her in a situation like that—you just jumped. I walked into the centre of the circle, stood there for a while figuring out what song might work acapella, and then sang the song "Please Fall in Love with Me" to Joan and to the circle. Pivoting from the centre, making eye contact with each person, especially my wife-to-be, who at this point in our story was resisting my Singer's charms. Time slowed and stopped, and it's fair to say I moved on as a singer in that moment. Joan received it gracefully then went into the circle to sing "Amazing Grace" to us with all the resonance of hope and courage that that song holds.

Afterwards, hearts blown open, people were leaving and lining up to thank Gabrielle and say goodbye. It was hard to leave these workshops; shared experiences and close bonds had formed and people were afraid that their newly discovered transformations might evaporate the moment they left the space. Gabrielle always hated this bit, especially if people put her on a pedestal, treating her like a Guru. Job done, she wanted a quick exit and to "normalize" herself.

I was standing by the doorway gazing out to the ocean, near an altar of fruit and various crystals. Escaping the line, she came up behind me.

"Now about that dream," she said. "I don't like the idea of being *just* the 'Mother' archetype to you." Her gaze was strong.

"I'd like to be seen as something a bit more rounded than *just* Mother," she said, looking down at the altar. "Why not some other archetypes? Why not…" She spots the fruit. "The Mistress archetype for example?"

She reached down and plucked two avocados off the altar, stuffed them down her black leotard creating fake boobs, and started to do this sexy dance in front of me in the silence, circling the avocados in my face. I joined in and we played out a mock seduction dance, ending up rolling around on the floor laughing and giggling like teenagers, whilst some solemn would-be devotees looked on in disapproval.

"I'm missing you and your laugh that opened all the worlds to view.

I love you.

See you next time."

 —From the song "All I'm Saying" by JAMES – lyrics Tim Booth

Photo by Natasha Bidgood

Tim, G, & Kate Shela, "The Wedding" —September 2005

Katherine Harber
New York, NY

Katherine is an actress who was gifted Maps to Ecstasy *in 1986; she read it on subways and busses throughout New York City, and could often be heard affirming aloud, "yes. Yes. YES!"*

I'd signed up for my first 5Rhythms workshop in the late '80s, but had to cancel almost immediately. Eventually, classes began to proliferate in New York, and I was dancing with several other teachers. Finally, the opportunity arose to take a class with the woman herself! It was in a tiny, dark studio— up a steep and very narrow stairway (to quote the song), and it seemed to me that everyone felt something of what I was feeling—anticipation and perhaps a bit of reverence for this special night with Gabrielle herself.

As we danced through the evening, I found myself laughing—chuckles, belly laughs, naughty giggles, uproarious guffaws—I thought she was a riot. (I also worried that maybe I wasn't 'getting it,' because I was often the only person laughing…) At the end of the class, Gabrielle gathered us all in a circle and said,

"Well that was fun—you're all a bit serious for me, but it was fun."

HA!

♫ *"I've given this body to folks,* ♫
I wouldn't lend my car to."

—song from early Mirrors production,
composed and performed on stage by Gabrielle

Kathryn Chaya Lebow
Los Angeles, CA

Kathryn is a mind/body psychotherapist and meditation teacher whose world was blown wide open when she started dancing with Gabrielle.

I first met Gabrielle when I was 20 years old in 1997. I was lost and terrified after being a passenger in a car that went off a pier into the ocean. I was told that dancing with Gabrielle might help put the pieces of me back together. When I walked into the "Heartbeat" workshop at the Omega Institute, I immediately knew I had found my teacher and met my tribe. After a particularly strong Chaos period, where I had danced the terror out of my bones and blood, but also practically given myself whiplash, I approached Gabrielle. She rubbed my neck, telling me that I would be okay, and helped me to find my way deep into the heart of the group.

A couple of years and many "Waves" with Gabrielle later, I found myself back at Omega, this time in the midst of a very challenging relationship. She had witnessed our courtship from when we first met on the dance floor in New York City, to the year ahead which took us all over the map, from heart-waking to heart-breaking. She observed us as we hashed it out, on and off the dance floor. She said to me in a loving yet serious tone,

"You know, relationships don't have to be hard."

Kelly Satz
Buenos Aires, Argentina

Kelly has been dancing for 28 years and is a devoted student and teacher of the 5Rhythms. She mostly teaches in South America, building bridges between countries.

The first time I traveled to meet Gabrielle, I only had a P.O. Box address for her. At that time nobody had a computer, no Facebook, iPhone, Google, etc. So I flew from Argentina at the bottom of the map to New York, and of course I only found a big building with a lot of mailboxes, but no Gabrielle. Imagine my frustration—I returned home without seeing her!!! This happened in 1993. (I did meet her three months later and became a "Waves" and "Heartbeat" teacher.)

I laugh at myself, remembering when I was a student: I gave Gabrielle a multicolored poncho as a present, and she was always dressed in black, but to me the poncho was amazing. You cannot imagine Gabrielle´s face, jajajajajja! She was so transparent, and of course she never wore the poncho, jajajajajaja.

And once, in January 1995, she invited me to share dinner, just her and me, alone, uauuuuuu. For me it was like touching the sky with my hands. I was the Sudamerican woman from the bottom of the map, a lost country, enjoying dinner with THE TEACHER!!! I felt so nervous, and she was wearing her black leather jacket and black boots, so beautiful, looking at me and smiling, and she said,

"Okay, Kelly, step by step, don´t run, breathe; you are an angel dancing with a huge heart, and you´ll become a great teacher. Never lose your smile and never close your heart; trust in your feet, and leave the cigarettes!!!!!"

The point is that I never smoke, but I have a very deep voice, jaajajjaajajjjajaajaj!

I feel so blessed that Gabrielle was my "Waves" and "Heartbeat" teacher; her teachings changed my life, and, when reading her books, I felt that I discovered the reason for my being in this life: to teach 5Rhythms!!!

Kierra Foster-Ba
New York, NY

Kierra is an educator, 5Rhythms teacher, and part-time mermaid who began dancing with Gabrielle in the late 1990s and appears in her Power Wave DVD.

One especially tender memory I have took place during my first Teacher Refresh. It was in January of 2009. During a witnessing exercise she remarked that my dance changed after I got feedback from my witness. I explained that my partner had told me to stretch out and take up space and that it was such a profound contradiction because I often feel that there is not enough space for me.

The next day we were all summoned upstairs and there was a mad scramble for seats. I was crestfallen as I looked around the room and instantly noticed that there wasn't anywhere with space large enough for me to sit down. Gabrielle noticed and patted a space beside her and asked others to scoot over so I could sit beside her. She then rubbed my back and soothed the unseen little girl inside the giant of a woman.

I will never forget...

Gabriella fantastic combination of fierceness and Grace!

love you madly,

Kierra

Lacey Burke
New York, NY

Lacey is the National Sales Director at Realm Cellars and had the privilege of keeping G's wine glass filled up with brilliant gems from around the world; in return she gave her friendship, great conversations and impeccable fashion advice.

I was lucky enough to have taken care of all Gabrielle and Robert's wine-related needs at Gotham. I was one of the sommeliers there for a few years, and in addition to that, I always had a passion for fashion. "High end goth" was one way I'd describe my style. Gabrielle also had a flair for the darker side of fashion, and we both shared a love for the designer Rick Owens. One night, while off-duty, I stopped into the bar in my new Rick Owens leather jacket, my prized possession.

Gabrielle and Robert were on their way out and she insisted I needed to walk with them, as she had just the right thing to complete my look. She took me home and into her closet and wrapped the most incredible Ann Demeulemeester hooded scarf around me and tied it in a way that I've never been able to replicate. I felt chic and edgy and sophisticated and will forever cherish that scarf as well as the moment.

She was right, it did complete the look.

photographer unknown

Lina Nahhas
Dubai, U.A.E.

Lina is a Palestinian global nomad and entrepreneur who became, with Gabrielle's encouragement, the first 5Rhythms teacher to bring G's work to the Arab world.

I speak today about my experience with Gabrielle Roth on a very relevant and timely occasion. I'm finding the urge to speak on the days and the week when massacres are being executed yet again in Gaza, when the fight over Jerusalem is insane, as it always has been over the centuries. I keep saying that the land doesn't belong to anybody, that the land belongs to God, and the land belongs to the Earth. And the language spoken in Jerusalem is neither Arabic nor Hebrew nor any form of any human language, but rather, it is the language of Nature and God.

I'm feeling really drawn to share my experience with Gabrielle on this day, as my heart is really bleeding, just bleeding for humanity, bleeding for this illusion of separateness that we have somehow concocted through the ego over the years of our so-called historical narratives that in my opinion are delusional. Why the philosophical introduction? Because my meeting with Gabrielle at Esalen in 2012 at her last workshop ever to be offered, Medicine Dance, was phenomenally resonant with what I'm experiencing now as a Palestinian.

Robert had facilitated a breakfast for me to have with Gabrielle during the workshop, and at that time she was feeling weak. We had a half hour together, in which time we shared stories of how I see the conflict in Palestine as a Palestinian, and how she sees it, and it was so funny that she was defending *my* right more than *I* was defending it; my right as a Palestinian. I remember very, very clearly, she looked me in the eye and said with such humaneness,

"Before you reach compassion, before you do anything, the Palestinians need to process their anger, because they have been raped, and their boundaries have been raped, and their humanity has been raped."

I remember the word "raped" so well. And I remember telling her that this is an anger that exists on both sides of this story. I was defending the Jewish narrative equally, because I believe in that. And she said,

"That's right, but the Palestinians have the worse side of this equation at this point, as humans, and we need to honor the raping because they are actually on the worse end of receiving the violence."

I took that in, and I thanked her for her time, and I said, "I got you some dates, I hope you like dates,"

and she said,

"Well open it, open the box now!"

And there was this little excitement in her voice as if we had not just shared a really heavy topic.

"Open it, let's have some!"

I told her, "I want to leave you now to rest a little bit before we start the workshop. I understand there is a lot going on and you are taking on a lot from so many people," and I will never forget the look she had on her face when she smiled at me with such appreciation that I saw her as a human being who needed some rest. It touched me so deeply the way she just looked at me, as if saying,

"Thank you, thank you for seeing me."

I gave her a hug, we had some dates, and parted. Fast-forward to the next moment in the workshop when she was speaking again, to a room of about 80-100, and she started her talk by saying,

"The work doesn't end here, friends. We have to ask ourselves, 'What are we doing for other people?' What are we doing, for example, for the people in Palestine? What are we doing for the people and children in Rwanda?"

And she continued to list three or four other places of conflict, and three or four underprivileged people in the world that are living in circumstances who had gotten there because of our lack of humanity in our collective consciousness. I felt my tears on my face, as I do again right now, because in a way she sensed, and brought into the teaching, whatever it was that passed through her that day. Whether it was me or somebody else, she took it in to create the awareness and consciousness for the group. I remember thinking, "I can't believe that Gabrielle Roth is teaching *me* about how not to forget my own people, and other people of the world." I was so deeply touched at how she saw me in that moment, and saw us, and saw the world. I really cried and my dance was about how we see each other and how we can go beyond the illusion.

At the very end when we were saying good-bye, she signaled to me and said,

"Don't forget to write to me,"

and I just have never been seen so much as an individual, as a human being with a narrative and a story to tell, and as a nation, all of which today I really *do* give away, not as an individual story because I believe that our way out is to see each other as a collective and not as individuals. And yet, it is still important for me today to honor the anger that's going on. I'm running a class with a friend, and I'm constantly in touch with my fellow

Jewish/Israeli friends. My class is a vigil, rather than just a prayer for peace, a vigil of solidarity in order for us to process the pain, process the anger and turn it into compassion, process the fear and turn it into courage, and process the helplessness and turn it into hope.

All of that is thanks to Gabrielle in that moment at Esalen. For me to say, "Do not forget where you're at: process it, feel it, and move it forward into the bigger hope, bigger peace." If not for her I would not have become a teacher; it was that exact moment in 2012, in June, that made me want to become a teacher, just because of that moment with her. She was, and in my mind remains, one of the most humane, all-seeing, deep, thoughtful human beings, who saw the humanity and then saw within that the potential for a Divine narrative, but not before being human first.

So that's my moment with Gabrielle Roth. It shapes me, and in every single class I hold that moment in my teaching and in my resonance with sameness rather than diversity. May she rest in peace and always continue to inform my seeking for seeing beyond the illusion of separateness. Thank you.

Lucie Nerot
Tours, France

Lucie is the founder of Dancing Across Borders and an Open Floor trainer who met Gabrielle in 2002 after falling in love with her creation. What exactly happened between them remains a mystery, but the grace of freedom and radical aliveness is still dancing in her.

New York City, ego work, Gabrielle asks us what we are definitely *not*. I answer "superficial." She spends the next couple of days insisting on small talk with me, will only chat about clothes, hair style, restaurants...it gives me a sense of humour about my oh so serious self...

Madhuma Thompson
Bermagui, NSW Australia

Madhuma was an early Osho Sannyasin, so the 5Rhythms community felt like a resonant sangha of movement devotees. Gabrielle certified her to teach in 2008 and she is now holding space for people who went through the devastating bushfires in Australia.

I live in Australia so mostly I'd travel to California for Gabrielle's longer summer programs. Even though she inspired me tremendously, and I felt the ring of truth in her teachings, I was nervous around Gabrielle, and was afraid of being in close proximity with her.

One year, after her "Silver Desert" workshop at the glorious Westerbeke Ranch, I went to Gabrielle and offered to give Jonny an acupuncture treatment. She'd mentioned that Jonny was coming down with a bug and would be taking the long flight to Australia himself soon. I was always more relaxed, confident and easy-feeling after dancing in those long workshops, so it was a true and easy gesture in my Flow.

Gabrielle was so appreciative and warm and chatty. I was a bit gobsmacked! She beckoned me into her room while she nattered away like my best girlfriend telling me about her experiences with Osho. She knew I was a sannyasin and wanted me to know that Osho had asked her to come to the Poona ashram to teach 5Rhythms there. She and Osho had corresponded for a time and then through his secretary, Ma Yoga Laxmi, he had sent Gabrielle an air ticket from California to Bombay.

"Some orange dude just showed up and handed me the ticket."

She was clearly tickled by this, yet knew that ashram life and being a disciple was not her path.

She used to quote Osho all the time back then and I felt a confluence of those two lineages. After Osho died, the 5Rhythms sangha felt like my natural next step for inner work and community.

Gabrielle's last long summer program was in Sausalito. One hot summer night after an intense day of dancing, about ten of us spilled out onto the pavement for some fresh air, sharing, debriefing, flirting and figuring out dinner plans.

Suddenly I saw a blur of black in the corner of my eye and the next thing I knew, Gabrielle was right in my ear whispering,

"I love you,"

and then was gone. Whoa! She could pierce through layers and get down.

I think the last time I saw her was at the NYC Teacher's Refresh about nine or ten years ago. She had a black knit hat on with "Fuck Cancer" embroidered in white across the front. She was teaching as eloquently as ever and was skinny as a rake handle. She knew my mother had just died and I'd spent the last eight weeks tending to her and her dying.

Or maybe she didn't know that about me?

Anyway, we'd all been told NOT to try to hug Gabrielle because her immune system was so fragile at that time. When she saw me on the dance floor she came right over and opened her arms wide, and wider—staying back a few feet. Her love, her gaze and her presence were so kind and holding. She gave me the longest, most breathtakingly tender air-hug ever.

She had a way of melting through the layers.

Layers of holding it together, of unexpressed love, and yes also of time.

So many ongoing thanks to her.

Manfred Mroczkowski
Mill Valley, CA

Manfred is a German expat lawyer-turned licensing agent who met Gabrielle in a Munich swimming pool in 1966 and later found that all his favorite authors were friends of hers.

This American woman with raven black hair and incredibly pale complexion—sitting in the shade of a tree in a swimming pool in Munich—and I got to talk. It was the summer of 1966. I had just turned 22 and was taking the day off from my law studies at University in Munich. Before long we were in deep discussions about life and politics—the Vietnam war was still very much going on and the US was on my shit list, yet I found myself more and more drawn to this person whose name I learned was Gabrielle.

I got my first whiff of a new paradigm of thinking and being and it felt like coming home to something I knew deep inside. What did Gabrielle say to me?

"You have to come to America when you are finished with your law studies."

That is what I did in 1970 and eventually made the San Francisco Bay Area my home. In my ensuing career as an agent I met and represented many outstanding people, among them the writers Shakti Gawain, Dr. John Lilly, Louise Hay, and of course Gabrielle. Shakti, John, and Louise all knew her and called her their friend. (John Lilly actually called her an agent of ECCO; for those of you who do not know, that is "Earth Coincidence Control Office," and I swear he was right!)

She also sang a great rendition of "Monday Monday" by the Mamas & the Papas, on the street in front of the student house where I lived on the fifth floor when she wanted to call me down.
Get it? Manfred? Monday Monday?

[Editor's Note: No. I don't get it. He tried to explain it to me but it didn't really help.]

<div align="right">

Margaret H. Wagner
Corte Madera, CA

</div>

Margaret, a poet and travel memoir writer, first danced into a 5Rhythms workshop in 2000 and has felt Gabrielle's magic, depth, and healing ever since.

"Keep Dancing"

I find it such a challenge to describe Gabrielle: dancer, spiritual poet, champion of those in need of assistance or compassion, director of Ritual Theater that cut to the core of human experience, shaman for modern times.

In the face of all that, perhaps it was her simplicity that was remarkable. The way she would greet Robert, her beloved husband, with a kiss when he entered their home; or making a cup of tea, talking about the latest movie.

Once, during a moment in a workshop, I danced by and told her that I marveled at how I would cry one moment on the dance floor and be deliriously happy the next. Gabrielle said:

"Yes, isn't it wonderful. Now keep dancing."

And so, I did.

A few years later, I was in the first module of the Teacher Training. The group was cycling through an exercise where a few of us moved while the rest witnessed. I was on my knees, in a dance where I felt the pain of separation from my birth mother. I felt my baby arm and hand against my birth mother's inner thigh. I was bereft at being separated from her, suspended in the space of being close and not being able to touch her.

It was time for the dancers and witnesses to switch roles, which Gabrielle cued, but she said to me, "Margaret, keep dancing."

The groups rotated through, and each time, Gabrielle said,

"Margaret, keep dancing."

I was thankful for those extra moments of moving in that tender space. I was thankful to Gabrielle that she encouraged me to stay there until I felt ready to leave and walk away. I made the decision to say good-bye to that moment—someone else didn't make it for me.

I shared with Gabrielle how challenging it was for me to do some of the "Cycles" material. There were always multiple threads for me to work with—my adopted parents' lineage, the unknown birth parents and relatives—a dark abyss greeted me every time I worked with ancestors and bloodlines. It's possible my conversations with Gabrielle opened more inclusive language for her around the subject of ancestors. More importantly, as I worked with Gabrielle, I gained a greater sense of writing my own story. The abyss became a wonder.

Nearly fifteen years after that Teacher Training dance, I started to search for my birth parents. I know Gabrielle's words,

"Margaret, keep dancing"

will serve me well on this journey.

Margaux Skalecki
Boston, MA

Margaux is a trained dancer and performing artist who was gifted a cassette tape called "Bones" nearly 30 years ago and has been a student and teacher of the shamanic/5Rhythms way of Gabrielle's work ever since.

I remember an edgy moment at a hugely attended 5Rhythms workshop at the Omega Institute. Gabrielle walked in and onto the stage and said hello, and then,

"I know the room is packed, and you all might think it is too crowded…" (pause) "but I want to go shopping for new clothes."

Her implication was that the workshop had been oversold because she needed extra spending money! I loved hearing this as I looked around to see the faces. It all worked out. ☺

As a fellow teacher, there was another moment at an Omega workshop I so appreciated:

Once again there were many of us in the room. Some of us were doing our usual solo warm-up and others were just sitting or standing, waiting. Gabrielle enters the room and says as she is walking through,

"Some of you look like you are waiting for something to happen instead of being ready when something *does* happen."

Right the freak on, Gabrielle!

Another favorite:

This occurred before a workshop at the Kripalu Institute in Massachusetts, when Gabrielle was checking in at registration. The person hands Gabrielle her room key and says,

"The women's sauna and whirlpool is that way, and the men's is the other way."

Gabrielle leans in and says,

"What if you don't know which one you are?"

Ha! Ha! Ha! Ha!

I would have dreams with Gabrielle in them. Once I had a BIG dream about her being full-out exhausted, as in non-stop exhaustion. I wrote to her and she confirmed this.

I had always loved the phrase, "Sweat your prayers." I never even thought to ask Gabrielle about those words, because for me they seemed sacred and logical. Of course, when I am deep in the dance, that is clearly what I am doing: "sweating my prayers."

And then I heard Gabrielle say,

"One day I was leading a workshop in a church, and I looked around and thought, 'Right! We are sweating our prayers.'"

And as we all know, the rest is history!

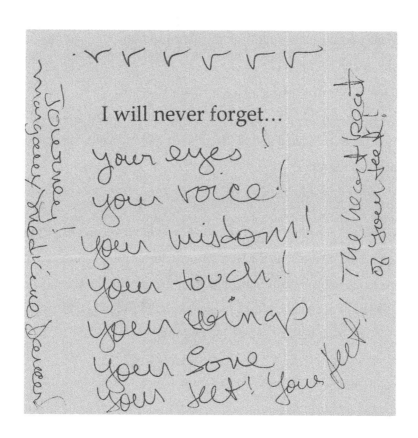

Mark Bonder
Great Neck, NY

Mark is a musician and 5Rhythms teacher who knew Gabrielle as a person first, and an inspiring friend and teacher later.

I feel fortunate in that I got to meet Gabrielle not as a teacher, but as a dinner companion. This was back in the fall of 2000. I had just begun dancing only a month or two before, and a number of people went out to dinner for Jonathan's birthday after one of his classes. I wound up sitting at Jonathan's table, next to Gabrielle, about whom I knew almost nothing. She treated me like a friend, and over the years would continue to do so, in whatever situation we would meet in. I remember during a workshop in California some years later, I was talking to my mom on my cell phone during a break when Gabrielle passed by in the hall. On a lark, I asked her if she wanted to say hi, and she took my phone and said,

"Hi, this is Mark's friend Gabrielle!"

Things like that really stick with you, and to me, really show the kind of person that Gabrielle was. She was many things, but really, overall, she was a friend. She could see you, and point out things about yourself that you might not have considered before. But it's her humble nature, beyond her "Urban Shaman" mystique, that I will remember the most.

~ ~ ~

Gabrielle was subbing in Jonathan's class one week, and in the second half of the session, she was leading the group through all the rhythms via the feet: Flowing feet, Staccato feet, etc. When she called out "Staccato feet," everyone in the room literally started kicking the air with their feet. I stepped to the side of the room, near where Gabrielle was standing, just to watch, as it didn't really feel comfortable on the floor in that moment. Gabrielle looked at me with an expression that said,

"Oh well," and then in a soft voice, "It'll be over soon."

I loved the humanity in that woman…

If you're making a list of pros and cons

about a relationship in order to decide

whether it's the right person or not,

even if the pros win, it's not the right person.

Because when it's the right person, you just know,

and you don't have to make that list.

—Gabrielle

Mark Metz
Berkeley, CA

Gabrielle guided Mark's early publishing efforts with Conscious Dancer *magazine and enrolled 5Rhythms as founding members of the* Dance First Association.

Back in the early days of publishing *Conscious Dancer* magazine, around 2008 or so, I used to have long-distance phone conversations from Berkeley with Gabrielle in New York City. In one of our dialogues, we were discussing the different terminology used to describe various movement practices. When I casually mentioned the word "ecstatic" in relation to 5Rhythms, her voice rose and sharpened with her trademarked edge, and she hissed,

"Don't you dare call 5Rhythms 'ecstatic dance'!"

She knew that our word carried some weight in the field. She was happy that we were popularizing the term 'conscious dance' and felt very comfortable using that label to describe 5Rhythms. And she was well aware that with the title of one of her most influential books being *Maps to Ecstasy: The Healing Power of*

Movement, it was an easy slip for people to think that the word "ecstatic" summed up 5Rhythms.

But by then "Ecstatic Dance" had become a style in its own right, signifying loosely-held, 'no booze-no shoes' freestyle spaces with DJ's playing primarily electronic dance music, bearing little resemblance to the intentionally facilitated atmosphere of a proper 5Rhythms container.

"5Rhythms is a map for feeling every emotion," she said, "joy and sadness, elation or grief. Ecstasy is just one facet of the experience."

Gabrielle's words ring true to this day, and I'll always remember and respect the way she adamantly defined the practice.

Marisa Tomei
New York, NY

Oscar-winning star of film, stage, and television, the effervescent Marisa Tomei needs no introduction.

I cold-called Gabrielle because I was researching "The Dance of the Seven Veils" for my role in Oscar Wilde's *Salome.* What was the origin of that dance? How do I channel what was intended? Gabrielle's name popped up in my Google search.

A couple days later, she walked over to my apartment and said,

"Start dancing," and then just kept pushing me for the next few hours, past any limits or propriety. Had never laid eyes on her before. The daring and thrill and impunity! She was there with me on opening night.

~ ~ ~

Always feeding me body and soul— lots of grilled cheese at a tiny Japanese sandwich shop we loved, pizza down her (our!) block, the fabulous Gotham, Balthazar.

~ ~ ~

Tried to make a love match for me a few times, ah well.

~ ~ ~

Gales of laughter together at "The Book of Mormon," howling and celebrating…

Marlen Lugo
Los Angeles, CA

Marlen met Gabrielle in NYC and was surprised that such a "rock and roller" had a deep, transcendental practice that resonated with the way she had been wanting to dance all her life.

Chocha Fanning

During my last months in New York City I helped Gabrielle prepare for renovations in her home. There were many logistics regarding what needed to be stored, what to keep at hand, and what to toss. We engaged daily in this task for a couple of weeks, with little time left before the contractor and crew would arrive, demolishing everything in their path.

One afternoon we were in the office when Robert came by to ask something of Gabrielle. Being so busy, Gabrielle responded with few syllables and Robert went on his way. I don't remember the nature of his request, but there was no gravity to it. I said to Gabrielle,

"We are not here fanning our chochas."

Gabrielle looked at me and I simply mimicked holding a hand fan and airing between my legs to refresh my "female parts."

She burst out laughing and asked me to repeat this "chocha fanning" expression so she could learn it. It was adopted beyond Gabrielle and into the dance tribe, as something women must do to keep happy.

It is fantastic that something got lost in translation and it became entirely different from its Puerto Rican roots. The irony is that it became a favorite of Robert's and he would mention it often when I saw him and Gabrielle.

PS: And just for cultural clarification; what it truly means is that someone is making an unreasonable inquiry at a time that you are super busy, as in:

"We are not here just fanning our chochas."

Masha Delfinden
Maui, Hawai

Masha is a poet, a musician and an alien struggling to belong, and Gabrielle showed her a place of belonging: in her body and bones, her feet and her music.

I was surprised once about somebody being touched by my music, and when I shared that with Gabrielle, she said to me,

"Sweetheart, the universe is speaking in tongues into your ear. You are pure magic, never doubt it."

~ ~ ~

A dream or vision:

I am laying "dead" on the ground, at the very edge of the universe. Like there literally is an edge and I am close to it. I cannot talk or move. From the corner of my eye I see Gabrielle walking the rim of that edge. At some point she notices me and starts to move toward me. She is wearing a very cool Mad Max-meets-Cats (the musical)-meets Ann Demeulemeester outfit. She gets close and asks me,

"What are you doing lying on the ground?"

Somehow I communicate to her that I am dead. She shrugs and says,

"Being dead is a poor excuse for not dancing," and then she saunters off.

Mati Vargas-Gibson
Dallas, TX

Mati is a visual artist, translator/interpreter, and the founder of BodySpirit Dance. Gabrielle rocked her world when they met in 1998, and she has been teaching the 5Rhythms since 2008.

Thank you for being outrageous, thank you for being risky, thank you for saying fuck, thank you for being edgy, thank you for loving black, thank you for pushing and not pulling back, thank you for not being new agey but timeless, thank you for being a punk, thank you for your devotion to irreverence and to endless poking into the abyss, thank you for not playing safe and throwing me into the deep end of the pool, thank you for stepping on toes and calling bullshit, clearly seen and cleverly hidden in all the stupid dances of resistance, thank you for having one million feelers that you trust completely, thank you for saying fuck, again, and fucking and awesome, and go!

~ ~ ~

Best thing Gabrielle ever said to me:

It was at a dinner during "Mirrors" in California, I was a few years in of dancing. I had never really talked to her that much, never did the backstage thing or was part of her privy council. Somehow we ended up sitting side-by-side, both of us spent after a few days dancing, and after a few niceties and eating, we dropped into a sweet silence, just being, sitting on a bench.

Then she turned to me and said:

"I guess we both hate small talk."

And I never felt awkward around her again.

Melinda Caroll
Maui, HI

Melinda, a singer/songwriter, is also a fan, practitioner, true believer and living proof of Gabrielle's 5Rhythms work.

The first time I actually saw Gabrielle was the day I arrived at Esalen for a workshop and she was standing in the bright California sunlight dressed like a female Hell's Angel in a buckled-up black leather jacket, black kick-ass GI Joe army boots, and with a fierce, dark expression and piercing eyes that matched. She felt like anything but safe, but when she smiled at me, I could see her compassion. Then she laughed with that high lilting laugh and I was scared again.

That first day of dancing pressed every major button in my psyche and soul and I found myself constantly overwhelmed and challenged in every way, feeling completely out of my depth! Nonetheless, I persevered until the first time we danced Chaos. Somehow, I got swept up in the middle of a throbbing dance floor with our wild, sweaty, pulsating tribe, fully abandoned to the live drummer's beat.

Before I even realized, I went into a full panic mode and felt violently ill. I stumbled my way out the door into the night air and threw up. I laid down on the ground in fetal position and tried breathing my way back into my body. After a few minutes, I got up and went back inside to try and join in again, moving hesitantly around the outer edges. Gabrielle caught my eye and glided over and began dancing next to me. She could see my struggle and I could feel her giving me permission and encouragement to fully experience what was happening on my terms, all of this unspoken. I let go and offered up my resistance.

It seems so utterly simple now, but that small act on her part made me feel seen and loved. It was all I needed to push beyond my own control issues and edges. I consider that moment a true turning point in my life, when the dance began dancing me.

Melissa Michaels
Boulder, CO

Melissa began dancing with Gabrielle over 30 years ago and is a first generation teacher of the 5Rhythms. She now initiates and educates emerging leaders around the world.

I was in my mid-twenties, sick of my scene and ready for change. I was heading to an Al-Anon meeting in my hometown of Pittsburgh. Posted on the co-op wall was a flyer that riveted me into attention. Staring right at me was this dark-haired woman, wired to her headset, sitting on concrete city steps, a funky mysterious being who was offering a dance workshop in my very own neighborhood. I did not even see her name. I just knew I had to be there. I wasn't even a dancer. I barely knew I had a body.

My babysitter did not show up the next morning when the workshop started, and I let go of being able to attend. Then a friend drove by as I was playing outside with my daughter, and when he heard my situation, he looked at me and said, "No way! I will take Mariah for the day." He must have sensed something significant was in the air. And indeed there was. And so I managed to get into the room and meet one of my soon-to-be greatest mentors, Gabrielle Roth.

The first day of dancing, I was so out of my body, yet psyched to be moving energy, that I blew out my ankle. Sprained and swelling, of course I could not then disappear in the group. Nervously, I shuffled up to Gabrielle. She smiled warmly and told me to dance off of my feet and begin using my whole body on the floor. She also encouraged me to join her group going out for lunch. As we drove through the city streets a few hours later, I sat behind Gabrielle in the car. She was talking about her first Teacher Training that she was beginning later that year.

I asked her, "How do you know if you are ready for something like that?" She turned around and simply said,

"Often those who do not think they are ready are the ones most ready. Pittsburgh needs a shaman. Why not apply?"

What could I say to that? I applied.

photo by Robert Ansell

My conversations with Gabrielle were always brief. I was shy. She was quick to respond. She called me her baby. I sometimes really acted like one too.

"Gabrielle, we have to figure how to work with trauma when moving the body so much. Look at me."

"Melissa, that's yours to figure out."

Bam. I dedicated the next decade to the interface of the 5Rhythms and trauma renegotiation.

"Gabrielle, I had a dream where I saw this old woman standing, overlooking the vast desert. She lived on a big ranch. Everyone had gathered there. I know it was you."

"Really Melissa, try again. That was *you*."

Bam.

She always knew.

I followed Gabrielle around. She took me in. I followed her around. She ignored me. I followed her around. She taught me that the one I was looking for was inside me.

I finally found her.

It took a few decades.

She gave us all a compass. We either used it or not. She took us into the woods. Left us to find our way out.

I did.

She never taught again in Pittsburgh.

I did. On the banks of the Allegheny River, our date with destiny was kept.

Dancing through the layers of confusion, of heartbreak, of disembodied trauma seeking resolution, we slowly healed. We emerged connected, and as she would say, *congruent*. Madly creative too! Thirty years later, we have true gifts for the world. We are part of Gabrielle's legacy. We have returned home…honored, innovative, and dancing.

Meredith Davies
Woodend, Victoria, AU

Meredith is co-director of Moving Essence. She trained to teach 5Rhythms with Gabrielle in 2001 and was instrumental in bringing the 5R curriculum to Australia and New Zealand.

Gabrielle was sitting on the edge of the stage during a Teachers Refresh (Jan 2009) and we were all sitting on the floor waiting for the next thing. She had been given something to read and as she picked up the paper, she fumbled to gather her glasses and put them on…I noticed this moment and spoke up, saying "Oh, you look so cute." She looked up very deliberately and said,

"Well, *nobody* has ever called me cute before!"

I had a phone call with Gabrielle back in about 2008. We talked for a long time; in fact, I was gardening at the time and walking around with a rake and garden tools in one hand and the phone in the other. She was rabbiting on quite a bit, and talking generally about the 5R field. The one thing that stood out for me in that call, was her saying,

"I sit at the axis of all complaints."

I remember having one of those Dance-of-my-Life experiences, where at the end of the dance, I had no idea where I was, who or what I was—literally just an experience of energy, in the shape of an exhausted body in the yogic child's posture on the floor. The group gathered and suddenly I sensed some feet just behind and gently tucked under me. I was surprised: Who was this? What are we doing? Looking around, I saw that the feet belonged to Gabrielle—she was standing behind me.

Michael Stone
Gibsons, B.C.

Michael is the host of KVMR's "Conversations," loves the 5Rhythms and dances with Gabrielle in his heart every day.

Every August I would go to her month-long trainings. I went because I felt seen by her, although she scared the shit out of me. Yet I couldn't get enough—it was like buying an E-ticket on the scariest ride in the park, and she never disappointed. Some broken shard of my self-encapsulated ego was always left on the dance floor.

For years Gabrielle was very insistent that nobody take notes in her workshops, saying that our bodies would remember the important stuff, and all the rest was useless mind-chatter. So one day we were gathered on the floor during a session to listen to G do one of her spontaneous brilliant talks, and I had my notebook out and was scribbling furiously.

"MICHAEL!" she called out, upon noticing me there with my head in my journal instead of being present with her. As soon as I heard my name, I instantaneously tossed my notebook and pen high in the air.

She and everyone else laughed uproariously. Just one of those moments to remember.

Mirjam Van Hasselt
Amsterdam, Netherlands

Mirjam is the founder of Moving Sparkles, and always loved dancing more than talking; she met Gabrielle in 2003, and eventually became the first teacher of the 5Rhythms in Beirut.

One of the many powerful experiences I had in the years I have been dancing the 5Rhythms was with Gabrielle in California, during "Mirrors" 2010. I was doing the "Repetitions" exercise with a partner, in front of the group. We got stuck in the usual stuff:

"I'm nervous/You're nervous."

"I'm stuck/You're stuck."

I remember trying to get out of that stuckness without success. Gabrielle interfered, inviting me into a repetition with her:

"You're a wounded healer," she began.

I was wearing a bandage at the time. I repeated, as we do in repetitions:

"I'm a wounded healer," taking it on, with joy.

I can't remember many more of the words that continued between us. What I *do* remember is the vibrancy, the lightness, and the provocative playfulness in that meeting. She invited me in a loving and provocative way to show myself and to stand up as I am. And I—we, I guess—had fun.

During our first module of the Teacher Training, our main topic was the "Embodiment of the 5Rhythms." Gabrielle was already ill during those days and it was harder to speak to her personally. She attended sessions and rested during our breaks, so a chance to work with her in person was a rare opportunity.

During our session about Chaos, Gabrielle asked for a volunteer and I stepped in. She molded my body with her instructions. She gave direct physical feedback on the body level with her words. It felt like with every instruction she was literally sculpting me toward the shape and experience that she was looking for. We were working one-on-one in a bigger group and she was totally with me in that moment. Instructions that I remember were things like:

"Move like you might fall over, like you are on the edge…now hold it."

I was stretching my upper body outward and forward, reaching and almost tipping over.

"Relax your shoulders…now breathe…bring your weight down more into your feet…yes, and still

keep it on the edge of falling."

The dimension of grounding and at the same time almost tipping over gave me a sense of surrendering.

"Okay, hang in there…yes…and now move on."

I was finding a new way of moving with this new feeling of edginess.

"And stop."

Now my body was curving backward, even harder to relax in that posture, and she gave instructions like:

"Now take it to the edge, a bit further…drop your shoulders, relax in the 'here' and breathe…yes, and take it further, take it to the edge here again…you're almost falling…open the chest."

I felt like there was an open space in the back of my body, a space to fall into, and it was just a moment of relaxing in the falling/not-yet-falling: free, relaxed and present in the surrendering, on the edge.

"And now move on."

This went on for a while and I could feel the energy vibrating in me and between us. It was hard "work" and exciting. I got the experience of a different way of Chaos. I could sense that we both loved working and playing that way, so incredibly physical and precise. I was a bit nervous to be that exposed in the middle of some 80 people witnessing, and at the same time there was so much pleasure and expansion.

When the session was over, she came to me and we shared about how much we both had enjoyed that experience. She told me something like:

"I so much love working that way. I don't have the opportunity very often. That is what I really love doing. When I come and do a theatre piece in Europe, I want you to be there."

This gave me the feeling that she really could see me, and was acknowledging what had happened for both of us, which is still precious to me.

And I guess we were both aware that it was a question as to whether that theatre piece would ever happen.

Muireann O'Callaghan
Stonington, CT

Muireann is a writing teacher and managed the 5Rhythms office—then called "The Moving Center"—in Newark, NJ and NYC from 1998 to 2000.

When Gabrielle was in the hospital for a lung biopsy in 1998—(at least a decade before her cancer diagnosis, Gabrielle had a brief forewarning that was negative)—I worked as her office manager for The Moving Center. As I recall, the only person allowed in to see her during those few hospital days was Robert. But for some reason, I don't remember why, I was asked to visit—perhaps for updates on classes or mail or phone calls. It seemed an odd time to catch up on business—organizing paper was not really Gabrielle's thing, as she told me; organizing energy was her specialty.

When I walked into her hospital room, I acted reserved and smiled and commented on the fancy wood paneling in the room. She remarked on the food and was happy to say a nurse had access to just the right music when she needed it. But then the issue of the hot water bottle came up.

"Fill it the right way," she said, handing me a bloated and heavy red rubber case. I grew up in Ireland when the only option of keeping toes warm in bed at nights was a hot water bottle, and somehow Gabrielle must have known this. I emptied just enough hot water from the bottle and let it drain down the bathroom sink, squeezed out the air, wiped the lip with a towel, and screwed on the top. I wrapped this lighter hot water bottle in a towel and placed it back in her arms, where she let it rest on her belly, and closed her eyes. It was something grounding in a disorienting environment, and she was content with this comfort.

Later the next week, she asked me to work from her Union Square loft instead of at the office. I did the usual tasks of filing letters and scheduling events and making calls; but she asked me once again for a comfort task.

"Will you wash my hair?" she said, dressed in a bathrobe.

I really didn't want to. I was so scared of hurting her. But I was more nervous to say "no," so ran the kitchen tap at a medium setting and lathered her black hair as she leaned her head forward, arms resting on the aluminum edge of the sink. I could tell she was frustrated with my tentativeness and cautiousness. She didn't want me to be so careful. I'm guessing it was a bit of an insult to her, me treating her as if she were weakened. After all, she was a strong woman who was not going to be hurt by some soap and water in her eyes or a bit of

strain on her bent back.

I was grateful for those intimate moments, when she let me see her as vulnerable and dependent. She could have scheduled a nurse or her massage therapist or asked Robert or one of her many dear friends. But she wanted to get a few basic things done, no fuss, just business-like, as independently as possible. But doing business with Gabrielle was never quite just business; it involved a good deal of heart.

Nancy Lunney Wheeler
Santa Cruz, CA

Nancy was the Program Director and a Musical Theater workshop leader at Esalen Institute for many years, and is the creator of "Gestalt Singing," a weekly practice she offered there. Her and Gabrielle's career evolved in a parallel manner and chronology.

In around 1969, my then husband, David Lunney, who had read about Esalen when the article written by George Leonard for *Look Magazine* first appeared, decided that taking a workshop there was just the thing he needed to do. I thought this was crazy, and definitely not for me! But he was determined to go, and the only workshop that had any room in it was a five-day program called Yoga, Movement, and Massage, and it was to be taught by a young woman named Gabrielle Roth. So he signed up, and I stayed home with our not-quite-two-year-old Elizabeth.

When he came home, he was glowing with the experience, and told me much about the teacher, and how she was so pregnant that they all expected her to deliver on the spot. I was not persuaded that this Esalen place was an experience that my New York sensibility would be comfortable with, so shortly after that David cleverly decided that we should take a family vacation, driving up from LA where we lived, heading north, strategically passing through Big Sur, where of course we would stop by Esalen so I could check it out.

Gabrielle was living on the other side of the property. Which house it was I can't remember. Maybe the Jade House. But we ran into her. I had never met anyone like her, so graceful in a way I hadn't come across before: interesting, charming, penetratingly smart. She decided that David and I needed to go to the

baths without Elizabeth for my first time there, and she so sweetly offered to take Elizabeth for us while we did. That prescient gesture gave me the opportunity I needed to feel Esalen in a way I couldn't have imagined.

Little did I know that that visit, with her support, would end up with Esalen becoming my life's work some years later, and that it was the beginning of a relationship with her that spanned decades, watching and supporting her as her work developed, and as she became known as "the star"—the fierce force of nature she always was. It took some time for me to get up the courage to take a workshop with her, but I finally did—a never-to-be-repeated experimental five-day featuring Gabrielle, David Schiffman, and I believe Alan Schwartz. She was as kind and patient with me as she had been on the day she had taken care of our daughter for my initiation to Esalen, the day that I see now ultimately changed my life. My only regret is that I never thanked her in person for being such a catalyst for me.

Neda Nenadić
Brighton, U.K.

Gabrielle said to Neda: "You, my dear, are pure chaos." And Neda said to Gabrielle, "I love you forever and afterward..."And we are still dancing that dance...

The first time I met Gabrielle I was 26, in Devon to do a 10-day "Mirrors" workshop. It was my first residential experience and we did *amazing* work. I started dancing when I was about 20, so meeting the founding teacher of this 5Rhythms work was a big deal to me. A lot of my friends at the time had gurus and followed particular teachers, but I had never ever met anyone that I wanted to follow. I was always quite strongly opinionated and stubborn I guess.

At the end of all those teachings for 10 days, Gabrielle got up and said,

"Everything that I have said to you could be wrong. Don't follow me; find out for yourself through your own dance."

I think that's actually the moment I felt in my heart that "this is my teacher." This incredible lady had just simply negated everything that she had said and made the Dance itself the most powerful teacher.

I thought I really understood what this practice was about.

~ ~ ~

During the second module of our Teacher Training in New York, we were talking about each of our rhythms. I was speaking to Gabrielle and she asked me,

"What do you think your home rhythms is?"

I was looking at her, trying to clarify why I thought that it was Staccato, and I was giving her all these explanations. She just lifted her hand up, looked at me, and said:

"You, my dear, are pure Chaos."

And I *so* wanted to be clear and work hard to have Staccato as my home rhythm, but to this day I know Gabrielle got it right.

Another teacher recently said to me, "Neda, you really are a true queen of Chaos." And yes, it is the Chaos rhythm today that so deeply plugs me into something in my soul, both when I dance Chaos or teach it.

~ ~ ~

Quite a meaningful thing happened on that second module of the training. Gabrielle very clearly explained that,

"If you have to work *so* hard for something—if you have to analyze it, justify it, struggle with great difficulty to hold onto it—how would it actually be if you were to just surrender and let it all go, and seek empty space?"

And so that was when I came back to England after years of challenges in my marriage and I decided to let it go. I told my husband that I was ready to not analyze and work so hard at our relationship. Because deep down in my gut I knew for a few years that our marriage was over, but I just didn't have the courage to leave. And by letting go of my marriage I had to enter into a completely new level of engaging with my own self-hatred and fear and living as a human being.

That so-called "emptiness" held a lot of needed work for me.

~ ~ ~

In one workshop I was in, she told us,

"When you come to a group or situation in life and there is somebody that you absolutely adore, and you have put them on a pedestal and you are in absolute awe of them, there is something about that person that you have disowned within yourself and have projected onto this other person. If there is somebody in the room that you literally can't stand and all you do is judge them and criticize them for who they are, there is something in there as well that your self has disowned. When this happens on the dance floor, walk straight towards it; there is something for you to learn there."

I have followed this on the dance floor and in my life and every fucking time it was absolutely true.

Nora Bateson
Stockholm, Sweden

Nora is dancing with Gabrielle in words and images across generations, ranging from her father, Gregory Bateson, to her daughter Sahra Brubeck, who was goddaughter to Gabrielle.

Gregory, Gabrielle, and Me

My father was dancing.

His extra-long, extra-white, extra-old legs were lifting like a mime rhythmically expressing the movement of a praying mantis. His forehead was a planet in distant orbit to his huge hobbit feet. But his hands were full of the world.

Gabrielle moved in another texture, her body was in lithe communication, capturing bright gestures. My father was more like an enormous marionette. They reorganized my future in that moment.

He enjoyed this research of pattern, connecting to the realms of rhythm and knowing—without words. To be frank, he scoffed at almost all of what was going on at Esalen in those days. He found the thinking to be lazy. But he liked to say that,

"Gabrielle is onto something important."

And they danced.

As they did, the old man and the woman in black were contributing a new archetype to the world.

It was 1978. I was 10. I knew that the way they danced together was how growing up would be. I was so sure I was growing up in a world of Gregory Batesons and Gabrielle Roths; I was. I saw the two of them dancing open the vastness between mind and body.

Around them so many young seekers moved in melodramatic earnestness. By contrast, Gabrielle and Gregory's dance was a new architecture. Their dance traveled in curious integrity, sparkling humor, and was a theater of new truth.

The emotion-scape they found was well outside the mire of sanctimony.

As a child, I saw in the adult world a moment of honesty I would never let dim. Decades after my father's death, and not so long before Gabrielle's, I phoned Gabrielle to tell her about a dream I had had. In the dream we were playing a game of identity where we took turns dancing expressions in gestures of an aspect of self. Our bodies formed symbols that reached into other times. In the dream we called the game, "Capture the Flag."

"Oh, I love it," she said through the phone.

And I knew she would.

Gregory was one of the most inspired and inspiring individuals I ever knew…he had one of the most profound minds of our time…his genius was contagious…other teachers had recommended my work to their students, but Gregory actually did it, surrendered himself to it totally. Seventy-seven years old, his lungs shot, his feet so swollen he could barely walk; he never missed a beat.

—Gabrielle

Peter Mandl
Montreal, CA

Peter worked closely with Gabrielle in designing and creating 5Rhythms websites (including 5RRO), as well as for workshops and events.

Gabrielle put the ART in HEART. Together, we created 5Rhythms-inspired artworks for workshops and the web. I dove in, long before we had met or even talked, emailing her a first round of exploration. It was months later that she replied,

"I fell down a rabbit hole! Let's talk."

One of Peter's creations.

At that, my head was spinning! I wanted to be ready to explain the designs in detail, but the more I reasoned, the deeper the chaos. I called. And in that voice that truly grabbed me, Gabrielle had just one thing to say about the work:

"It's beautiful."

No explanations needed. Deep discussions could wait. She received what was there, trusting in what would come. Which just made me want to give her more. And so I did. From the heart.

Peter Selwyn
New York, NY

Peter is a physician who was honored to meet Gabrielle during the last months of her life, and later enrolled in the 5Rhythms Teacher Training program.

I met Gabrielle in June of 2012, in the cliffside dance dome at Esalen; it was her last workshop, and my first. I knew nothing about Gabrielle: not that she was very ill at that time with recurrent cancer, nor that this workshop would be her last, nor that teachers from all over the world would be coming to spend this last time with her.

~ ~ ~

More than 30 years earlier, the year I graduated from medical school, I made a brief visit to Esalen while on the West Coast for internship interviews. I had heard there were amazing mineral baths there, but I learned when I got there that I couldn't just walk in unless I was registered for a workshop; however, I was welcome to come back after one in the morning to use the baths.

It was a moonlit night, 2 am, with more stars than I had ever seen before. A light mist was hanging over the ground, and as I made my way in the darkness down the path, I started to hear some rhythmic drumming, faintly at first and then insistently louder. I felt drawn to a deep, pulsating energy that I started to feel in my chest, as if something was waking up inside of me. I realized the drumming was coming from the lodge, and I approached to hear and see it more closely, and looked through a large window into a dimly lit room.

Inside were about 20 people, all moving to the primal, penetrating rhythm of the drums, completely immersed in the beat, no one watching or following anyone else, yet seeming to move together as if one giant

264

organism. There was a thin woman with jet-black hair, walking through the room beating a hand drum, who seemed to be the leader of whatever this process was that I did not fully comprehend. I was transfixed, but also felt a little voyeuristic, like this was not meant to be observed, just experienced.

Reluctantly, I turned away and made my way down to the baths, then back to my Big Sur campground, then down to L.A., and finally back to the East Coast, where I did my training. I then spent the next 30 years becoming a doctor and immersing myself in the AIDS epidemic and the care of dying patients.

~ ~ ~

Fast-forward to 2012, the first day of a five-day workshop at Esalen with Gabrielle. The 100+ participants greeted each other warmly in the dance dome, with overflowing hugs and smiles. I thought to myself that these people really seemed like a special tribe, with their own language and rituals, reuniting after a long sea voyage or exile. I heard many people asking each other, "Where do you dance?" and "Who is your teacher?" to which I could only reply, somewhat sheepishly, "I've never done this before."

Robert and Sanga played the drums for most of the sessions, and I felt like I was dropping into something that felt immediate, energizing, and fun in an unexpected way. Something felt oddly familiar about it as well, though I couldn't define it exactly. Gabrielle began the second day with some verbal teaching, sitting in a chair like a beloved schoolteacher, with us on the floor leaning in to be sure not to miss anything.

"Doing these workshops at Esalen," she said, "I always feels like I am coming home. The practice started here over 30 years ago—sometimes I would lead long sessions of drumming and dance, usually in the main lodge, going late into the night, where people would experience dropping into the rhythms for hours at a time, sometimes entering a trance-like state."

I suddenly jolted upright, and realized that this was exactly what I had seen and been drawn to *30 years prior*—as if my whole life had brought me in a great arc from that moment to this one; as if, oddly and unexpectedly, the rhythms had brought me home.

After the session, I told Gabrielle the story. She smiled and said,

"Welcome back, I'm glad you made it!" and I thanked her.

Late that night, I sat in the baths and looked up at the night sky filled with stars, reflecting about everything that had happened over those 30 years: how many choices, how many lives and deaths I had encountered. It

started to seem like more than just a coincidence that I was back there.

Each day of the workshop concentrated on a different rhythm, and the next day turned out to be "Chaos day." Gabrielle said,

"Chaos is often the rhythm of deep sadness; sometimes it is held, without knowing it, deep in the body, and it may start to move and be released as you let yourself go and enter more fully into the rhythm."

Like most things I had heard in the workshop, I had more of an intellectual understanding of her words than a visceral one. That suddenly changed, though, about halfway through a long Chaos sequence later that morning. After about 40 minutes, I felt myself dropping deeply into repetitive, shaking movements: bouncing, rocking, left/right, back and forth, feet on the floor, head shaking, arms punctuating the air like a wild bird. Suddenly I felt an upwelling of tears and deep sorrow, seeming to come from my core, relentlessly, rising up and pouring out in uncontrollable sobbing, no words or explanation, just release, going on for minutes that seemed beyond time, flowing until there were no more tears, flowing like the waves rising up from the sea below, building, crashing, and receding on the rocks beneath the cliff.

No one in the room of a hundred dancers seemed to notice, except for Gabrielle, who was dancing with us at that moment. I saw her noticing me from about 20 feet away, through the crowd. She stopped moving and looked over at me; I had stopped moving too, and was just standing and holding myself in a hug. She smiled, gave a little nod of acknowledgment, and then we each started moving again, back into the mass of swirling bodies.

I remember thinking in that moment how powerful this medicine was. As I would hear Gabrielle say many times over the next six months when I spent time with her in New York,

"The movement is the medicine."

I finally understood that statement, and witnessed firsthand how, without words or stories, the body-in-motion can learn to tell the truth and move through loss and pain to help heal itself. I felt drained, exhausted, cleansed, and invigorated, like some new life energy had just moved inside me. In closing, Gabrielle said to the group, although I felt she was saying it directly to me,

"When we are able to fully let go in Chaos, and leave everything we have on the dance floor, the body becomes open, empty, free, and becomes the begging bowl of the spirit."

<p style="text-align:center">~ ~ ~</p>

Gabrielle was incredibly generous with her time and attention during those months I spent with her in New York, even with her own advancing illness, right up until weeks before her death. We met numerous times to discuss my hopes of bringing the 5Rhythms to the hospital where I work in the Bronx, to bring healing to our patients, caregivers, and a diverse urban community. She was enthusiastic, supportive, visionary, and totally engaged in helping me bring this into being, even as she was dying. Through her generosity and collaboration, we started bringing the practice into the hospital and community, integrating it into programs for medical trainees and staff, as well as for caregivers dealing with grief and loss, and for people of color from the inner city.

This has become the new work of my life, a new wave that started on that Esalen cliffside eight years ago, or perhaps 38 years ago, peering into the lodge! I feel lucky to have encountered such a fierce warrior of the heart, continuing her warrior's journey right up to the end. One day, as she lay with her eyes closed in bed, she mentioned softly,

"I am beginning to fully understand Stillness from within."

<div style="text-align:right">

Phil Brown
Colorado Springs, CO

</div>

Phil is an educational consultant who met his wife on the 5R floor, was honored to participate in an unreleased film of Gabrielle's teachings made a year before she died, and considers her a mentor.

In the fall of 2011, to my great surprise, I was invited to New York to participate for ten days in the filming of a documentary that Gabrielle intended to be a capstone record of her teachings. She clearly knew that lung cancer was getting the best of her, and so she invited a group of about 30 5Rhythms teachers from all over the world, sprinkled with a few people whom she picked for her own reasons. I was fortunate enough to be one of the latter; I figured I fit some category, such as "old white guy." Everyone in the film was there

for Gabrielle, really *there*. After the third day, my aging knees were so worn out I wasn't sure I could make it down the stairway to the subway platform. But my painful knees paled in comparison to what Gabrielle was dealing with.

We all knew Gabrielle was very ill. Her skinny frame seemed held up by sheer will and beauty. But when she entered the room she was totally "on." Her directions were completely purposeful, the changes she made in what she wanted from us were on the spot, in the moment. A few days in, Robert told me that she couldn't eat solid food, that it was too painful. A few times a day Gabrielle would gather us together and talk, mic on, cameras rolling. She mentioned once, early on, that it was hard to get comfortable sitting on the floor, because,

"I don't have much of an ass these days."

That was about the extent of her complaining, until about the fifth day in, when, during one of her talks, she paused mid-sentence, searching for a word, then said,

"That damn Percocet!"

and then went on teaching for five more days.

It was an experience that permanently changed my attitude from "This practice is something I *do*," to, "This practice is who I *am*."

Phillipa Oneal Burgess
New York, NY

Phillipa was Gabrielle & Robert's housekeeper for 40 years!

I remember one day I came to the house and she was in the bathroom putting a color in her hair, and instead of it turning brown it was a bright orange. We fell on the floor laughing.

Rebecca Henderson
Louisville, KY

Rebecca Henderson The Bluegrass Gypsy is a published playwright, storyteller and ukulele player who is devoted to Gabrielle in the Divine, and never knows how anything happens.

I read a poem aloud in a workshop and Gabrielle said,

"You rocked that writing Rebecca."

Amazing how timid I can be. She helped me see that. She taught me courage through the wordless journey of movement in emptiness. And she reminded us that,

"The hands are the Messengers of the heart, and the hands writing are the spider's dance of the mind, grounding its chaos...into the art form of writing."

I had profound dreams of spiders that summer.

She directed us to all dance nursery rhymes, and dropped a line to me about the "itsy bitsy spider" and when it "gets washed out" how it simply begins again...hmmm.

And each day during that month-long gathering, she would make sure the bees stayed outside. If a stray one got in, she would say,

"Wait, we have to get that bee out of here, I *hate* bees! Could someone help? Please be careful."

~ ~ ~

"I am always looking for the Exit door," she said. "I check that out first thing when I get into any room."

That stuck with me because in theater history I learned how many people had died in fires caused by footlights (candles floating in oil pots) and later the gaslights also trapped many audiences and actors. She would have us explore a room and the empty space just to notice where the edges were: exits, windows, ceiling, floor, and then any shapes or feelings that had no words.

"If you don't do your dance, who will?"

~ ~ ~

The "Repetitions" exercise became my nightmare. Gabrielle threw a glass of water on me; I was all wet then.

~ ~ ~

Long ago, perhaps 1989, I had a copy of a feminist magazine called *Snake Power* that had a black cover with a purple snake on it, and featured an interview with Gabrielle about her new book *Maps to Ecstasy*, and that is what allowed me to find her. Years later at a birthday dinner for me, I shared that story with her. She digested what I said, gazed at me across the table and said,

"Rebecca, there were only about 300 of those magazines printed in the whole world, and YOU have one in Louisville, Kentucky."

She just gazed and made a Raven-like movement with her head, and eyebrows; a smile.

~ ~ ~

Remember her answering machine message? Her voice answered,

"Oh, if I'd known it was *you*...I would have NEVER gone out. Please leave me a message."

Rivi Diamond
Beit-Zayit, Israel

Rivi completed her training with Gabrielle in 2008 and became one of the first three 5Rhythms teachers in Israel, where she teaches weekly groups to this day.

Gabrielle was informal and down-to-earth friendly, as I found out the first time I met her in person. I had moved from Israel to Philadelphia for a couple of years, and my first project in my new city was to build up a 5Rhythms community, which did not exist there at the time. Only three months after arriving in the states, I produced my first workshop and a viable dance community in Philadelphia was unleashed.

A bit after that, I went to dance in New York with Gabrielle for the first time. Of course I was all excited, a bit nervous, and kept a respectful distance from the famous Gabrielle Roth. When she heard my

name—(to my surprise she already knew I had set Philly on fire with the 5R)— she talked to me like we were old-time school friends:

"Girl! You rock!"

She always answered my emails within a short time, writing in lower case letters, with friendly warmth, being as real as it gets:

"i'll write more later gotta run to get my taxes done."

And when I expressed concern for not having all my prerequisites completed to apply for the Teacher Training (being a mother of two young boys and living in a remote country had limited the possibilities and opportunities for me to attend the qualifying workshops) she dismissed my worries with a hand gesture and a face that clearly said,

"Of course you're in."

We all know that Gabrielle was in no way, shape or form, ever a "by-the-book" person.

Robert Dilts
Santa Cruz, CA

Robert, an author and trainer of the Hero's Journey and NLP, was deeply inspired by Gabrielle's genius and incorporated her maps into his work.

The very first time I met Gabrielle, she walked through the door of the restaurant and tripped and fell, and I caught her and she said,

"I think I'm falling for you." :-)

That was such an example of her wit, her ability to pun, her way of making you feel good. To make a pun out of something that wasn't initially verbal—at the same time that she's actually falling—that was just how she was, able to see things from multiple perspectives.

Roger Peters
New York, NY

Forty-two years ago, a wet Gabrielle ascended the hill from the Esalen baths to the deck and into Roger's life; she and her creative energy continue to inspire his work and study at Columbia in theater and film.

I met Gabrielle 40 years ago at Esalen, when I was assistant, secretary and general factotum to Gregory Bateson during the last two years of his life. I love Stewart Brand's dedication in The Whole Earth Catalog:

"To Gregory Bateson, one of the ten greatest men of the twentieth century. If Gregory is in heaven, and I could get to heaven by being good, I'd be good."

We all knew Gregory arrived in Big Sur to die, following horrific exploratory surgery and a diagnosis of terminal lung cancer, having lost over one and a half lungs in the process. He lived at Fritz Perls's house and made a daily pilgrimage to the Esalen baths, which I think he loved almost more than anything. Because of his diminished lung capacity, it was necessary for him to make several stops on the long walk up the hill to recover his breath, and benches were constructed along the way for him to rest.

It was during this sacred time that Gabrielle literally bounced into his life. She was conducting one of her huge workshops in Huxley when Gregory walked slowly past and stuck his head in the door. Gabrielle invited him in and quickly saw that the necessary chair was fetched for him to sit. Of all the work I did for him, and time I spent with him, he once told me that the most useful was keeping away all those people who wanted to take up his precious time, whilst welcoming those he *wanted* to see and be with, since he was *truly on a deadline,* writing his two final books.

Yet the magic of Gabrielle created an immediate attraction for the great man, who began to attend each and every session. And his eyes would light up as she stuck her head in his door up at the house for the evening ritual of Dry Sherry & Stilton Cheese. The relationship continued in its depth and complexity, flowering later in a "Roth/Bateson Workshop"! The last time I saw Gabrielle, she told me of the final wave in the time she saw Gregory. She was again teaching in Huxley; Gregory had hauled himself up from the baths and into his chair. Sometime later, in telling the story, she declared,

"I got him up on his feet and he danced and danced and danced with the class."

And this glorious image, just a short time before his death, is the last I have of Gregory & Gabrielle—no one else on earth could have done what she did. I loved them both.

Ron Hagendoorn
Rotterdam, Netherlands

As Gabrielle once said, "You can take Ron out of Holland, but you can't take Holland out of Ron."

All or Nothing

Gabrielle was an inspiring and at times also a challenging woman. I sometimes heard people say: "She is not for everyone." Some people were afraid of her because she was so unpredictable. I was one of the many people who trusted her intention. She challenged us to wake up and bring out the best in ourselves. Our true, radiant nature. Are you ready for a challenging story about Gabrielle Roth's style?

We were together with 150 people in Germany. An international workshop led by Gabrielle. She never played music from a sound installation, but was always with "her" drummers. Dancing to live music with such a large group is a great experience. But not always.

It was the second day of the workshop and around noon we had a break. After the break we came back onto the dance floor and the energy and inspiration was very low. The lunch break is the time to take a nap afterwards. And with that energy we started to dance.

Gabrielle worked hard to get us moving again, and she did that by inspiring us with words. It was without result. After a while she stopped the live music and asked everyone to come together, and she said,

"This is very precious time we have together here. You need to have a powerful focus to awaken your soul. It takes real discipline to become a free spirit. So you have two options: Change your attitude and dance with much more attention and discipline, or go home."

The whole room was in shock, because she was serious! As far as I know, nobody chose the second option and nobody went home. But everyone was aware of the fact that we were not there to swallow something. Imagine what effect these words had on a group of 150 people. The dynamics changed completely, and we danced as if it were our last dance here on earth. Wild, deep and full of surrender.

Gabrielle took the dance and the freedom of the soul completely seriously. And she did that with a lot of humor. And I am eternally grateful for that. I started to love her and I still do. Thankfully, I can develop my own style and keep the 5Rhythms alive with many colleagues around the world.

Sarena Wolfaard
Edinburgh, Scotland

Sarena is the co-founder of Handspring Publishing and has been inspired by Gabrielle since 1999.

I was doing a "Mirrors" workshop in Totnes, Devon, in the U.K., early 2000s. A few of us went clothes shopping one morning, in the eclectic little shops in Totnes, feeling a bit guilty about doing something so "superficial" while attending such a "deep" workshop. In walks Gabrielle.

"Honey, this is the color for you."

She hands me a pinkish/reddish coat to try on. I am astounded that she recognized me, being one of about a hundred participants, and that she knew what would suit me. I would never have chosen this color myself. It was magic. I still have the coat, the zipper has long gone, but in my heart I just can't bring myself to throw it out.

Occasionally it comes out and I wear it with pride, shabby as it is now, but with such a beautiful memory of a moment in time when I felt Gabrielle's spirit in a wee shoppy in Totnes.

Saryo van Lakerveld
Delfgauw, Netherlannds

The 5Rhythms have been moving in Saryo since 1991 and he has been teaching the work since 1998.

In the beginning when the 5Rhythms was not known so much to a larger audience, my wife Mati and I started to have a close relationship with Gabrielle. Mati applied for the Teacher Training way before the training even existed. When Gabrielle finally found the form to put her work further out into the world, she created a Teacher Training and began accepting people into the program; Mati was directly in. I was looking at that and felt a little bit of jealousy, but quickly denied that feeling. Then we did some of Gabrielle's workshops in White Sulphur Springs, California and I remember her stepping into this big hot tub, naked, walking straight over to me and saying:

"Why the fuck are you not applying for the training?"

I was shocked, as if she could look right through me. The next thing I knew, I applied. That was 20 years ago.

Mati and I did not have the money to do the training; we were actually in debt. We decided to grow a big marijuana garden in the attic of one of our friends' homes, and we made very good money with it. One week before the training started, we had everything together, including flight tickets, accommodations and so on. We were exhausted, because we had been working seven days a week to come up with all the money.

We closed up the garden and went to New York. The first two days Mati and I were sick—so sick that Gabrielle made a bed for us on the stage in the workshop room, and gave us time to recover. We told her why we were sick and exhausted. She had such a big laugh about how we did it. From that moment on, whenever someone came to Gabrielle saying that they did not have the money for the training, she would say,

"Go talk to Saryo and Mati, they will tell you how to do that."

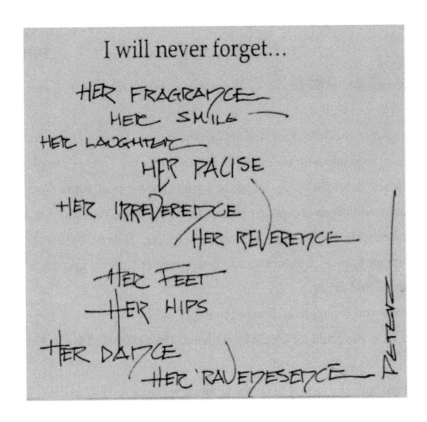

I will never forget...

HER FRAGRANCE
HER SMILE
HER LAUGHTER
HER PAUSE
HER IRREVERENCE
HER REVERENCE
HER FEET
HER HIPS
HER DANCE
HER RAVENESENCE — PRESENCE

Shoshana Diamond
Stowe, VT

Shoshana appeared in Gabrielle's world in 1998, became a regular, and was certified to teach the 5Rhythms ten years later; she was often asked by Gabrielle to demonstrate "flowing feet."

Upon first meeting, she asked,

"What do you do?"

"I'm studying photography."

"Sometimes I wish I could have gone into film or photography; you know the eyes are the windows of the soul."

~ ~ ~

"A mother's work is never done," she said, as I was sweeping up a mess of Jonathan's.

~ ~ ~

The Chapel of Sacred Mirrors (COSM) in New York: After a class with Sanga on drums and Gabrielle teaching Jonathan's Tuesday night session, I was on crew and we were all hanging out afterward in the front of the building, along with Sanga, and Gabrielle came out. She joined us and we were talking about being torn by not knowing which lover to be with. She said,

"Why not both?"

We all gasped. Then she said,

"Just don't get caught!" And she smiled and walked away. We all laughed.

~ ~ ~

Gabrielle, after one of my "Repetitions":

"What is your resistance?"

I gave her lots of different answers that she wouldn't accept. Then I started talking about my dominating father and she said,

"There it is. Keep going with that thread."

Profound revelations and lessons ensued.

~ ~ ~

She told me:

"You are shy. You don't have to be 'shy.' I have been called 'shy.' People may *see* you as shy, but don't take it personally. It is useful. It will help you to observe the group field."

~ ~ ~

She would comment on my clothing and bags. She showed me how to wear a belt once:

"Wear a skinny belt and move the buckle to the side, not directly in front."

$\sim \sim \sim$

After about a year of doing 5Rhythms extensively, taking lots of workshops and classes, I had met her a few times and had convinced myself she didn't know my name. So one time after class I went up to her and introduced myself and said my name as if we hadn't met before. She smiled and said,

"I know who you are!!!"

I was floored because basically she caught me in the "seen/unseen" ego trip, and called it out.

Silvija Tomcik
Zagreb, Croatia

Silvija is a 5Rhythms teacher who found her calling and followed her destiny when she first read Gabrielle's Maps to Ecstasy *at the age of 20. She is the author of a book about the work called* Waves—Voice and Vision.

I was pregnant during my Teacher Training. I was in that first trimester, vomiting my soul, and I lost a lot of weight. I was sitting on the dance floor, and Gabrielle passed by and said:

"Honey, you look even thinner than me, that's not good."

$\sim \sim \sim$

Gabrielle invited me to be part of a filming project she was doing in New York, so first I immediately said "Yes, I am coming!" But then I realized that the dates were just after Thierry's and my wedding, so I told her that I wasn't sure if he would be happy for me to fly away to New York just after we got married. And she said,

"Oh, of course, bring him with you to be a part of it!"

It was like she was giving us this amazing and unforgettable honeymoon!!!

$\sim \sim \sim$

At one workshop somebody asked her, "Are you a good witch or a bad witch?" Gabrielle said,

"I am the one looking at both of them."

Sophia Campeau-Ferman
East Sussex, U.K.

Sophia has been dancing the 5Rhythms since 1989, is a certified 5Rhythms teacher, and a lifelong student and friend of Gabrielle's.

I was 22, an art student at university and had danced for a year each day on my own, following Gabrielle's first book. Gathering all my money to travel to the other side of Holland to see her for real was very exciting and scary. In some way I had managed to make up a vision of this round, earthy woman, calm and meditative, a female Buddha, Nature-bound.

One glance at her, standing up high, in all black, skinny, on the altar of the church where the event was happening, and I turned around, ran panting to the street, wanting never to go in again.

In shock, I realised that inside this church in Amsterdam was the more extreme, animated image of my own mother! And I so desperately was trying not to become her. Embodying the opposite of the ideal I had made up in my mind, instead of a calm, round-formed woman of the earth, I saw a skinny witch with piercing eyes, and a far-too-loud, all-American voice.

I swallowed my judgments and went back in.

Afterwards, when I had already fallen in love, I wanted to thank Gabrielle. When it was finally my turn, I didn't know what to say.

I looked at her and said: "I want to be like you."

She laughed out loud in her so distinctive chuckle (piercing into bones) and called out:

"So, be yourself!"

I looked back into her eyes and waited awhile. She stilled.

279

"You know what I really mean," I said softly.

She answered:

"Yes, give me your address, we will write."

And so we started a long relationship. Not just of dance, where she had been seeing the potentials of who I am that I could not have imagined myself, but also a friendship. When I lived in New York, we worked together one-to-one and she took inspiration from my dance, and at the same time I received so, so much from her. She took me in as a daughter for those years and let me look after her as well as she looked after me.

I wanted just one thing: to go onto the streets and perform her Ritual Theatre with her. During my first workshop with her, I told her so. Her answer was:

"That is my biggest dream too, but that is not happening for now; do you want to be a teacher?"

I returned with: "No thank you," and it took me another 20 years or so, during which I really tried to explore teaching, before I started to accept, "I am a teacher."

Once, with over 600 people in one room at a conference, she divided the Ritual Theatre dancers who were there into six columns, each facing about 50 people on either side of us. She was teaching the crowd, and us, about how she truly embodied her work:

"So that people don't just hear what I have to say, but see it, right up front, close, on ground level."

This was the fastest I have ever seen a mass crowd, who had started off sitting in chairs, ready to "listen to what the dancing guru had to say," being instantly ready to dance it, even when they had never moved before.

My highlight of being with her was near the end of her life:

For ten days, I had the privilege of being, dancing, massaging, cooking, creating and philosophising with just a handful of people, including Gabrielle and Suprapto Suryodarmo, Stillness Movement Master from Java, Indonesia. We were gathered at the beautiful farm of Hans Li in Hudson Valley.

Gabrielle was fragile at this stage and, while I was massaging her, I felt something small, but very wrong, in the right part of her lungs. (I still feel guilty that I did not tell her at the time.) When I mentioned something like, "It feels like I should not massage you too deep there," she asked me to do the opposite. But voilà, it is hard to hold those regrets and a bit stupid to assume things would have been different if only…

Anyway, she was fragile then and more present than I had ever witnessed her before. Full of

wittiness, humour, and honest sharing, deep and insightful. She wanted to show us her true colours, so instead of her habitual black, suddenly red, yellow and other colours came out of her wardrobe! In those days, she rebelled against her own sense of fashion, can you imagine?!

She was experimenting with eating also, as we cooked and prepared amazing food together. I knew how food had always been an issue for her (she had asked me to be her personal cook once, after I made a soup that helped her recover from an operation on her lungs some years earlier.) I asked her why she was eating all the food we were cooking.

"I am eating a little of everything that feels good, instead of following strict diets and being picky. I believe that my body can tell what is good for me as long as I can enjoy it."

I think it was her time to show us and herself that she could still do whatever she felt like, to grow and change. We spent those retreat days in healing and truly meeting each other, on Hans's exquisite land in the countryside. The workshop was called "Conversation in Motion," including meditative movement practices, conversations, and sacred ritual and theatre intended to bridge between our different cultures: the Far East, the USA, and Europe. Mostly Prapto led us but often he and Gabrielle created duets. It was such a privilege to witness these two Masters of Movement conversing on the front porch, speaking of deep spiritual matters along with mundane, day to day things, always laughing and loving, in such a place of great beauty.

And this is how it was, my relationship with my teacher, dearest beloved Gabrielle, who is always in my dancing heart:

A well of deep laughter, love and beauty, permeating even the most mundane, day-to-day moments of my life.

Stephanie Diamond
Cold Spring, NY

Stephanie is an artist who has exhibited her work across the globe, began dancing the 5Rhythms in 2006, and was certified to teach in 2018.

The last time I saw Gabrielle, she spoke directly to me for the first time in person; it was just a few months before she passed. This moment happened when we were in the threshold of the doorway after class. She overheard me speaking about meeting my husband on the dance floor. She paused and said,

"Cool,"

with a drawl that she only used when she truly meant it. I felt grateful to have this be my last time with her, and for her to know that she moves love so deeply on her dance floor.

~ ~ ~

There is a lot of talk these days about the Divine Feminine and Masculine, and how the ideal leadership is a combination of both. Robert and Gabrielle figured out this balance in a very powerful way, and I saw how essential their partnership and love was for the existence of the 5Rhythms.

I attended "Slow Dancing with Chaos" at Omega Institute, led by Gabrielle. I learned later that right before the workshop she had just found out that she had been diagnosed with cancer. Robert was there at the drums, as always, and he had a very strong presence throughout the workshop. When Gabrielle stopped or faltered, he would take up the teaching. Instead of replacing words she would have said, he shared his own experience. Gabrielle and Robert flowed in and out of teaching in a seamless, awe-inspiring manner. It was one of the most incredible workshops I ever took with Gabrielle and the first time I had heard Robert speak to us in that way.

Some years later, in 2017, I entered the Teacher Training. During the first module, we met outside of New York City, where Robert was able to join us. His role was to talk with us about music and rhythm. Yet he brought so much more to the room. In addition to music, he began to speak about Gabrielle. He shared his deep connection to the practice and the entire 5Rhythms community. The energy in the room shifted and Robert's great capacity for love was pouring out to and for us. He was transmitting his love for Gabrielle, for the Rhythms, and for us, keeping it alive.

Sue Rickards
London, U.K.

Sue was trained by Gabrielle to teach the 5Rhythms in 1994 and has been holding classes and workshops wholeheartedly ever since.

The first thing I remember is dancing and dancing and being very judgmental about how often my first 5Rhythms teachers would refer to Gabrielle. In my mean little mind I was thinking, "Who is this Gabrielle, why do we have to hear so much about her? I'll have to check this out for myself." So I saved up and saved up and got myself into a workshop that Gabrielle was teaching, all prepared to dismiss her.

So of course we danced and danced and my defenses started to come down—and she hadn't even arrived. She swanned in, clad in black and alive and laughing with someone. Defenses right back up. Danced and danced. Then later when she started to speak, I was mesmerised. As she spoke, she mentioned resentment, seemingly looking straight at me. "Bloody cheek," I thought, "who does she think she's looking at and saying 'resentful'!?" Whereupon her eyes swept straight back at me again, and she said quite simply,

"Double Resentful."

And even though I wanted to carry on in my surliness, I started to laugh at myself, and I was lost.

A short time later I shoved a note in her hand asking, "If you ever train anyone again, can I be one of them please?" (In those days there weren't scheduled Teacher Trainings as such. She had only trained a group of close students before, and I didn't know whether she would ever train anyone else again.) And here I am, still teaching her work in the UK over 25 years later.

Terry Iacuzzo
New York, NY

Terry was Gabrielle's Tarot card reader. From the very first cut of the deck they both knew they were kindred spirits from many lifetimes ago.

Gabrielle and I were both wild-heart mystics, ancient souls who found each other while fleeing from our desperate tribes that hounded and begged us to decipher their secret maps.

Terry, why do you still read Tarot cards? she asked me. *I read cards for a long time but found that the people I read for wouldn't let me go. I had to get away from it.*

Gabrielle trusted me to read her cards. She called me romantic; she wanted tough-truth. I told it to her. The first time I met her was when she came for a reading. Just as she sat down I told her that she was running out of her nine lives. She told me that she had been close to death many times but wasn't ready to go just yet.

Hers were the readings I longed for. Tough-truth. When others were asking about their soulmates, Gabrielle asked,

Tell me about the night. What does it want of me?

I didn't want to let her go.

Gabrielle was a giant next to me, walking alongside of her was a challenge. We loved our downtown streets.

Terry, what is it that makes us love New York City so much? I can dance inside the gears of its enormous machine. It grounds me. The chaos and noise, my music.

Gabrielle and I believed the city was our Tibet, our Hawaii.

She told me my animal spirit was Crow. Crow and Raven. We walked and talked without destination.

In the dark now, in the middle of the night I often hear her talking, she speaks the language of bird's wings. I decipher the sounds.

The meaning of night is…

Be still, listen, can you hear her?

I hear her in the wind, in the black birds on the Norfolk broads, in the music on the streets, in every black dress that passes by me, in the space between the stars.

There was only one Gabrielle.

I'll see her again one day; I hope we all will.

I remember when I was 4 years old,

getting my tonsils out,

and they brought me a coloring book,

and this nurse came over to me and said

"PANTS AREN'T GREEN,

PEOPLE DON'T WEAR GREEN PANTS!"

And my little crayon froze in space, but I said,

"MY PEOPLE DO!"

I mean who decides?

I was just ahead of my time.

—Gabrielle

Tim Foskett
London, UK

Tim is a psychotherapist and founder of Loving Men. *He first encountered Gabrielle in 1996, wearing only her underwear (see below).*

The story of the underwear is quite sweet. I had a report about my work with gay men that was hot off the press, and I'd brought a copy to give her at a "Mirrors" workshop in Britain, even though I didn't know her. (It's good to remember myself being so bold!) I took it to her cottage and knocked on the door but no one answered, so I opened it tentatively and called out hello. I heard her voice in response so I entered. We met in the hallway. Me with my report, and Gabrielle in her underwear, holding a towel. She thought my hello had been Jonathan, who was in the bath, asking her to bring him a towel! She was, of course, completely at ease. That was our first encounter.

The workshop coincided with my completing the purchase of a flat in London. Just before the morning session was due to start, I received a message that I needed to call my solicitor, urgently. Back in 1997 I didn't have a mobile phone. There was a pay phone at the venue but I didn't have any coins. I blurted out to a crowd of people, "Does anyone have any change for the phone?" Gabrielle's hand emerged from the crowd with a British 50-pence piece in it. It was exactly what I needed. I was shocked and disarmed by the simplicity of the gesture. But I always wondered why she was carrying around British money on her person just before teaching a session?!

Another encounter that sticks in my mind was on the first Teacher Training module I attended in Mill Valley, California, also in 1997. I went into the kitchen and Gabrielle was looking through the cupboards. I remember feeling a bit self-conscious and leaving the room after exchanging a few words. Then it dawned on me that perhaps she had actually been asking for my help to find something! Later that day I asked her if she had needed my help in the kitchen and she answered quick as a flash,

"Well, I always like being helped, honey."

Towards the end of the Teacher Training, I remember telling her I was going to have ear surgery and there was some risk that I'd be left quite deaf. We were standing in a studio with quite a lot of people milling around us. She looked at me with her dark brown eyes and in her low New York accent said,

"Are you scared?"

Of all the things people said to me during that process, it was the most refreshing and connecting sentence anyone had uttered. Of course I was scared, which I confirmed. She looked at me thoughtfully and said,

"You know there's always a place for you in this tribe, whatever happens, don't you?"

Again, she spoke straight to my underlying fear of exclusion, that disability so often brings. (I'm happy to say the surgery was relatively successful!)

Later, when Gabrielle was ill and having treatment in Germany, I was having another surgery on my ear. We swapped a trail of emails, just chatting about the day-to-day realities of her treatment and my recovery. It was a sweet, simple, connection between two humans engaged in difficult parts of life.

Tim Stephenson
Bali & UK

Tim was a student, trained 5Rhythms teacher, personal assistant, and friend of Gabrielle's.

30th August, 2019

Years ago, more than ten, I lived in New York with my partner Giles. Just for four months.

Every day I'd "ride" the subway from Brooklyn to Manhattan. Walk up from Broadway or down from Union Square, to my teacher's apartment on East 13th Street. Gabrielle was her name.

I never arrived before 11am; she didn't want me earlier.

I loved that. It allowed me time. Time to begin my day, savour the city. Watch. Desire. Dream. Gape. Time to prepare. For work. The day ahead. I needed stamina and wits. To be sharp. Ready.

The elevator from the street and entranceway opened straight into the living space. I'd only witnessed that in films before. It seemed decadent, exciting.

A long, sleek table, always adorned with a simple vase of cut flowers, "ordered" with various piles of paperwork, books, pens, sunglasses and sticky notes, was lined either side by solid, wooden, matching

benches. It stretched from the kitchen area through towards two light, neutral-coloured, comfortable sofas. The bench nearest the lift had things on it, to be "remembered," to be returned, or cleaned, or delivered.

The entire end wall of the high-ceilinged apartment was windows. Light flooded the room.

I'd step from the lift and she'd greet me, often with wet hair, half-dressed in a nightgown or wrap. Elegant. Confident. Always. Her thin, expressive arms would envelope me in a hug and her intoxicating, subtly pervasive perfume, one of her signatures, would flood my senses. Black, wavy, conditioned, attended hair would brush my face and neck, and I'd return the embrace. She'd step back, her dark, deep eyes, intense, taking me in. Assessing. She'd smile. (Usually, not always.) Her distinctive, chiseled features opening. Large, white teeth shining. She'd ask my news. Comment and be off. Striding to the bedroom, billowing black cloth, to finish dressing. Reappearing, perhaps ten minutes later. Determined. Ready. Classy.

Tea. Barry's Tea, would be brewed and our day would begin.

She had ten ideas an hour. At least. Every hour. Every day. The days flew by. She never sat for long, unless writing. Even then there was constant chatter as her thoughts spilled out. Some unfathomable. Some brilliant. All distracting. Insistent. I'd leap from one project to another, from one note to another. Create lists, diary dates, spreadsheets, sift through hundreds of emails, attempting to make order. Sense. Plans.

We'd be working on something and she'd leap from the bench, grab the "swiffer" from the cleaning cupboard, glide up and down the apartment gathering dust, lint, and errant detritus. Pushing the long-handled, swivel-headed "broom" ahead of her, she'd arrive at some conclusion, solution, or sought-for phrase. A moving meditation. It soothed her. She would viscerally delight in the mundane, simple task of returning the polished wood floor to an unblemished shine. Swiffing.

A deep exhale would signify her arrival at decision or resolve, back at the bench. Within minutes she could be off again. Striding. Intent. She'd call from the bedroom or bathroom. A name, appointment, complaint, revelation, observation, a laugh. A plan. They all came together. Regardless. Unedited. Unorthodox. Ordinary. Brilliant.

We finished our day when Rob got home, sometimes earlier. Usually by 5pm. Exhausted and exhilarated. Fifty seeds planted. Twenty left fallow.

For four months I was immersed in her world. In her words. In her passions. So completely human. So very, very ordinary. Different. Insightful. Ethereal. I love her and I miss her. I put her on a pedestal that I think she'd rather have not been on. She taught me to be me. Friends. Thank you.

photo by Hans Li

Tina Merethe Foss
Tjøme, Norway

Tina is a massage therapist who discovered Gabrielle's 5Rhythms in 2001, giving birth to new spaces that carried over into her daily life and work; rhythm has always been her path through life.

During my first workshop of the Teachers Training, Gabrielle comes up to me and asks me how I am. I answer that "I'm fine, but…" and then I go on talking about my past. Gabrielle looks at me and says,

"But you are here now."

And then she left me.

This is a moment I will never forget.

I give thanks to her for that sentence, it visits me every so often.

With love,

Tina Foss

Tyr Throne
Bali, NYC, Germany, Costa Rica, and Mexico

Tyr is a dancing writer & healer who had his mind & heart exploded open by Gabrielle over 30 years ago

Moments:

When I found you my body was so broken from ballet I could barely walk, and could no longer dance because of the pain. I had not written a poem in years. Drinking way too much. Wandering confused.

The first of many times you blew my heart and mind wide open was when you said during "God, Sex, and the Body,"

"Feel how your head wants to move right now."

I am stunned. Whole body vibrating. I have never imagined dancing by following how my body *wants* to move. In ballet, every moment is pushing my body to the point of almost killing myself, always dancing on

the edge of pain.

Your seductive voice, mysterious images, and wild music, splits my soul open, the feeling of heaviness falls away, all injuries slowly dissolve, my spirit sings, falling lost in a dance of healing my body, mind, heart and soul.

It is remarkable how both tough and kind you are. I remember you threatening during a "Mirrors" warm-up:

"Don't anyone dare to speak. This is sacred space."

You dance into trance when you teach, and speak from that place. In "Heartbeat" you share:

"Go to the edge, and jump. On the way down you might meet God. Or the person you are supposed to fall in love with tonight."

In ballet I always get to rehearsal early to warm up. I remember showing up fifteen minutes early on the first day of a "Bones" workshop, and finding the music is already playing and you and the tribe are already dancing. What's up?

The next day I come thirty minutes before the class, and again the music is already playing and most of the tribe is already dancing. Interesting.

The next day I come *an hour* early and you and the musicians are getting set up and I realize how brilliant it is that you have created a dance *without a beginning*, that the dance is already going on, and everyone enters in the middle. Mind-blowing.

The maps you share in "Cycles" are about honouring and nurturing our inner child, teenager, grown-up and elder, guiding us from birth to death. So many incredible ideas come flowing out of your mouth:

"You are five years old and dancing in front of a mirror. Your father comes in. What is your dance for him?"

I repeat the words to you during lunch and ask how you created such an amazingly healing ritual. I am stunned speechless when you respond:

"Did I say that? All I remember is dancing."

I move with you every night before I sleep…and whenever I am afraid I remember you holding me and whispering, "Dance Wild & Free Forever, Tyr."

Visudha de los Santos
Taos, New Mexico

Visudha, a desert dweller and 5Rhythms dancer since 1999, delightfully carries Gabrielle's shamanic lineage. (Sadly, our beloved friend Visudha left this world on November 8, 2021.)

Shedding Skins

I danced with Gabrielle for several years, shyly watching her from afar, never engaging with her personally. I never knew how to respond to her intense eyes, her unpredictable expressions that ranged from a deep warmth that emanated from her center, to her quick exclamatory outbursts, or the energy that I could feel arise as she moved past me on the dance floor. I lacked the confidence to even put myself in the line of people thanking her and saying goodbye at the end of workshops. I always had feelings, gratitude and opinions I wanted to express but somehow my feet held me back, and the words stayed lodged in my throat. I would always leave a workshop berating myself for not saying anything to her.

There was a gesture she was famous for: "The Roth Turnaround," wherein she would end a conversation with an abrupt turnaround, and rapidly depart the area. I experienced one of those during one of our first personal engagements, which was quite short, and left me simply mortified when I realized what I had done moments after she left:

During the end of a session, while in a conversation with an intimate group of dancers at a workshop in Marin County, California, I felt a light tap, tap, tap on my right shoulder. I turned around and to my surprise my eyes met her eyes. I was taken aback, astonished that there she was, face-to-face, wanting to speak with me.

Her words were simple:

"Can I see your tattoo?"

That's it. No preamble, no other conversation, direct and to the point. How she knew I had recently acquired a tattoo, I never knew. The tattoo was quite large, curving around the back of my hips and down both of my thighs. Shocked, I didn't, couldn't think, and simply reacted by pulling down my pants, right then and there. She looked cursorily, said,

"Hmph," and then did her signature turnaround move.

As she walked away, I quickly pulled my pants up, embarrassed and bewildered that in one sentence this woman did what no man has ever done: got me to drop my pants so quickly! And, in a public place! In front of people! In front of my friends and fellow dancers!

Years passed, I eventually lost my shyness, gained some confidence, and learned a lot. She influenced me in very deep and profound ways. She never spoke of the tattoo.

At one point, I approached her and shared some shamanic experiences I was having, hoping to get more insight and guidance from her. She declined, stating that,

"I never teach that."

I was incensed, of course, given that she was a self-proclaimed shaman. She knew what I needed, however, as her refusal is what sent me to the jungles and the mountains of other countries and worlds learning shamanic methods.

In 2008, at my teacher graduation, she escorted each graduate partially down our future pathway. Each student received a different form of escort. For me, she walked arm-in-arm for a few steps, paused, looked me in the eye with her glittering eyes, leaned in and whispered into my ear,

"Fly, snake shaman woman, fly."
She turned rapidly, stepped behind me, and fiercely shoved me down the path.

That was her only reference to my tattoo or the shamanic path in all those years. I've known my path from almost the beginning of this dancing journey, but her whispered sight was the validation that I needed to take my confidence to another level. She always knew how to give what was needed, not necessarily what was desired, but certainly what was most helpful.

R.I.P.
Dear Visudha

April 28, 1965 – November 8, 2021

Willemijn de Dreu
Deventer, Netherlands

Willemijn rolled from theatre school right into Gabrielle's magical dance space in 1996, began teaching two years later, and never stopped being connected with G or the 5Rhythms.

There was no Internet or email when I started working with Gabrielle.

After the training in 1997, I always had many questions to ask, but I was living in the Netherlands, so by the time I sat down to write a letter, mostly I realized that the answers were inside me already; I just had to imagine what she would say, and listen. One day I did write a letter though, telling her I was struggling to find the words while teaching; I am a dancer, not a talker, and most of my students were much older than me (back then, not anymore, hahaha) so I felt shy.

Weeks later I got a postcard back, with the Raven logo on it, saying:

"Just keep showing up. I love you, G."

A few words, but the postcard is still inside me, and it became a road sign in my life: in any difficult situation, I would hear, "Just keep showing up." So yes, amongst all other things, she definitely taught me something about presence.

Another sweet story:

You know how Gabrielle always sang that song, "Row, row, row your boat, gently down the stream"? The first time we sang it, my English wasn't very good and I didn't know the song and I was overwhelmed anyway, so stumbling along, I made up my own words: "Roll, roll, roll your bones, gently down the streets."

When I found out the original words, I actually liked my version more so I kept singing that. Years later I told Gabrielle and she was delighted about this. She made the whole group sing "Roll your bones!"

Gabrielle's postcard to Willemijn:

294

Translation:

Dearest Willers

Zora is beautiful! Of course – how could she miss with you and Aryan!
You are an amazing teacher – just keep showing up! ! ! I am very well –
dancing & starting to teach & kick butt!
I love you

Gabrielle

Did Zora get her gift?

Xoli Fuyani
Cape Town, South Africa

Xoli is the Environmental Education Project Manager at Earthchild Project. She started dancing in 2012 and trained as a 5Rhythms teacher in 2014, teaching it in People Of Color areas and running weekly outreach classes.

June, 2011 was my first encounter with Ms G. I sent her an email expressing my gratitude for the dance and my curiosity to get to know her "personally!" To my surprise, one day after she wrote back saying,

"I know you might think this is crazy, but I am booking you a flight to NYC so we can get to know each other." It was the time when her dearest friend Lekha Singh was shooting a documentary about her. On the last day of the filming she squeezed and hugged me for a very long time and then whispered in my ear:

"You just fell on my lap, and I had to catch you."

Radio Host to Gabrielle:

"Do you think your dying process
will follow the pattern of the 5Rhythms?"

Gabrielle:

"I don't know,
I've never died before."

THE FINAL JOURNEY

photo by Robert Ansell

The 5Rhythms were my language,

my way to communicate

all that I was experiencing, feeling, seeing.

They came to me in the night in the sweat of dreams,

in the dance that never stopped moving,

in the peak of orgasm, in the prayer of childbirth.

They came to me raw in their silence,

they came to me in waves that washed over me and

emptied me and filled me with their

aliveness, their presence, their spirit.

—Gabrielle

hanna k. lippe
hamburg, germany

the day gabrielle died i sat by her hospital bed, set up in her bedroom, but not a regular one; hers was made of black, matte metal. even death she faced with style. she looked frail in her black velvet sweat pants, like a little bird fallen from its nest. dying is no joke, I thought. she looked like gabrielle and she did not. her spirit had already almost passed the veil, her mind unconscious. i sat with her for some time telling her all the things I needed to tell her, silently, in my mind, holding her hand. and while i sat there, beside her sleeping, dying body, her spirit rose and her presence filled the room. it was the wildest metaphysical experience i ever had, but it was real. i saw her as a wild black river, that was suddenly running underneath my feet. she was the space between the lean, tall fir trees of the still, misty forest on the river's bank. she became a dark giant angel rising behind me, made of black clouds, stretching up high into the sky. her energy, her force, her gentleness, it all came alive right there and then. gabrielle in all her glory.

i saw the raven taking flight. i sat there and all the things unsaid were said. all the feelings unfelt were felt. it was all okay. she squeezed my hand. it was all love.

she died later that night. in her dying she was my greatest teacher.

From 1997 to 2010 I saw Gabrielle intimately on the bodywork table in her bedroom 5-10 times year. I felt a special closeness to her without asking questions or invading her life with my fears. I did transfer my energy through my hands to her body. We did some movement together after the sessions that never lasted long as she got bored or perhaps excited to return to her creative pursuits. As her cancer became an issue she became hesitant to have bodywork sessions as she had become so slight and delicate. I remember her "Fuck Cancer" t-shirt I think she got before going to Germany for her hyperthermia treatments.

Her left ribcage had always had a noticeable imbalance from left to right. The right ribcage tissue had no willingness to receive any penetration under the diaphragm. I had always been perplexed by this and Gabrielle certainly knew something was amiss. At the time I felt Gabrielle to be invincible and able to take care of herself so I didn't take the investigation any further. Later on when her cancer originated on the right side in the lung, I felt sad and angry with myself for keeping silent.

In April of 2012, the year she died, I was honoured that Gabrielle had kept a promise of sorts to come to Montreal. We had exchanged emails about her fear of coming.

"Will I make it?" she wondered out loud to me. Somehow she managed. My new wife Gillian found her an amazing hotel and arranged for a local osteopath/chiropractor/healer to energize her each morning. She ordered fresh juices with blended avocadoes. At the workshop we chatted behind the drummers as she rested, while 150 people expanded and contracted on the dance floor.

Our last conversation took place as I drove her to the airport. I asked her curiously what happened to the voice exploration we used to do with her. She answered in wonder,

"Hmmmmm, good question," and I promised to follow up next time I saw her. I felt her spirit so bright; I saw her living forever. And she has.

39

Amber Ryan
(continued from Page 39)

The Last Moment:

It had been a while since I had been with her. The time and space was very precious, as we knew she was passing. It was just Gabrielle and me in her room. She began to speak about what was really hard for her during this stage of her living and dying. She was always so independent and a great lover of aesthetic beauty. Part of her grief was her inability to do the things that she usually tended to; simple things that brought her pleasure and created an environment of Grace around her. Gabrielle loved having flowers in her

home. She had a favorite flower shop just around the corner. She would tend to those flowers each day, taking time to freshen their water and clip the ends of their stems to give them a longer life. While lying down resting, she said,

"Amber, it is so hard for me to see those flowers over there and know they need to be trimmed and their water changed, and I cannot get up and do it. It is so hard for me to not be able to do the things that I have always been able to do, and I cannot ask Robert to do another thing for me. He is doing so much. I have always been so independent, and it pains me to not be able to take care of the things I want to."

Then she gave me one of the biggest gifts she had ever given me; her approval and a transmission of full acceptance:

"Amber, you are so independent, just like me."

Those three words, "just like me," were a gift of connection that for me spanned our whole relationship, a resonance from the moment I read *Sweat Your Prayers* and knew she would be my teacher, all the way to this current moment. In that moment on 13th Street, I felt fully seen, embraced, loved, respected and appreciated by her.

Her Last Wish To Her Tribe:

A wish for us all to dance Stillness.

So I do.

I love you Mama G…"To the moon and back."

I will never forget...

Dearest Gabrielle,

I promise to hold your baby
in light, in dark, in laughter
in sadness, in work in play
and most of all with you.
Love,
Morgan Rae

Morgan Rae Berk
Brooklyn, NY & Salt Lake City, UT

Morgan met Gabrielle in the last months of her life, and brought her considerable marketing and business acumen with her, partnering with Jonathan to keep Gabrielle's vision for 5RGlobal alive and ever-expanding.

In the last weeks of Gabrielle's life, she was not moving around much and laying in bed most of the day.

I was visiting with her one time and she stopped the conversation suddenly, eyes wide, looking down at my feet. She asked what shoe size I was.

I replied that I was a 10, and she perked up full of energy like I hadn't seen in days, floated effortlessly over to her closet, rummaged in the shoes at the bottom for a few minutes and emerged with a hardly worn pair of size 10 Rag & Bone black boots.

She then returned immediately to the slow, frail woman that I had seen for weeks…needing help and not moving around much as she shuffled back toward her bed where she laid still for the next few hours.

I remember standing there in a bit of shock, mesmerized by what I had just witnessed. Nothing could hold back G's strong will for her fashion to live on, especially a pair of good black boots. Giving those boots a future revived every cell of her body for a few minutes in a way that seemed impossible.

In the years since, those boots have become my default Super Power boots—the costume and reminder that I can pull myself out of any low point instantly with the right footwear.

You can't get this in a pill, it doesn't come in a drug.

It comes in surrender, and in order to surrender

we have to be willing to let go of everything that's in the way.

We have to let go of our stress and our boredom,

let go of our thinking, all our judgments and criticisms.

Everything has to go.

We have to let go of all the emotional baggage we're carrying:

fear from ten years ago, anger from 20 years ago.

We have to be able to give it all up

in order to go to that incredible ecstatic place.

And once there, it's like God's drug:

you just want it, you want to go back, you can't help it.

—Gabrielle

Lourdes Vázquez
México City, México

Lourdes discovered Gabrielle's work in Switzerland in 2006 and was deeply touched and saved by her map, and became committed to sharing G's magic in her communities. She was certified to teach in 2018.

I have only told my husband (because he was sleeping next to me) and one friend this experience with Gabrielle:

I never met her physically; I tried to get to her, and was on the waiting lists for her workshops three times with no luck.

I remember when I heard about her sickness; I could not believe it. The comments and news of her situation were not very good, so when it was announced that she was moving into Stillness, I felt abandoned by a mother I never met, and sad for not knowing what was going to happen to the practice that saved my life.

To say thank you and send her blessings, my community organized a dance to celebrate her life and danced our prayers for her. I had long conversations with teachers and members of the tribe about her, read her books again and felt very connected with her.

I went to bed on the 22nd of October, 2012, and at some point in the night, in a vivid dream or vision or whatever you want to call it, I woke up because Gabrielle had entered my room. She was there, powerful and grounded, loving, expanded to take up the whole space, and without words I just knew that she had died. My husband asked me what was going on, and I said:

"Gabrielle died; she came to say goodbye."

Margarita Levieva
New York, NY

Gabrielle Roth's medicine was the balm that healed Margarita's Russian ballet training wounds, and transformed her life forever.

I happened to be out in LA, shortly after Gabrielle's passing. Fortunately, the Los Angeles 5Rhythms community decided to hold a memorial dance in her honor. I was one of the first to arrive at the hall, eager to celebrate and mourn one of my most beloved teachers, to connect to her in the only way that felt appropriate, through dance.

There wasn't a dry eye in the room as we began our Flow. I danced with an intense feeling of sorrow and gratitude for a woman who had impacted my life so deeply. Every move felt like a prayer and communion with her spirit. About halfway through the two-hour Wave, as I found myself, once again, sobbing on the floor, Gabrielle appeared. She leaned in close to my ear, put her hand on my shoulder, and said,

"What are you waiting for?"

Her words echoed through my entire being. Just as in life, in this afterlife moment she had the ability to get to the core of exactly what I was personally dealing with at the time.

"What are you waiting for?" she repeated.

I knew exactly what she meant, and precisely how global that statement was for my life and everything in it. I ran to get a pen and wrote her question on my arm. As I went back into my dance with this newfound insight, it began to take new shape:

"What are you waiting for? What are you saving it for? What are you holding yourself back for?"

I continued to write those words on my arm daily, for a year straight, until a Russian tattoo artist from Bali asked me if he could tattoo those words onto my arm. I agreed. So, now, Gabrielle's words are permanently with me, to remind me, daily,

"What are you saving it for?"

Who knew that one of her greatest lessons for me would happen after she died? Although, knowing Gabrielle, I'm not in the least bit surprised.

Last Meetings

Considering that Gabrielle never appeared in public without looking absolutely stunning, I was extremely moved and touched when, toward the end of her bout with cancer, she welcomed me into her apartment, looking like shit. There is no greater human gift than to allow another to peek behind the curtain, to drop all veils of illusion and be utterly naked. What had she taught all of us, if not that? She had on no make-up, the cancer drugs had caused ugly marks to appear on her face, her hair was a mess, she wore a frumpy house dress, was thin as a rail, and I never loved and appreciated her more. She was utterly without self-consciousness and we sat on the couch together.

I am not a touchy-feely person. I'm not the type who normally offers people back or shoulder rubs (except when I was much younger and wanted to sleep with whoever it was.) But sitting there, with her bare feet just beyond reach, I was moved by a spontaneous impulse deeper than my habits and personality, and I got up and moved closer, and began massaging her feet. It was my last gesture of gratitude: giving a tiny little something back to the *very feet that lived in the beat* and had inspired and awakened the feet of so many other grateful soles around the world.

~ ~ ~

Another day while visiting, her doorbell rang: it was the delivery of a new, $2000 Dux mattress cover, to replace her old one.

"Will you help me get this on the bed before Robert gets home?" she asked. "Maybe he won't notice, or he'll kill me."

We managed to do the switch, and as I was leaving, she asked me to take the old mattress cover down to the garbage area of her building. But I had a better idea: This was no ordinary mattress, to be discarded in a rubbish heap. This was *Gabrielle Roth's mattress cover*, upon which she had spent countless nights, imbuing it with her magic, power and Grace. I would take it home! So picture me there, carrying a king-sized, rolled-up mattress cover through the streets of New York City, onto the subway, then a train, and eventually getting it all the way home to our house in Richmond, Virginia, where, as I already knew perfectly well, my wife

Shari would say *the precise words I had already heard her say inside my head* in NY the very instant I had thought of keeping it:

"We are NOT sleeping on someone's old, used, throwaway mattress cover, especially someone with cancer." And so it never made it to our bedroom. I wrote Gabrielle to ask her what she thought about the "karma" of the mattress, given her illness:

"Fear not," she replied, "there are no cancer vibes on that baby, just endless afternoons of tea and reruns of..." I can't remember which TV show she mentioned. When Shari and I left Richmond, I wound up giving the mattress cover to another 5Rhythms friend, for her son's use, and I can only imagine where else it has traveled since.

~ ~ ~

I don't remember who told me this story. Very near the end, a young hospice volunteer stopped by to visit, and clearly had no idea who she was dealing with. She attempted to offer Gabrielle the standard "death" talk that she had learned: to not be afraid, it was okay to let go, to go toward the light when the time came, and so forth. A few moments later she emerged from Gabrielle's room in tears, and one of the family team rushed in to ask G if she was okay, and in her semi-haze, she responded:

"Yes, I'm fine...but there was this child in here just now trying to tell me how to *die*."

~ ~ ~

Post-Mortem Supernatural Occurrences:

A few days after Gabrielle passed, she was very much on my mind, and I was sitting in an orthopedist's inner examination room, in Richmond, Virginia, waiting for the doctor. The door was open to the nurse's station, and I overheard a nurse get off the phone and say, "That was Gabrielle; she's *so* amazing...and you should meet her husband, Robert!"

Wow. Good one.

A few days later I was taking a train into New York, and I presented my ticket to the conductor. New Jersey Transit train tickets are completely anonymous, issued from a machine; there are no names on them. The conductor looked at my ticket after swiping it through his handheld machine, then he looked up at me, suspiciously, then back at the ticket, seeming confused. Then he came up closer, bent down and looked me

right in the eye, inches away from my face, *and I swear on my father's grave*, he said to me, firmly,

"YOU ARE NOT GABRIELLE!"

Lastly, I was driving on the Garden State Parkway, thinking deep and hard about her, and the traffic flow caused me to brake and slow down, and suddenly, right in front of me a car pulled into my lane; it had the word RAVEN plastered on the rear windshield, along with an image of a big black wingspread.

I will never forget...

when Gabrielle took me from
pounding my head into the gym
floor + walked me over to the
padded wall and told me that
I could do anything except
hurt myself (he way blnt.
allow it

I see the world through the

iridescent black of a raven's wing,

the sleek black of a panther's skin,

the luxurious black of silk velvet,

the tough black of smooth leather,

the ethereal black of soot,

the shiny black of a limousine,

the all-enveloping black of a nun's habit,

the thick black of Japanese hair,

the ominous black of a thundercloud,

the echo of the black cry,

the mysterious pull of the

black continent within.

—Gabrielle

Judith King
Wicklow, Ireland

Judith is a therapist and teacher who came to know Gabrielle only through the work of others way back in 1998. She "met" her for the first time on the night of her transition from life into death, through a powerful sense of Gabrielle's presence saying, "I see you, I know you, just dance, dance…" and so she does!

My story with Gabrielle belongs more to a "parallel universe" rather than this one. On the evening that Gabrielle died, this woman, whom I had greatly admired, but regretfully, had never met, seemed to visit me for a moment or two, in my living room, here in Bray, Co. Wicklow, Ireland. At that moment, I did not know she had died. She danced with me for a brief while and said,

"Just dance Judith, keep on dancing. Do it, with yourself, with others, particularly with any vulnerable others who need the healing, just do it, dance!"

"But what about the dance training that I haven't fully done?" I countered, "What's the story there?"

"None of that matters as much to me now," she said, with that characteristic, no-nonsense, no-smile look of hers.

"What is most important to me is that everyone who needs to, gets the opportunity to dance, to heal, to grow, to expand. Just do it."

It was as real as if I had had this conversation in a workshop. And never again was I ever able to "conjure her up" in that way. Nope, my guess is she made a quite a few visits, probably scores of them, en route to that place of mystery, out of here.

Endings

The last time I saw Gabrielle, we jumped into a taxi after a workshop and went to her Holborn hotel to have tea. We sat downstairs. She looked very young and thin. She said she felt all wrong in the clothes she was wearing that day. I said she looked casual and I liked the look. We laughed, and hugged goodbye. I turned back to look at her as I left. I felt sadness but I often did. I can't say it was definitely different that last time, but I felt clear-headed and knew that I had to leave quickly, without drawing it out.

About a year later—perhaps G was in remission?—I did a workshop with Kathy and Lori in London. We did that exercise where we witness our partner dance a "Wave" without music. It was very beautiful and simple and it reminded me so much of Gabrielle's teaching. The sun poured in through the skylight, and watching this unknown person dance was so moving that when it was my turn to dance, my heart cracked open. I managed to hold it almost together; I could have let it go, but I like privacy.

When the exercise ended, I crawled under the table that held the music system; it had a tablecloth draped over it so that I was hidden from view, and I cried and shook and silently sobbed into the floor. I was more completely lost to a wave of grief than I can ever remember. I was in mourning for Gabrielle, and it was unstoppable. The day ended and Lori knew I was under there but left me alone until they needed to pack up the table. I am not sure they knew quite what was going on, so I just said, "It's Gabrielle," and Kathy said, "But she is okay now." Yet I was in mourning.

A space had opened up inside me and I knew I would never see her again, never dance with her again. She was still alive and yet the loss felt so huge, it shook me to my core. I managed to get into my car and drive home as tears rolled down my face. Kathy and Lori called the next day to see if I had stopped crying. I felt so lucky that I had had a place to cry, surrounded by people, yet undisturbed and safe. Lori kept people away from me, but I knew that they both knew I was under there.

I called Gabrielle that night and we spoke for ages. At first I didn't tell her that I grieved for her under the table. I just said I missed her, her teaching, and her irreplaceable presence, that nobody could ever take her place as a teacher in my life. She said,

"Honey, I am still here!"

But she knew she wouldn't teach in London again. I am happy that I called her then; we chatted gently and then laughed when I told her about me under the table. I'm glad she knew a little bit.

I flew to New York for her last weekend. Jonathan taught. He was in a magical space, as if Gabrielle was by his side. He was inspired. I wouldn't have been surprised if he had started speaking in tongues. I didn't see her again. I didn't ask. It felt wrong; she was there in spirit, Jonny teaching, Robert drumming, Sanga drumming, it was in a different dimension. Unforgettable. Imprinted on my soul.

She died while I was flying home…in the clouds.

photo by Greg Rosenke

Jeannine Walston
Los Angeles, CA

Jeannine is a Cancer Coach who has worked in that arena for over 20 years and provided extensive coaching to Gabrielle during the last four years of her journey.

Wise Teacher & Cancer Pal

In July of 2009, I heard about a weekly dance gathering in Sausalito, CA, and my body was compelled to attend. Inside a circle, the drums ripped my body, shifted my mindset, and suddenly I felt some freedom. Since I knew nothing about the practice, I signed up for a one-day workshop in August with the 5Rhythms founder, Gabrielle Roth.

On August 4th, I received an email directly from Gabrielle. She had learned about me through a mutual friend who knew I had expertise on integrative cancer approaches as a cancer coach. She told me she had Stage IV lung cancer, asked me some questions, and I provided extensive information. She also said,

"Please keep lips zipped on the true situation."

She didn't want the community to panic about her condition.

I continued dancing in Marin County, and my exchanges with Gabrielle were frequent. Our ongoing cancer interactions cultivated more care and compassion between us that blossomed for over three years. Concurrently, I learned about her extraordinary wisdom as an evolved teacher and remarkable human being.

We both went to see someone at the Omega Institute in Rhinebeck, NY, in September of 2009. A few days prior, Gabrielle and I connected in New York City. As I entered her place, meeting her in person for the first time, she said,

"I feel like I've known you forever."

We talked about cancer, treatment approaches, healing, and other topics as we learned more about one another. She thanked me for helping her and told me that for her,

"Certain statistical information can be too much."

My head and heart understood her message, and I told her I'd be mindful. During our dialogue, we gradually moved into silence and stillness, keeping our eye contact in soft focus, dropping into more depth. Afterward, Gabrielle smiled and said,

"Very few people can do that."

Toward the end of our conversation, Gabrielle and Robert were scheduled to have dinner with friends from out of town. However, since Gabrielle endured breathing challenges related to the lung cancer, she had an oxygen system in her bedroom for assistance. Robert left to meet their friends at the restaurant. I held her as she boosted her oxygen levels through the machine, and when her vibrant breathing returned, we walked outside in NYC streets until we arrived at the restaurant and said goodbye.

At Omega, Gabrielle experienced some pain and her energy became more depleted. As we waited for transportation to the dining hall, Robert playfully called out to a passing vehicle to "Pick up a Raven!" Gabrielle sat in the front with a young man in his 20s, and Robert and I were in the back. Despite being totally exhausted, she somehow shifted within to muster her energy. She put her arm behind the driver and engaged in sweet, small talk. He dropped us off in the back of the dining hall and we entered the building where Omega staff members ate. As we walked through that space, over 100 people in the room looked at Gabrielle with reverence as she moved with confidence, flow, grace, and strength.

As I learned more about Gabrielle, I saw her wild, wise ways while being intuitive and mysterious. Throughout our cancer conversations, she also extended support for my own healing, telling me to

"Do anything to surrender to its way. You have given it your all. Trust your instincts and your body."

After a workshop in California while Gabrielle was in NYC, she asked me,

"How is the workshop settling?"

I responded by telling her how the experience was changing me.

"Changing," Gabrielle said. "The Chinese like this a lot. 'Change is good'—says the Chinese doctor."

Gabrielle's immense heart was vast, including the simple yet profound words she sometimes uttered: "Me loves you."

Gabrielle was a cancer patient, a fierce warrior, vulnerable person, and human being. She wrote to me:

"Compassion can't be taught. It must be earned by moving through the fear, anger, and sadness and 'smothering' them all to death. Only then can we be compassionate for the challenges of another, when we have faced our own.

Love you big, Me."

The last time we met together was in NYC. I connected with Gabrielle before, during, and after her chemotherapy at a hospital, and then we had dinner at a restaurant. From there, when saying goodbye, touches of tears emerged as I felt my heart broken inside; I wanted the cancer to disappear, and for Gabrielle to continue living her precious, powerful, and purposeful life.

She wrote me:

"Facing cancer is facing death. I'm not really afraid of death, but I *am* afraid of the suffering and pain that can precede it. That I know."

At the end of September in 2012, I attended a 5Rhythms workshop in Sausalito. On Friday morning of the event, before leaving my apartment, I received an email from someone caring for Gabrielle. With tremendous sadness, the description of her condition wasn't good, and I knew she was much closer to death. I went to the workshop crying inside, and I could not tell anyone. Rages of sadness and other emotions became blocked during the workshop as complexities about Gabrielle's life and death were hard for me to address at that time.

Although Gabrielle has moved to the other side, I feel she is present here on Earth. She continues to fly high with angel wings of embodied presence, which touches hearts into motion blended in the beat and feet "forevah."

Hannah Loewenthal
Cape Town, South Africa

Hannah discovered the 5Rhythms in 2002 and was certified as a teacher by Gabrielle in 2008.

This was my very last exchange with Gabrielle via e-mail, shortly before the cancer news—it's kind of crazy:

Gabrielle Roth <gabraven@panix.com>

to me

I wrote a song years ago with the lyric
don't shoot me down
i surrender
i want to die dancing

Raj Singh
New York, NY

Raj served as Gabrielle's personal at-home nurse in her last months and final moments on this Earth-plane.

Dear Robert ,

Thank you for enriching my life.

Today when I woke up, I thought about you and Gabrielle. I could write a book about it. As I am going through the gut-wrenching loss of my daughter, I heard Gabrielle many times, whispering,

"Raj, you are a flow...move."

I moved, I got up. But my mind had millions of thoughts. I could not sleep, I was not at peace at all, I was shaken up so very deeply. Then one day I was trying to pray and meditate, I was restless, and I saw Gabrielle holding my hand. She told me to stop shaking, made me get up (my eyes still closed, I was in a daze) and she whispered,

"Raj, now move your feet and still your mind."

I don't remember how long I danced softly to an ever-unheard melody, but when I woke up, I was able to pray with peace in my heart.

I was there to take care of Gabrielle, to teach her and nurse her, but instead I got nurtured, nursed, hugged, loved, and above all, I learned so much about myself and living and giving and healing. I learned about herbs, essential oils, fragrances, flowers, plants, drums and flutes. It is not that I didn't know about all that, but I learned anew in her light; it was all so different, it was all so moving, healing and caring. She called me a "snow cub" (small cub of a polar bear). I learned about nurturing, about unconditionally loving relationships and friendships, where there is no account of giving or taking, but just being there together and doing what is necessary.

I remember my sister Lekha Didi coming to visit her and the hugs were enormous, and Gabrielle would also hug me and say,

"She is a slut for hugs too."

I always remember that, and now I also give them freely to all who are near me or come under my care. Thank you Lekha Di for introducing me to dear Gabrielle. I consider myself blessed, lucky, and hand-picked by Lekha Di and of course God, who chose me to be with Gabrielle's journey of life at those precious moments.

Robert, you poured out your heart and soul loving Gabrielle. You helped her to live longer by supporting the essence of her soul and letting her be free like a raven. You made her breakfast daily with fresh bread, fresh churned butters, fresh squeezed juices, and every day a new recipe for dinner—with appetizers,

of course. You probably still collect recipes from the New York Times. You gave your all, and as Gabrielle said,

"Robert is the wind beneath my wings and Jonathan is my flight."

~ ~ ~

Gabrielle was ready for life every moment. She would sit for hours and speak to family and friends about her life, her dance and music, and even allocating her belongings. When she left to be with her God, I saw such peace on her face, like an Angel. Now I know a bit how perfectly and peacefully you can surrender when that time comes, but only a few can master it. Gabrielle was the top one of them.

Robert, Jonathan, Nilaya and I were so very close to her in her last days. Sometimes I was just awestruck with wonder and thought, "Wow, *me* next to *her*, how blessed can one be?" Gabrielle not only enhanced my life and my existence, but she also helped move my nursing profession to another level of acceptance, caring, loving, teaching, and touching.

In her last few days I was amazed by her graceful light that spread in her room like milk-white moonlight, which brings peace to anyone or anything it touches. And she danced with her hands in the air above her head, so softly that you had to be fully present there with her to even notice. She was so aligned with God or the highest powers up above. Nilaya also witnessed her dance in bed, with me at her bedside. She danced beautifully through life. It was divine being there with her until the last moment. She was not only a phenomenon, but a wave of life force that ran through the chaos of living, like a shimmering, dancing moonlight on the surface of a calm lake. Wow. Lucky me, and of course all of us who knew her.

Thank you Gabrielle for teaching me how to love and nurture myself in chaos, and how to still the mind and move.

And thank you Robert for your patience, love and caring.

Thank you Lekha Di for being you, caring and giving of yourself so unconditionally.

Thank you all for enriching my life

With all the love in my heart

Raj Singh

Ruth Pontvianne
Santa Monica, CA

Ruth is a master of the healing arts—and hearts—and was Gabrielle's personal health and spirit guide, and beloved friend, throughout her final journey.

Psychic Bitter-Sweet Moment:

Back in the summer of 2009 I decided to retire from taking care of cancer patients, after 15 years. I took a break from New York and went to Spokane, Washington, to continue studying essential oils and replenishing my so-depleted being.

But it was a short stay, because that's just when I got the most devastating call from Gabrielle, telling me that she had been diagnosed with lung cancer.

My body didn't want to go back and be part of that life and work style again, but my heart hopped on the first plane available. After all, it was Gabrielle, a human being that had dedicated her entire life to the service of others.

All I could think about while in the air was how I would tell Gabrielle that I couldn't live even one more minute within any other rhythm but Stillness!!!

As soon as I landed I went straight to her apartment. During the whole trip my mind was chit-chatting about how I was going to tell her that we would either create a daily living practice together within Stillness, or nothing; but then I also thought, Who am I to impose "My way or no way?" I was getting sick to my stomach just thinking that I'd have to pretend at first and then at the right time, I would just have to find a way to tell her.

I got to the elevator of her building with my heart in my throat, and as soon as the door opened, there was Gabrielle in the most vulnerable state I had ever seen her. I reached out and gave her a big hug, and the first words that she whispered were,

"I promise that from this point on, I'll live my life within Stillness and embrace every step of the way in it, don't you worry!"

From that point on we were fiercely engaged with her healing process until the very end. She respectfully lived up to every bit of it, from dance to nutrition, healing, medical procedures, laughter, many tears. And through her journey she helped so many others. I myself have helped hundreds of patients and I

could tell for sure that Gabrielle had transcended her illness in the most beautiful and enlightened way, which we all call Stillness.

Transforming the German Oncology Klinik

Gabrielle did all her research methodically, to figure out which direction she would take next with her own treatments. One of her best decisions was when she found the Bio-Med Klinik run by Dr. Frederick Migeod, in Bad Bergzabern, Germany. They offered Immunologie (vitamin infusion treatments) as well as Hyperthermie (high heat treatments).

At that point Gabrielle had done many different nutritional detoxes that were prepared and monitored by our beloved Robert, who also fed and cared for her impeccably.

She was always watching, learning, and investigating her next step. So when we got to the German Klinik, on our very first journey to the dining area, she had a drop-dead, disappointed realization:

"How can they offer such amazing natural treatments and feed us *this*?"

It was everything from cold cuts to potatoes, yogurt, and all the foods we were running from. Gabrielle immediately got into action! She gave me some money and told me to find a solution, while she was going to talk to the chief doctor of the hospital, about not only feeding her adequately, but everyone else that was staying there as well.

. Meanwhile, I rented a bike and went to town to see what I could find. Surprisingly, or due to a miracle, I found a Vitamix and a juicer. Back at the Klinik, Gabrielle had already worked her magic, and gotten a big YES! from the administration to allow me into the kitchen to cook her meals. But using her own private code, she said to me:

"Remember how super hungry I get, so make as much as you can."

That was her way of telling me that from that point on, she wanted to share her meals with everyone there.

The doctor said that that wasn't going to work, but that we could give it a try. It was the biggest success and most fulfilling moments that I have ever witnessed. Gabrielle became the caregiver and the helper for that two-week visit. Many patients approached her to say how she had saved their lives by introducing better nutrition. For the afternoon snacks that were usually white cakes and ice cream, she started sharing her

smoothies and juices. When we left, she donated all of our new equipment to the Klinik. She also tried to marry me off with the chef. That didn't work, I am still single!

We returned six months later and everyone couldn't wait to have her back.

A Funny Moment

Gabrielle & I had a long journey on our next trip to Germany. She was so tired, and very apprehensive because we had to take an oxygen tank with us and the altitude took a toll on her. We got to the Klinik around 10:30 pm and went straight to her beautiful room, facing the vineyard and mountains, which, as a wine lover, always made her very happy.

As she was getting ready for bed, she sweetly asked if I could give her a healing session. I said:

"You are my baby and I'm at your full command."

I started by giving her Cranial Sacral therapy. I was very concentrated, channeling, and making sure she was comfortable. But she was also always making sure that *I too* was comfortable and not working too hard, so in the middle of the session, she wrapped her long leg around my neck for support, and that's when the nurse walked in. The room was dark and so super quiet that you could hear your own heartbeat, filled with an amazing energy. The German nurse didn't really know exactly what was going on, and ran out of the room as fast as possible. Gabrielle opened one eye and whispered my name and said:

"Ruthie, now they definitely think we are lesbians!"

I never laughed so hard. Gabrielle was always finding humor no matter what situation she found herself in.

Our Final Goodbye

Gabrielle and I had a speechless connection. No words were necessary to understand one another, and we had an amazing practice throughout her entire recovery journey. I say "recovery," by all means. When she chose her time to transcend, she had a full recovery from her body as her spirit called to her, and she released every attachment still pulling her to stay on earth. Thank you Gabrielle—and a special thank you to *you*, Robert, for being the Anchor, and giving me your full blessings throughout the process. I couldn't have done it without your love & support!!!

~ ~ ~

On Friday, October 19th, 2012, I had the big realization that the time had come for me to separate myself from her choice to leave this planet. The moment had finally arrived and I felt it within our breath. Every day that we were together, every time, we had committed and made sure that we would respect each other's breath, pace and timing! I could see that hers was getting more and more spacious. I gave her a sweet kiss on her forehead and whispered in her ears:

"Gabrielle, this is my last kiss to you. Today I have finally decided to retire!"

She opened her big eyes, looked right through my soul and whispered back,

"ME TOO!"

She transcended three days later, on Monday, October 22, 2012.

photographer unknown

Martha Peabody
Atlantic Highlands, NJ

Martha is a poet, the founder of 5Rhythms Visual, and a Shamanic Apprentice to Gabrielle in this lifetime, a previous one, and the next.

Once upon a time in the Stephen Weiss Studio in New York City…

I did a visual installation for a "Bones" workshop in which I lettered this beautiful quote from the Raymond Carver poem "Late Fragment" on an oversized scroll laid out on the floor:

"And did you get what
you wanted from this life,
even so?
I did.
And what did you want?
To call myself beloved, to
feel myself
beloved on this earth."

I had found this quote in the Anne Lamott book *Traveling Mercies* years before, but had no idea who Raymond Carver was.

Moved by this expression of humility, I anticipated Gabrielle's praise for artfully presenting it. When I asked her how she liked the quote—she had been recently diagnosed with her illness—she responded,

"You know he died of lung cancer."

So one never knows.

I just know I died 5000 deaths in that moment.

Eventually everything connects.

Beloveds…

May we all get what we want in this life, even so.

Martha Peabody

A Recollection of the Medicine of Attention

July 4, 2018

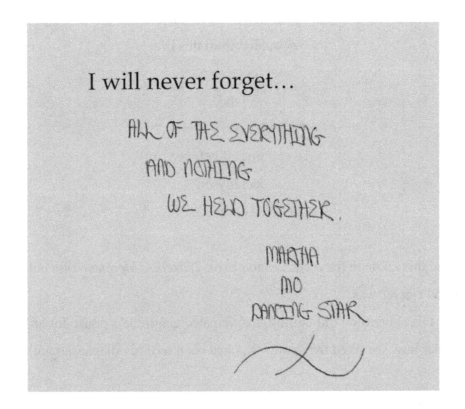

I will never forget…

ALL OF THE EVERYTHING
AND NOTHING
WE HELD TOGETHER.

MARTHA
MO
DANCING STAR

photo by Robert Ansell

Afterword

by Gabrielle Roth

Like a prayer wheel,

I spin in the winds of time;

in the downbeat of the Mother,

in the dark heat of prayer,

I soak in the Mystery.

And I do this for you and me and

everybody we know and those we do not know.

It's my offering.

Inside my cathedral of bones,

my blood pulses,

my skin tingles with sweat—

pounding heart, swirling breath,

and, for a moment, I remember:

God is the dance.

photo by Robert Ansell

photo by Robert Ansell

Left to Right: Eliezer, circa 1980

Eliezer Sobel met Gabrielle in 1978 and became a collaborator and performer in the original Mirrors Theater & Dance Troupe, as well as her lifelong friend and student for the next 34 years. He followed her to Esalen Institute in Big Sur, California where he rapidly became a popular leader of creativity intensives. Eliezer is the author of the prize-winning novel, *Minyan: Ten Jewish Men in a World That is Heartbroken;* a spiritual memoir, *The 99th Monkey: A Spiritual Journalist's Misadventures with Gurus, Messiahs, Sex, Psychedelics and Other Consciousness-Raising Experiments; Wild Heart Dancing: A One-Day Personal Quest to Liberate the Artist & Lover Within;* and two picture books for people with dementia: *Blue Sky, White Clouds* and *L'Chaim!* He was also the publisher of the *Wild Heart Journal: Art, Creativity and Spiritual Life,* and blogs for *Psychology Today.* www.eliezersobel.com

CPSIA information can be obtained
at www.ICGtesting.com
Printed in the USA
LVHW050855181122
733432LV00008B/570